HUMANS OF NEW YORK

Stories

Brandon Stanton

ST. MARTIN'S PRESS · NEW YORK

To Brian DeFiore,
you're a mensch.

HUMANS OF NEW YORK: STORIES. Copyright © 2015 by Brandon Stanton. All rights
reserved. Printed in the United States of America. For information, address St. Martin's Press,
175 Fifth, Avenue, New York, N.Y. 10010.

www.stmartins.com

Designed by Jonathan Bennett

The Library of Congress Cataloging-in-Publication Data is available upon request.

ISBN 978-1-250-05890-4 (hardcover)
ISBN 978-1-4668-8696-4 (e-book)

St. Martin's Press books may be purchased for educational, business,
or promotional use. For information on bulk purchases, please contact the
Macmillan Corporate and Premium Sales Department at 1-800-221-7945,
extension 5442, or write to specialmarkets@macmillan.com.

First Edition: October 2015

10 9 8 7

Occasionally I'm invited to colleges and seminars to explain the story behind Humans of New York. I bring along a very amateurish PowerPoint presentation, which I'm constantly tweaking because I never quite know where to begin the story. That's because Humans of New York did not result from a flash of inspiration. Instead, it grew from five years of experimenting, tinkering, and messing up. I always say that if I'd waited until I had the idea for Humans of New York, I'd never have begun Humans of New York.

The simplest way to describe the development of HONY over the past five years is this: it's evolved from a photography blog to a storytelling blog. In its early years, HONY represented an effort to photograph thousands of people on the streets of New York City—10,000, to be exact. But after cataloguing thousands of people, I stumbled upon the idea of including quotes from my subjects alongside their photographs. The quotes grew longer and longer, until eventually I was spending fifteen to twenty minutes interviewing each person I photographed. These interviews, and the stories that resulted from them, became the new purpose of Humans of New York. The blog became dedicated to telling the stories of strangers on the street.

The first Humans of New York book was published in the midst of this transformation. The book included some quotes and stories, but largely it represented the photographic origins of HONY. It provided an exhaustive visual catalogue of life on the streets of the city. But soon after it went to print, it became obvious that another book was waiting to be made—one that includes the in-depth storytelling that the blog is known for today. This is that book.

For those of you who may have picked up this book on a whim, I want to address one last element of Humans of New York. There are more than 15 million people who follow the blog every day on social media. If you are one of those people—thank you. Thank you for the positivity and kindness you bring to the comments section. Thank you for every time you've said hello to me on the street, and told me how much the blog means to you. Thank you for every time you've shared a post or told a friend about HONY. Thanks for all the money you've donated to the causes we've supported. I'm always asked in interviews how such a positive and uplifting community was created. The truth is that I'm not exactly sure. But the greatest group of people in the world seems to follow Humans of New York. And thank you so much for being a part of it.

<div style="text-align: right">Brandon</div>

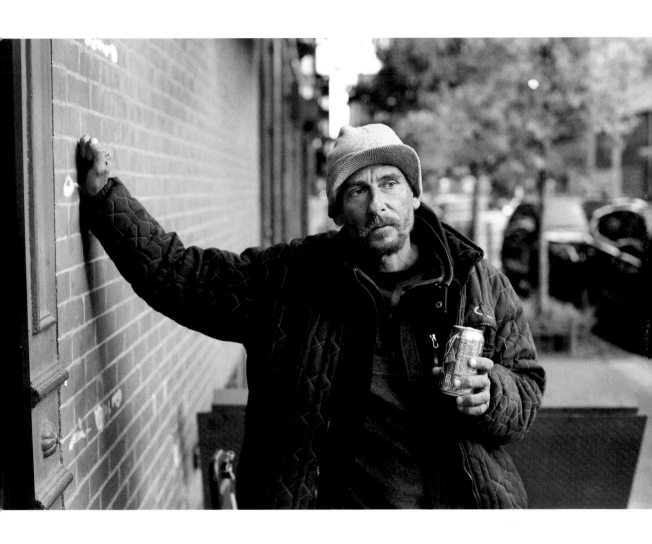

"I died for eight minutes on January 26th. And I've been having really weird dreams ever since."

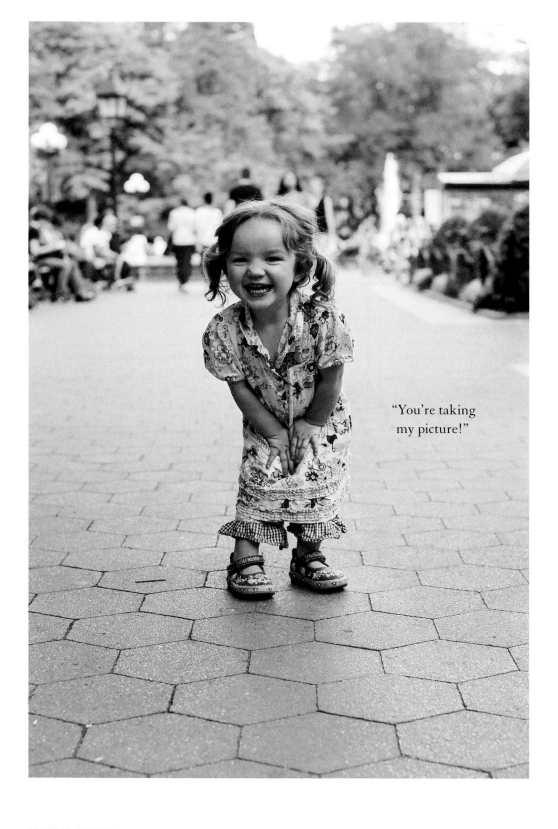

"You're taking my picture!"

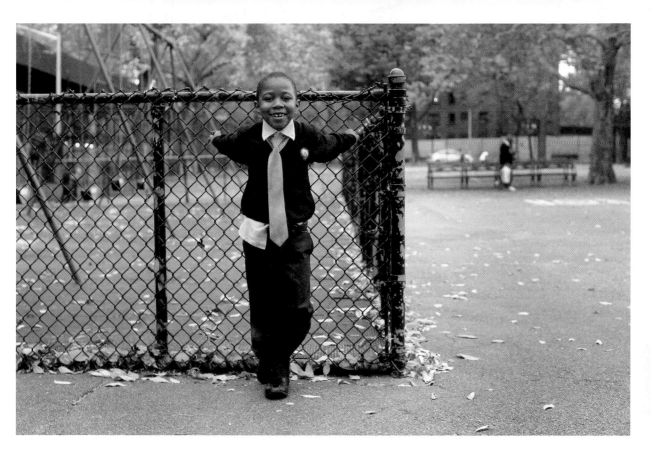

"I want to build a bridge."

"How do you build a bridge?"

"If you want to build a bridge, it's going to take a long time and it might be hard because your employees might not be as interested in building the bridge as you are. You have to think about what kind of bridge you want to make. One type of bridge is a suspension bridge and another type of bridge is an arch bridge. The Brooklyn Bridge is a suspension bridge and it was built by John Roebling and his family and that's all I remember from second grade. And the bridge has to be strong because the water can rise and push up the bridge. I'd maybe like to build a bridge in Wisconsin because there are a lot of people in Wisconsin who might not have bridges, but I don't really know where Wisconsin is."

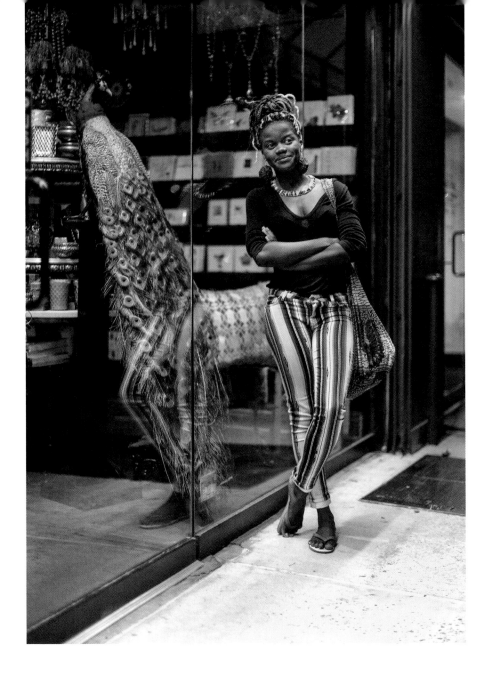

"I'm half Alur and half Lugbara. Both tribes settled
along the West Nile in Uganda."

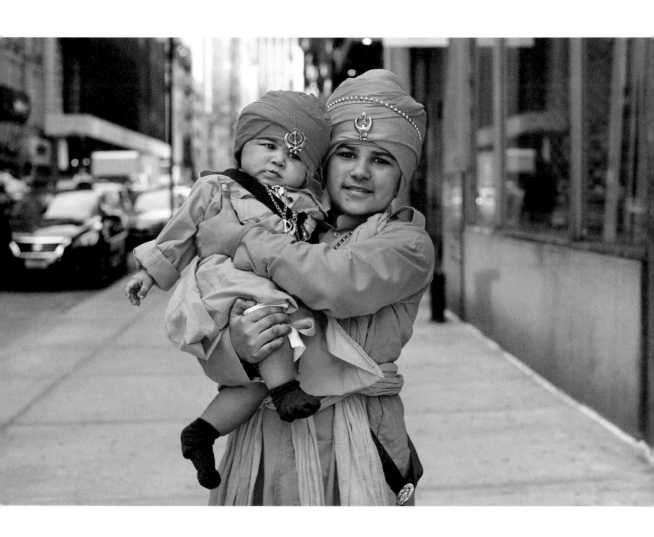

"What's your favorite thing about your brother?"
"He's cute."

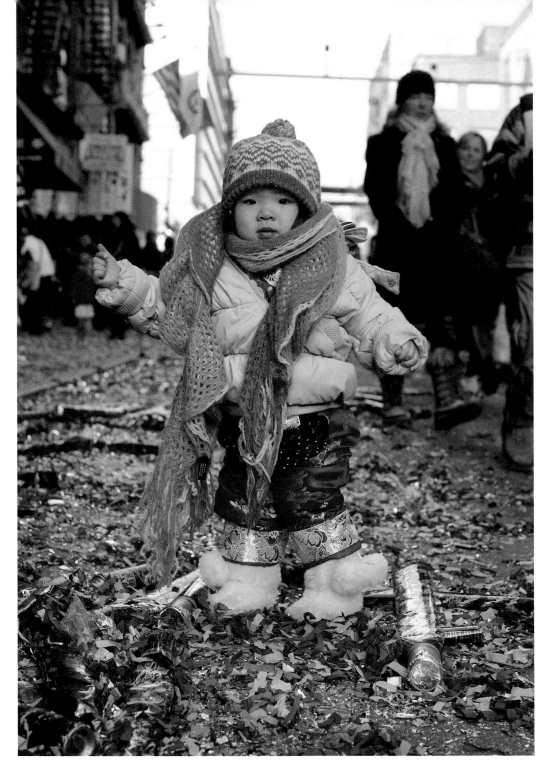

Today in microfashion . . .

"I worry that one day she'll get separated from me, and nobody will understand that she's deaf."

"She's always been very accepting and patient with my trust issues. I've always had a hard time getting close. But no matter how many times I doubted, she just kept saying: 'I'm not going anywhere.'"

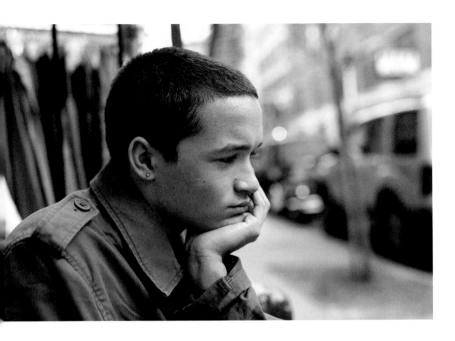

"I've sort of had an arrogant demeanor my entire life, and I'm learning that I'm going to have to change that if I want to succeed. I realized that it doesn't matter how clever you are if nobody wants to work with you."

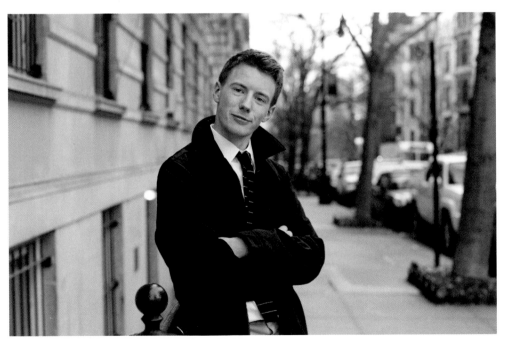

"I have trouble at school with things like maintenance and organization. Those are my weaknesses."
"So what are your strengths?"
"Raw intelligence. Not sure how else to say it."

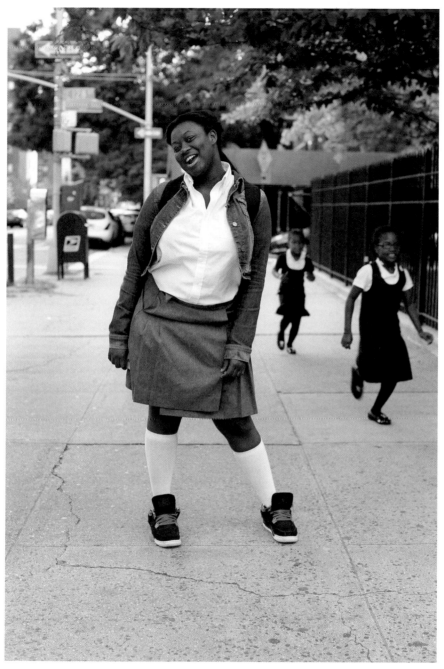

"Whenever I enter a room, I say: 'The **Queen** has arrived!'"

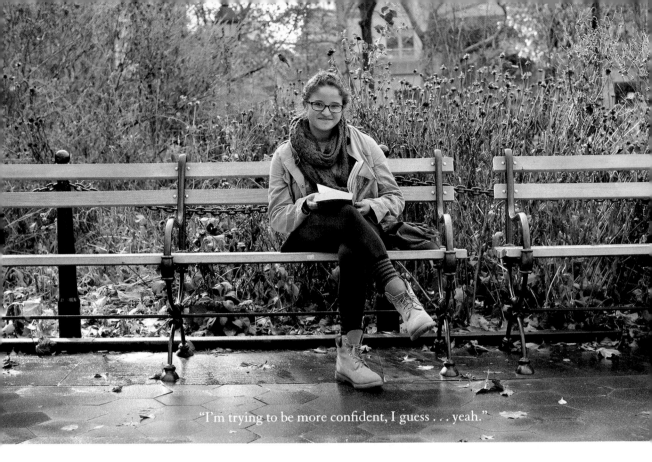

"I'm trying to be more confident, I guess . . . yeah."

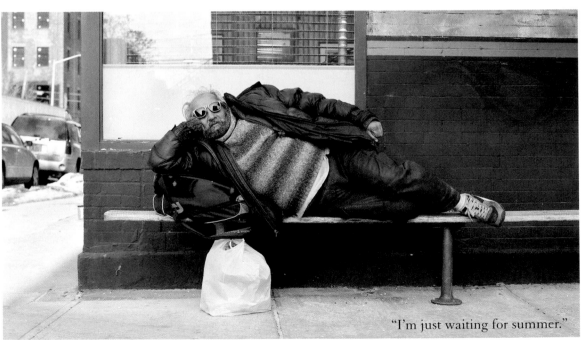

"I'm just waiting for summer."

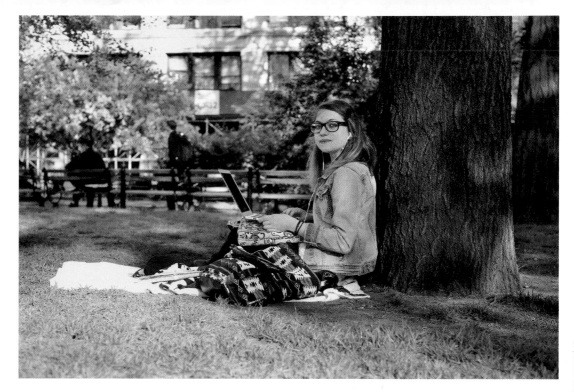

"What do you feel most guilty about in life?"
"Lying about my eating disorder. Telling my parents I was fine when I really wasn't."

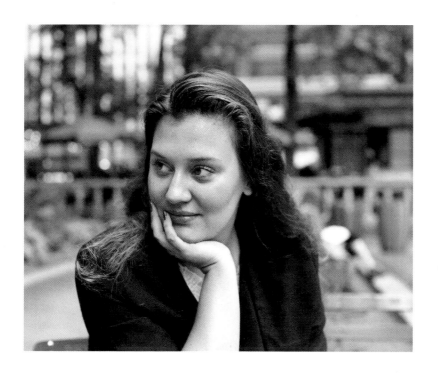

"He always says
I'm just like my
mother. He hates
my mother."

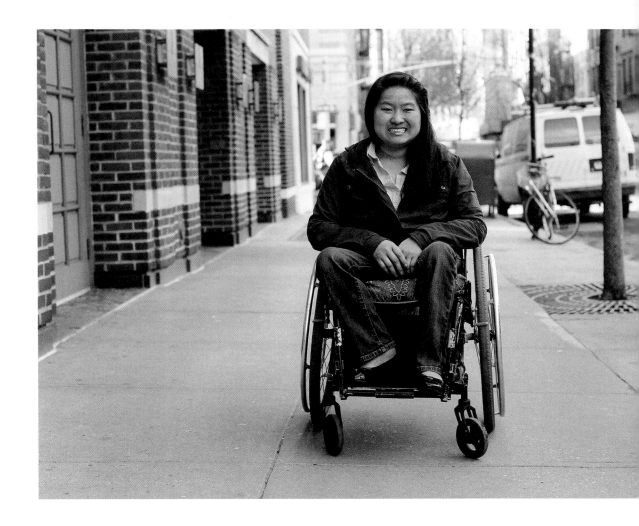

"I want to make life easier for people in China who have disabilities. I know what it's like, because I lived in a Chinese orphanage until the age of ten, and I wasn't able to go to school because I couldn't walk. But that's just a small part of who I am. I want to be a diplomat, and travel, and do all sorts of things that have nothing to do with being disabled. I don't want people to pity me. I don't want to be another 'poor her.' I don't want to inspire people. 'Inspiration' is a word that disabled people hear a lot. And it's a positive word to you. But to us, it's patronizing. I'm not living a wonderful life for a disabled person. I'm living a wonderful life, period. This morning I got accepted into the London School of Economics. Now hold on, let me put on some lip gloss before you take the photo."

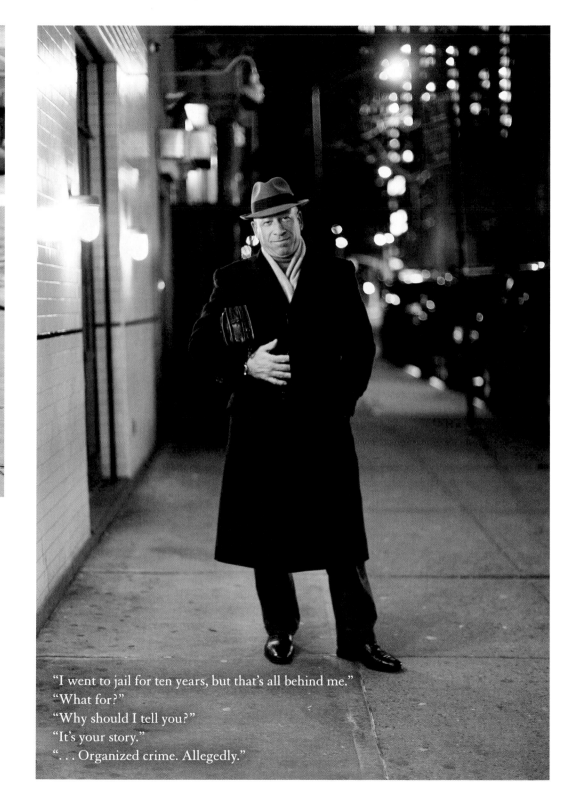

"I went to jail for ten years, but that's all behind me."

"What for?"

"Why should I tell you?"

"It's your story."

". . . Organized crime. Allegedly."

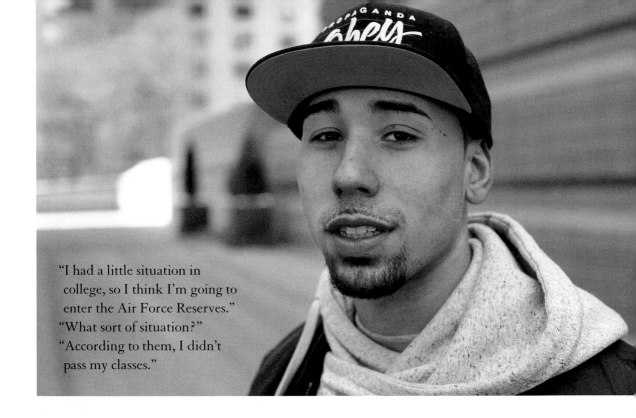

"I had a little situation in
college, so I think I'm going to
enter the Air Force Reserves."
"What sort of situation?"
"According to them, I didn't
pass my classes."

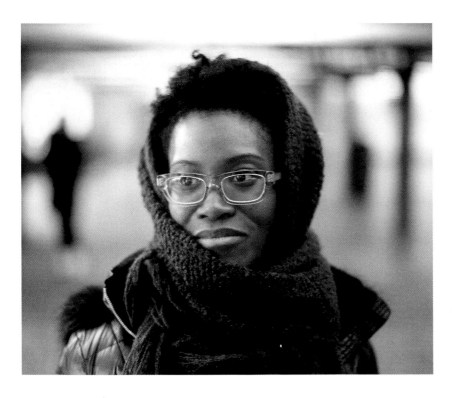

"I'm trying to write a
book based on myself,
but I keep changing."

"When I started, these rocks were bathed in light. Now they're just shadowy masses. So I have to decide how I want to remember them."

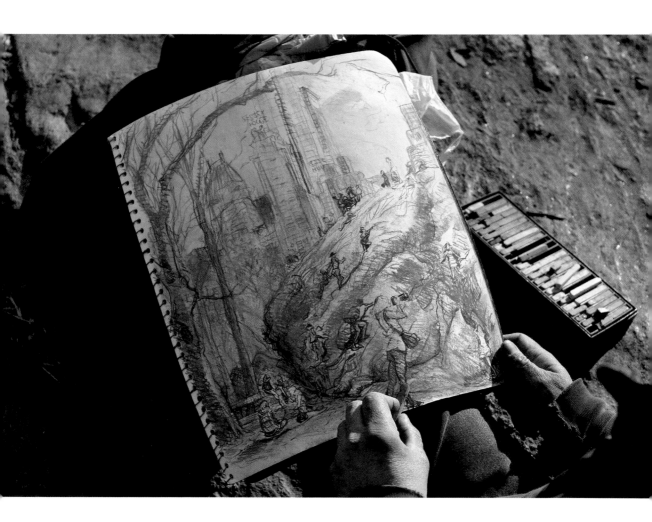

"I was sexually abused between the ages of eight and twelve. But honestly, I don't even like to talk about it anymore, because I've finally gotten to the point where it no longer defines me. For a long time I saw myself as a victim, but I've moved past that. I'm in a place now where I realize that my life is mine to create and enjoy, and that my future will be the result of the decisions that I make."

"This is getting too personal."

"I didn't sleep much last night. I've been feeling a little blue."

"Why's that?"

"Oh, you know. The holidays. Memories, memories . . ."

"I've got five haters. Everyone else loves me."

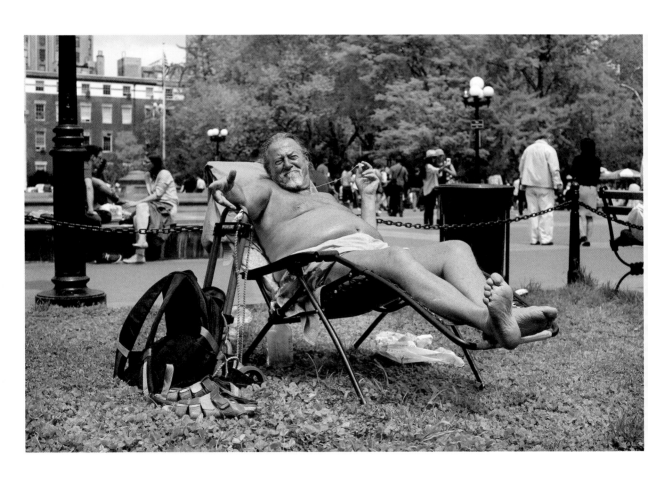

"When you yell at someone, who hears it more: you or them?
You're only hurting yourself by getting angry. I want to live to be
one hundred. I haven't raised my voice in forty years."

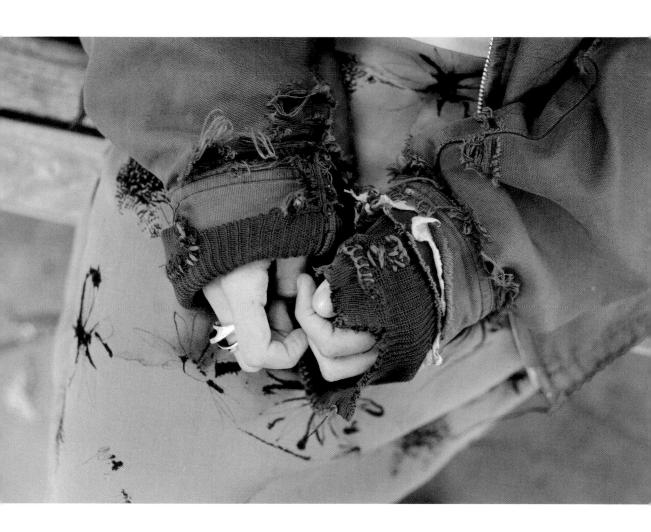

"I learned the word 'fidget' at a very young age."

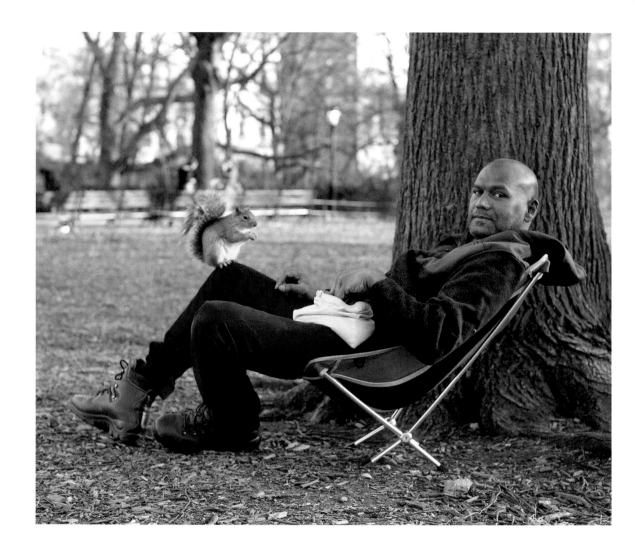

"Humans do everything they can to try to forget they are animals. We create these institutions and customs that deny our animal nature. Take our relationships with our parents, for example. No other animal keeps a relationship with its parents after it's been raised. It's not natural. Yet we insist, because we think that's what makes us human. Think of the people you know. Are they happy when they go visit their parents? Is it something they naturally want to do? No. They bitch about it. But then they go anyway. Because that's what makes them feel human."

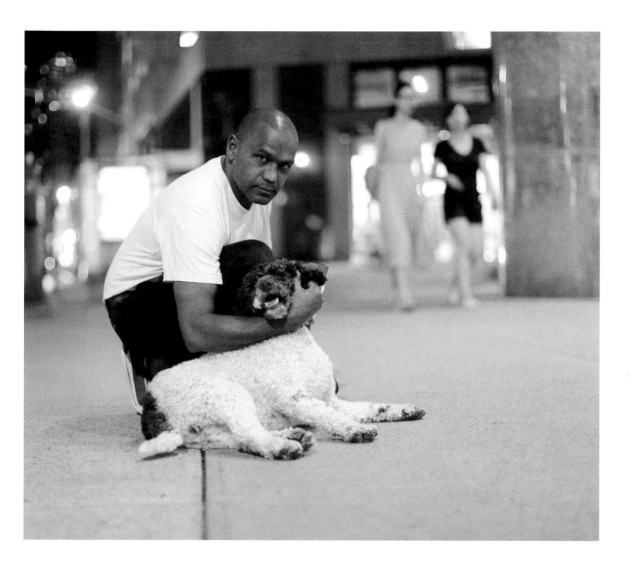

"I see something in animals that I don't see in humans. They have a focus and energy that humans don't have. They just want to live. They aren't trying to impress anyone. They aren't trying to hurt anyone for no reason. Even the rat you see in the subway—his only thought is finding the food he needs to survive. Animals only want to live. It's humans that demand more than they need."

"I've been a deep believer my whole life. Eighteen years as a Southern Baptist. More than forty years as a mainline Protestant. I'm an ordained pastor. But it's just stopped making sense to me. You see people doing terrible things in the name of religion, and you think: 'Those people believe just as strongly as I do. They're just as convinced as I am.' And it just doesn't make sense anymore. It doesn't make sense to believe in a God that dabbles in people's lives. If a plane crashes and one person survives, everyone thanks God. They say: 'God had a purpose for that person. God saved her for a reason!' Do we not realize how cruel that is? Do we not realize how cruel it is to say that if God had a purpose for that person, he also had a purpose in killing everyone else on that plane? And a purpose in starving millions of children? A purpose in slavery and genocide? For every time you say that there's a purpose behind one person's success, you invalidate billions of people. You say there is a purpose to their suffering. And that's just cruel."

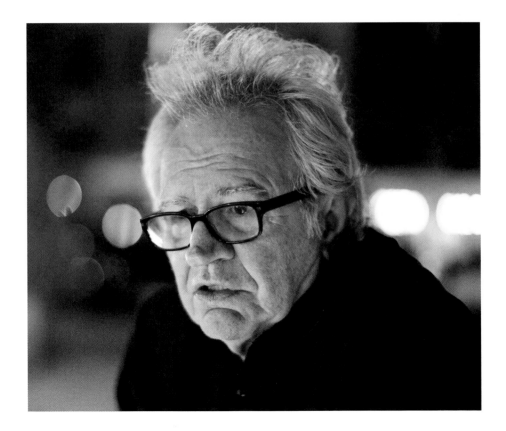

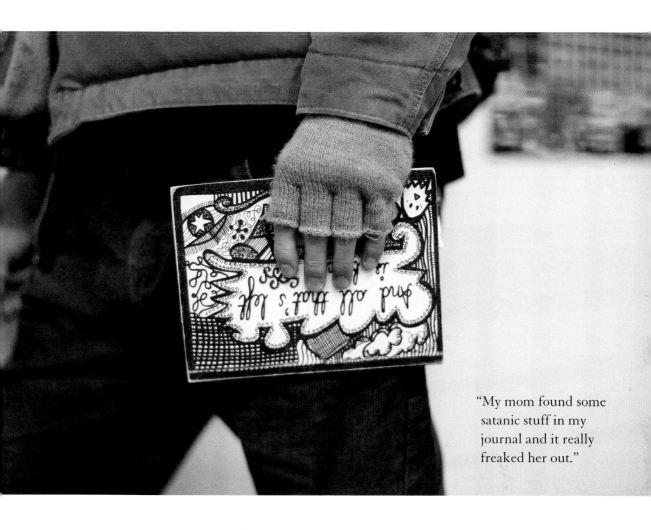

"My mom found some satanic stuff in my journal and it really freaked her out."

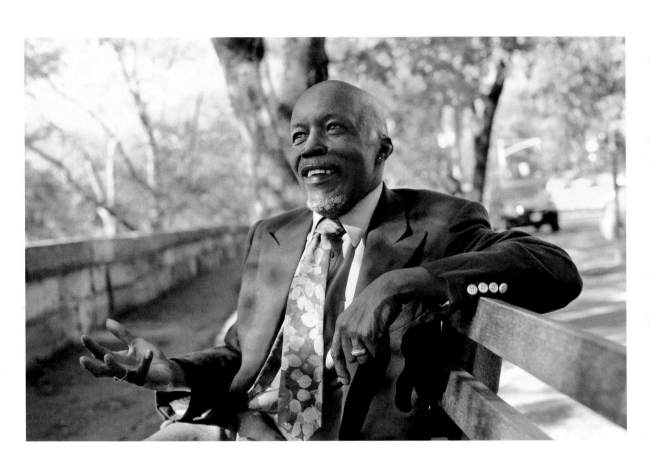

"I'm telling you. Prayer works."

"What's a time that prayer didn't work for you?"

"The time I didn't pray."

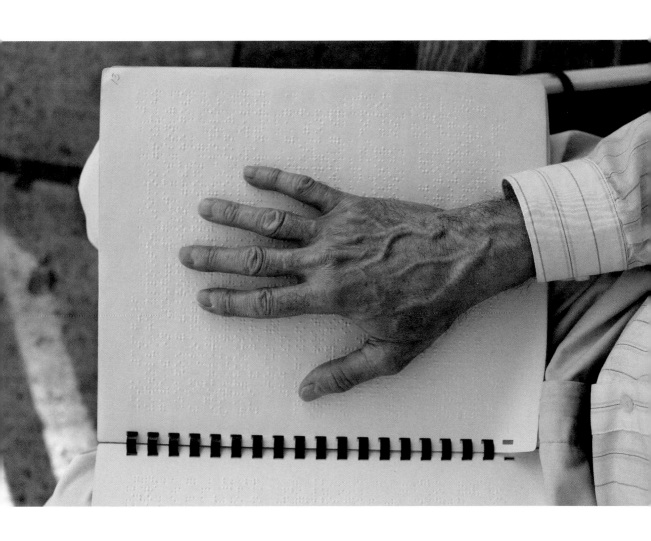

"I hated God for a long time."

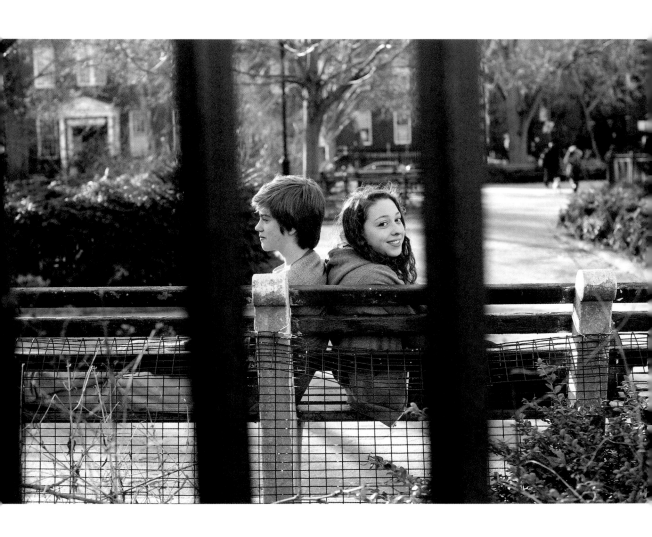

"Are you dating or just friends?"
"That's a good question, actually."

"First date."

"Sixty-one years today!"
"Sixty-two."
"Sixty-one."
"Sixty-two."

"I kissed a woman yesterday."

"I got this bracelet from a photojournalist I met in Istanbul. He gave it to me after a night of drinking. He said that every time things got really bad, he'd count the beads, and for each one, remind himself of something that he was grateful for. I looked at his website later. There were all sorts of raw photographs. The first one I saw was a dead teenage girl in Syria, covered in blood."

"Until you've shown that you're committed, you're not going to meet my son."

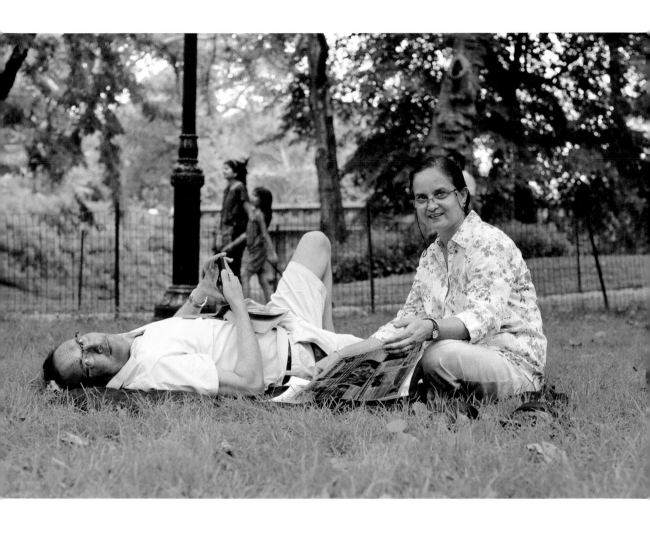

"She does her thing, I do my thing. We interact in between.
We've been married thirty years, and that's how we like it."

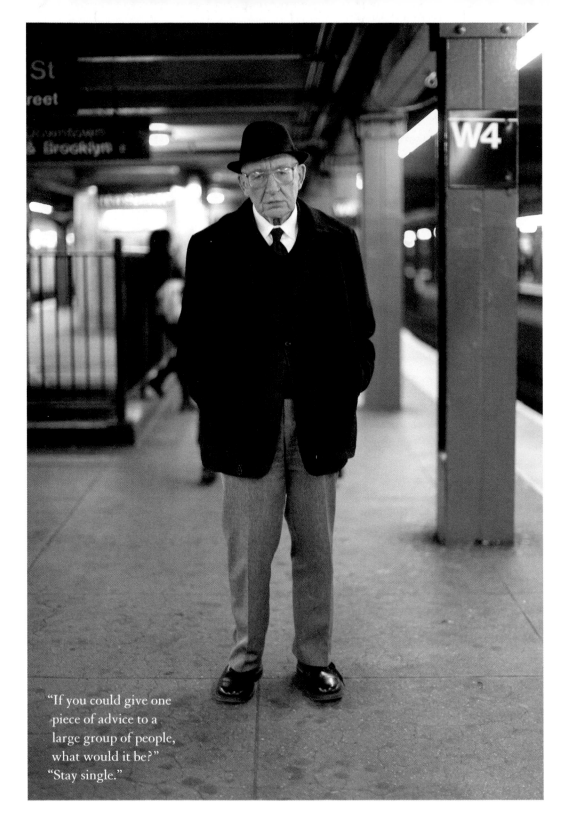

"If you could give one
piece of advice to a
large group of people,
what would it be?"
"Stay single."

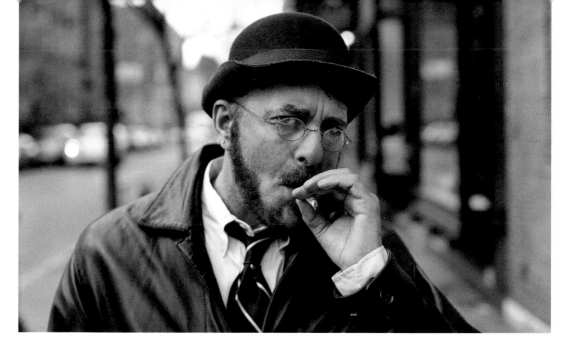

"I'm a shamanic healer. My body's here but the main part of me is on the other side. I've got like three hundred YouTube videos where I talk about this stuff. When I want something, and I imagine it hard enough, it will happen. I select it, project it, expect it, and collect it. I wanted to be in your book."

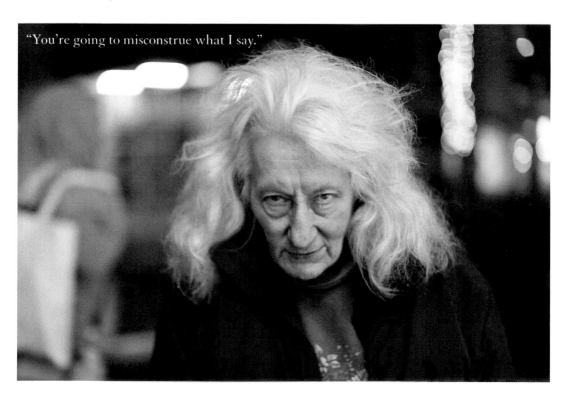

"You're going to misconstrue what I say."

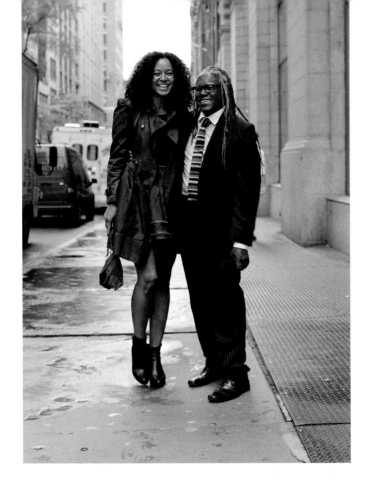

"When I was little, he'd always let me stand on his feet when we walked in the ocean, because I was so afraid of jellyfish."

"My dad is being a huge asshole right now. He told me all I do is cost him money. I don't care if you write that. I already did an art piece about it."

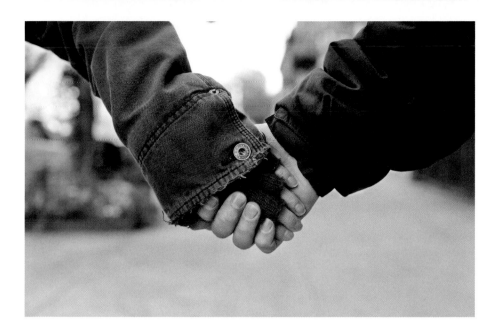

Brandon,

I'm the teenage girl you met earlier today when I was walking with my dad and we talked for a little while about my eating disorder, but I realized that I didn't quite give the answers I felt were completely honest or were what I wanted to say. Thinking about it, what I really should have and wanted to say was that this whole experience of having an eating disorder has been complete shit, and it's the hardest thing I have ever and probably will ever do. There's no specific moment that has been particularly hard that my dad has helped me through, because the entire time it has just been an ongoing nightmare.

If this is what you want for the caption, I could keep going into great depth about what it's like having an eating disorder, portraying it in a multitude of metaphors and descriptions that would give people something meaningful to respond or react to. But even still, this probably wouldn't come close to giving people an idea of how difficult, confusing, draining, and indescribable this disease is.

However, since this was originally about my dad and I, I wanted to say that another reason I can't think of a specific time he's helped is because he has been here for me through all of it. The entire time, he has been trying his hardest to help me beat this, which I realize has been incredibly hard on him, too, and I'm very appreciative and grateful for that. By the way, would it be okay if you used the picture of our hands and left out my name?

Thank you.

"I'm learning to deal with negative feelings, like envy. I'm envious of all the normal things. Women with more successful careers, things like that. I'm finding that if you try to resist your envy, it sticks around. But if you accept it as natural and don't judge yourself, it will pass, like a cloud."

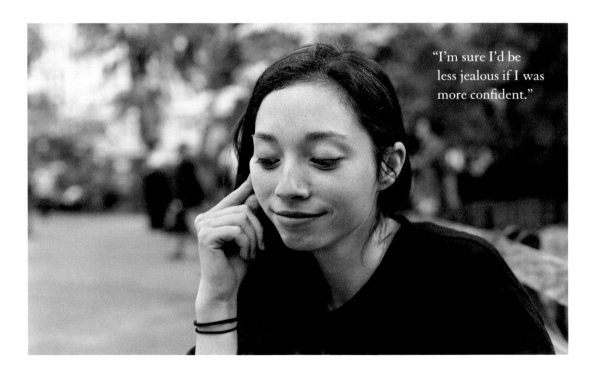

"I'm sure I'd be less jealous if I was more confident."

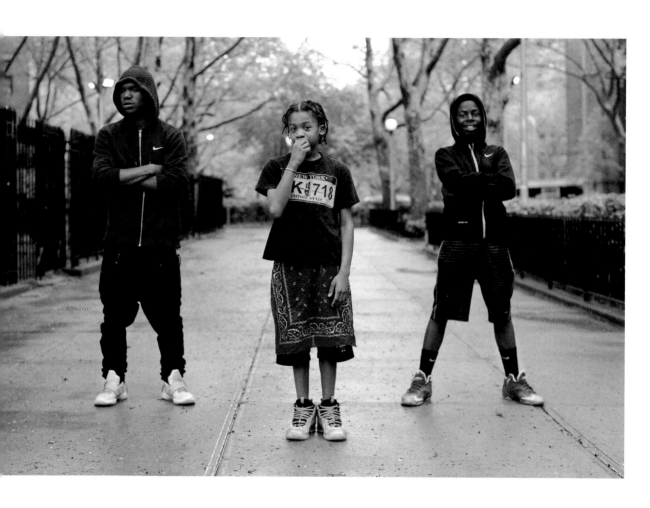

"The haters are going to be so mad when I make my millions."

"A whole art movement has sprung up around me. I have a tribe."

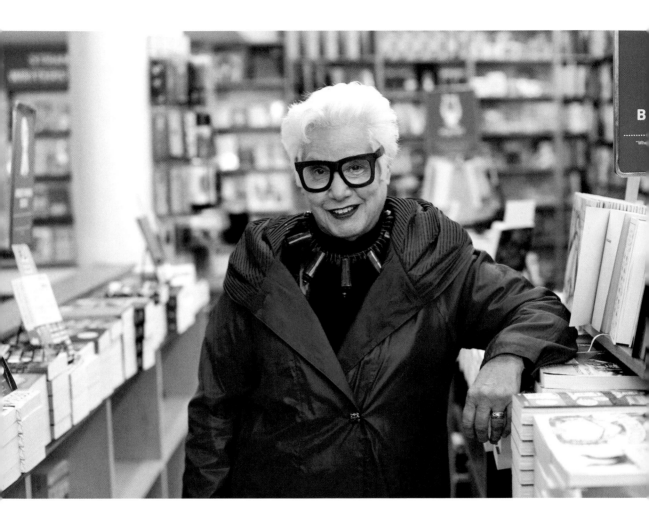

"I used to be obsessed with cooking. It was all I thought about. I did cooking shows on the BBC. I wrote twenty-seven cookbooks. I wrote a whole cookbook just about garlic. Then one night, I was editing the proofs for my twenty-seventh cookbook, when I picked up a marker and drew a mermaid on a piece of scrap paper. I looked at that mermaid, she looked at me, and I never thought about cooking again. Ever since that moment, I've thought about nothing but art. I was sixty years old when I made the switch. I'm not sure what caused it. It was either menopause, a psychotic break, or a muse bit me on the bum!"

"I ran for senator in the Dominican Republic. I campaigned for four years. I went door to door, ate in people's houses, did radio interviews, put up signs. But when it seemed like I might win, the current senator bribed the chairman of my party, and they substituted me on the ballot for some old guy who only got nineteen hundred votes. That's how it goes in the banana republic. They wouldn't even give me back my registration fee."

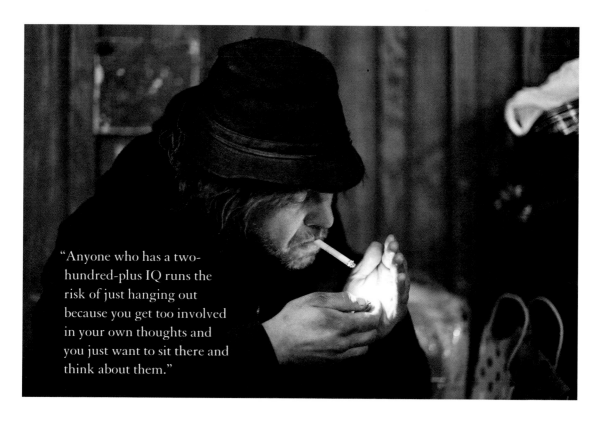

"Anyone who has a two-hundred-plus IQ runs the risk of just hanging out because you get too involved in your own thoughts and you just want to sit there and think about them."

"I was engaged eight years ago, but my fiancé died in Iraq. After that, I promised myself that I'd never be that dependent on someone again. So after I met my husband, I fought marriage for the longest time. But we got married in September. And even though I was rebelling against it, and I always saw it as a meaningless formality, I've been surprised. There's a comfort in knowing that you're sworn to someone else."

"I didn't see my son for the first five years of his life. I supported him financially, and his mother sent me pictures, but I never met him. My relationship with his mother was very strained, and I was always afraid that she would use him to control me. So I stayed away. Then one morning I woke up with nine missed calls on my phone, and I found out that his mother had died."

"What do you tell him about those five years?"
"We don't really talk about them. But I thought it would be best for him if I was not in his life, and with how well he turned out, I think it was the right decision."
"Do you think that's true or do you think it's a rationalization?"
"I don't know. It may just be a rationalization. It was a tough call for a twenty-year-old. I was young and I was scared. And I missed a lot of important moments like the first time he walked, and his first words. But I took him to his first day of kindergarten. I taught him to ride a bike, I taught him to read, and I taught him to play sports. And he turned out great. He's a great kid and an honor-roll student."

"I've flown straight my entire life."
"How do you fly straight?"
"If there's an election, vote. If there's a cause,
 participate. If there's a war, enlist."

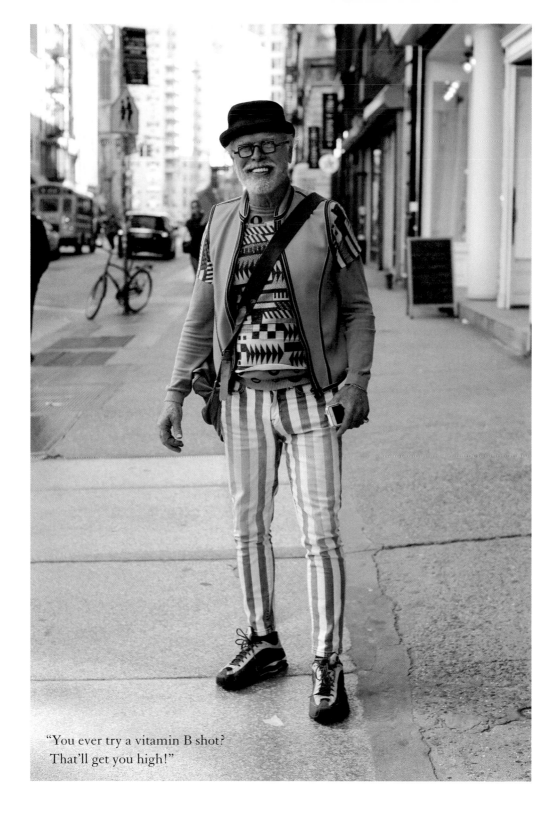

"You ever try a vitamin B shot?
That'll get you high!"

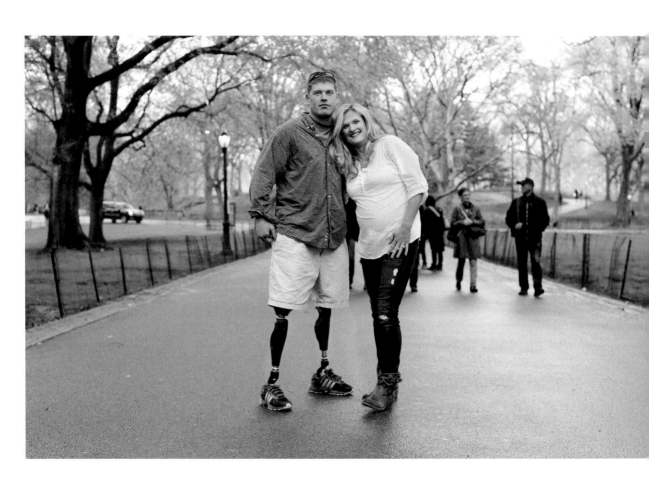

"I've got a lot of faults. I'm sure I'm not easy to live with.
I'm not the best communicator. And I'm sure it's not
very cool to see your man crawling on the floor of a hotel
room. But she loves me."

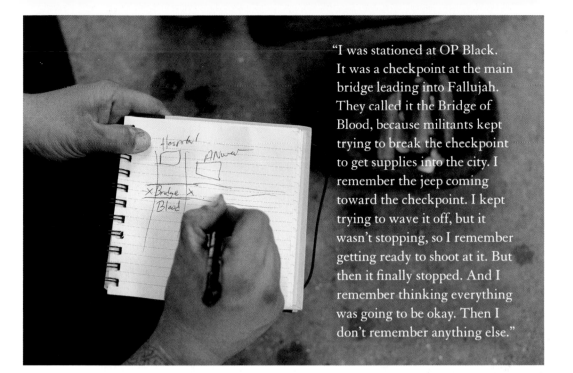

"I was stationed at OP Black. It was a checkpoint at the main bridge leading into Fallujah. They called it the Bridge of Blood, because militants kept trying to break the checkpoint to get supplies into the city. I remember the jeep coming toward the checkpoint. I kept trying to wave it off, but it wasn't stopping, so I remember getting ready to shoot at it. But then it finally stopped. And I remember thinking everything was going to be okay. Then I don't remember anything else."

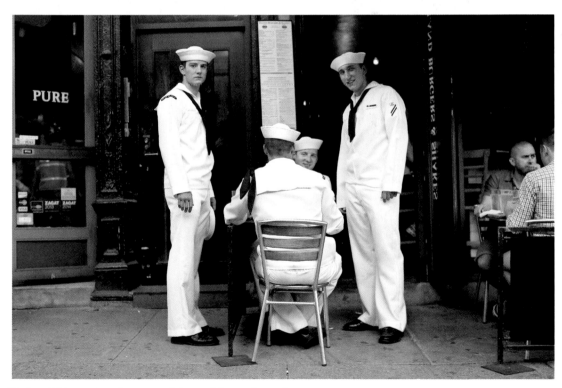

"I should have just kept working with my Pops."

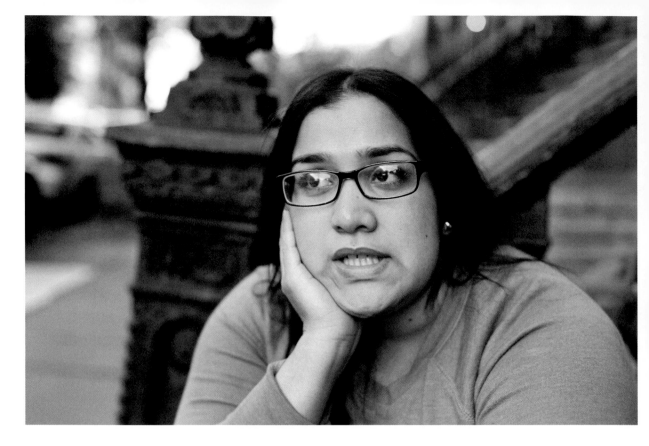

"When I was sixteen years old, I was watching *Saturday Night Live* one night, and I accidentally hit my foot with the remote control—so hard that a piece of the remote broke off. But I didn't feel a thing. I got confused and started hitting myself, but I couldn't feel anything on the entire left side of my body. When I went to the doctor, they said that they'd have to do brain surgery or the numbness would spread. I was so scared going into the surgery. They told me that there was a chance of paralysis or stroke or even death. I woke up when they were wheeling me out of the operation. There were clouds painted on the ceiling, and I remember thinking: 'Oh, I died.' And I was perfectly fine with that, but then we bumped into something, and suddenly it felt like someone had wrung my neck like a towel and kicked me as hard as they could in the head."

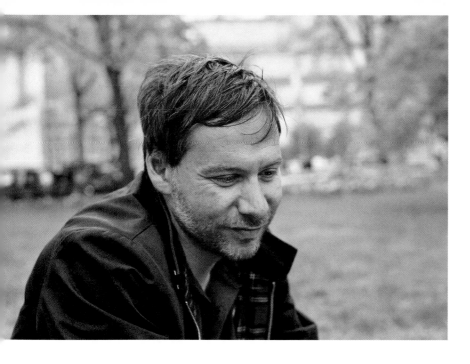

"The amplitudes of life get smaller as you age. There are less and less things to experience for the first time. And each time you experience something, you don't get quite as excited. But you don't get quite as hurt, either. I wonder what it will feel like when I'm seventy . . ."

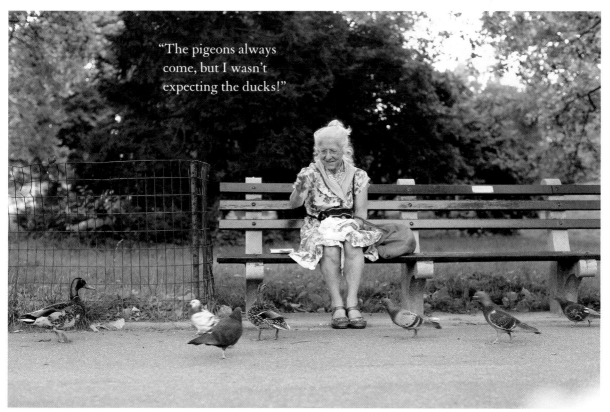

"The pigeons always come, but I wasn't expecting the ducks!"

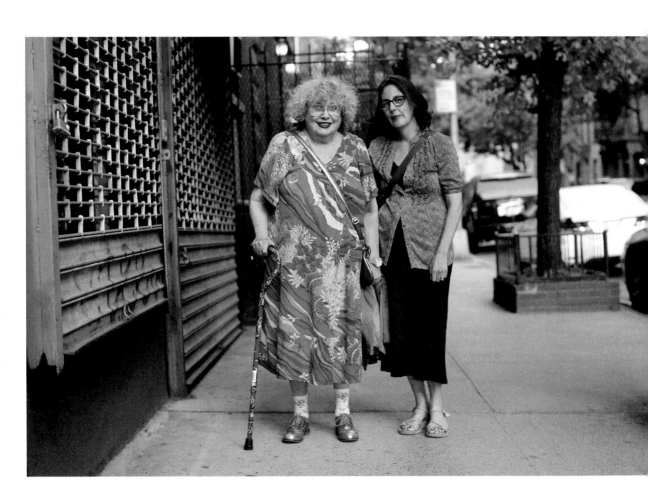

"She loves life more than anyone I've ever known. I hope she doesn't mind me telling you this, but recently she's had some health problems. And her health got so bad at one point, she called me and said: 'I was starting to wonder if there was any reason to go on. But then I had the most delicious pear!'"

"She still gets giddy when she sees a firefly."

"I'm having trouble getting my work out there. I have a hard time finding the self-confidence. If it was up to me, I'd just make my work in isolation and not worry about the marketing or promotion, but I know I can't do that. The problem is—my work is really quiet. It's very subtle and subdued. It takes time to appreciate. And there's so much image saturation in today's world, it seems that only the most aggressive imagery is getting noticed. I'm finding that it takes a lot of boldness to take a firm stance in making quiet work."

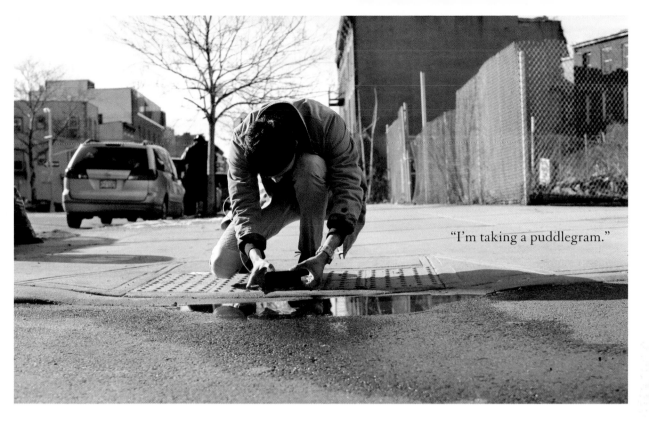

"I'm taking a puddlegram."

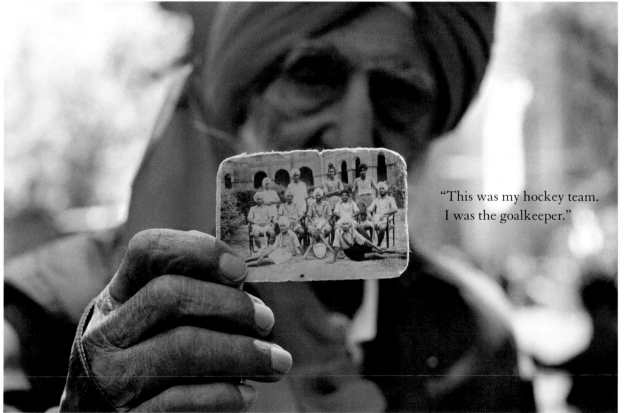

"This was my hockey team.
I was the goalkeeper."

"I don't believe in anything."
"What's the last belief you held?"
"That I could believe in something."

"My wife fell, and now
she's inside with two
broken legs. It's hard for
me to see her like this. We
used to teach dance classes
as the Waldorf Astoria.
We'd do Latin dancing,
the mambo, the jitterbug.
Now all she can do is look
out the window."

"Do you remember the time you felt proudest of your sister?"
"When she tried to walk."

"My nickname is Black Jesus."

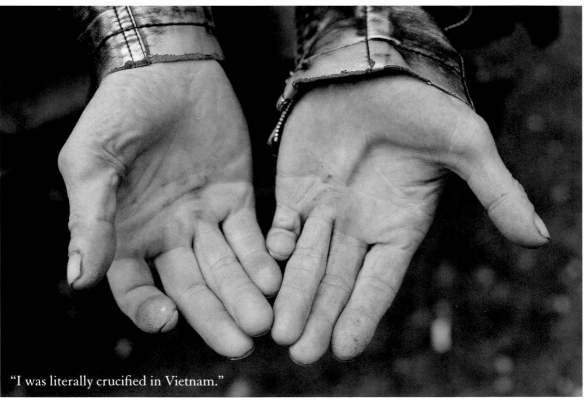

"I was literally crucified in Vietnam."

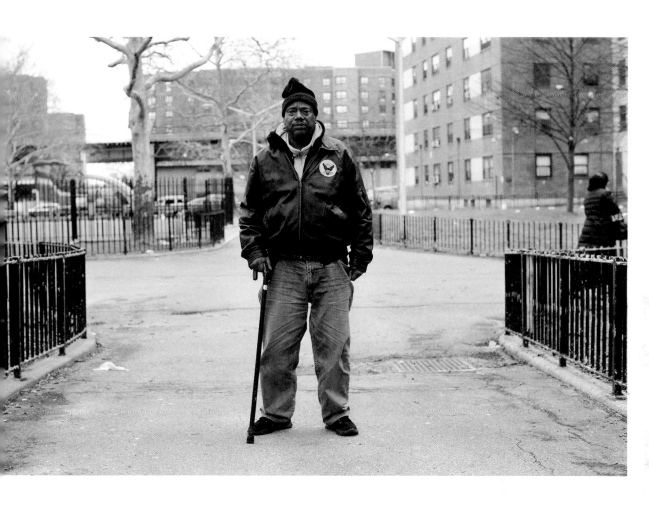

"I got captured in Vietnam. And I fell out of the helicopter when they were rescuing me from a prison camp."

"How'd you get captured?"

"I was on patrol. And I noticed a bush where there hadn't been no bush before. So I says to the guy next to me, 'That bush is moving.' But he didn't believe me. So I took the bubblegum out of my mouth, and I stuck it on the bush. Then we walked a little more, and we turned around, and sure enough, there was the bush with the bubblegum. I said to my friend, 'There it is! I told you!' Then they jumped out and got us."

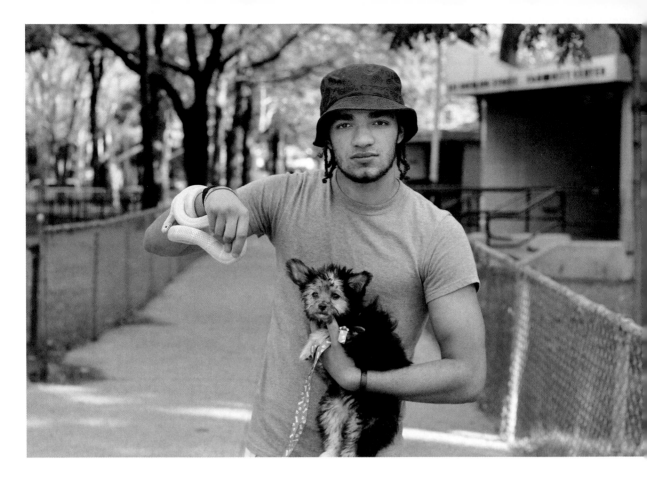

"I spoil every girl I'm with. I'm bringing this dog to my girlfriend now. I've already gotten her a snake, a rabbit, and two dogs. She loves animals. She wants to be a vet."

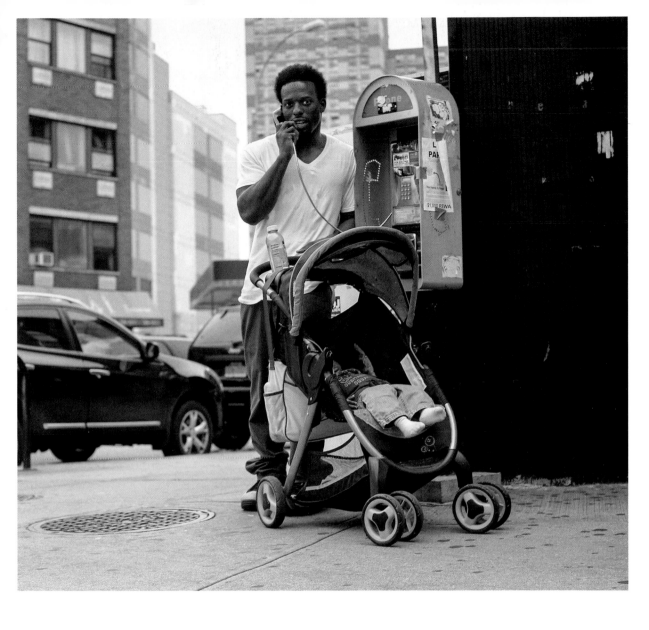

"I've got what I want. I've got a place to live, a girlfriend, and a child.
My biggest struggle is just figuring out how to maintain."

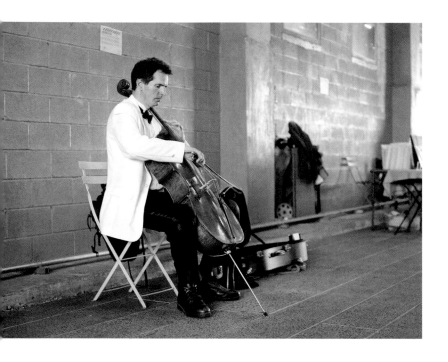

"I've been trying to get into a full-time orchestra for the past twenty years. I'd guess I've been to over two hundred auditions. It can be pretty heartbreaking. I tried out for the New York Philharmonic four times. One time I prepared three months for the Los Angeles Philharmonic audition, flew all the way across the country, and they cut me off after twelve seconds. But believe it or not, I still have a certain amount of optimism about the process. And I think I'm getting better."

"I'm having a hard time trusting in The Process."
"What process?"
"The process that says if I do my part, everything will turn out right."

"When you're twenty-five, you feel like you're riding a wave. You feel like opportunities are just going to keep coming to you, and you think it's never going to end. But then it ends."

"When does it end?"

"When you turn forty, and they start looking for someone younger."

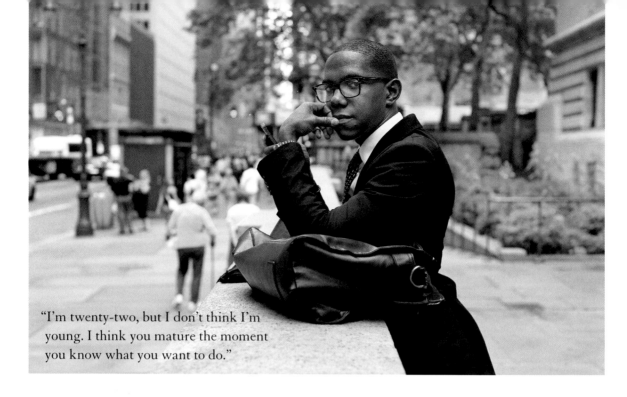

"I'm twenty-two, but I don't think I'm young. I think you mature the moment you know what you want to do."

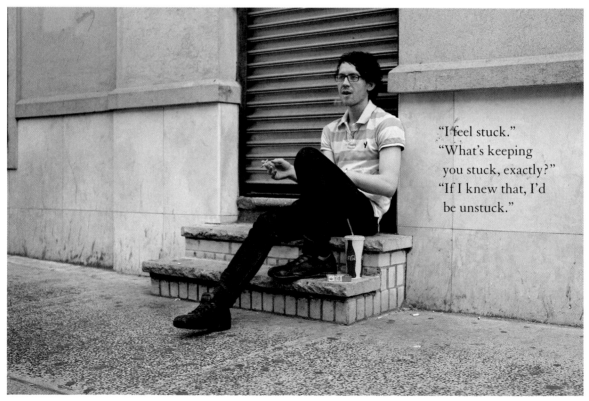

"I feel stuck."
"What's keeping you stuck, exactly?"
"If I knew that, I'd be unstuck."

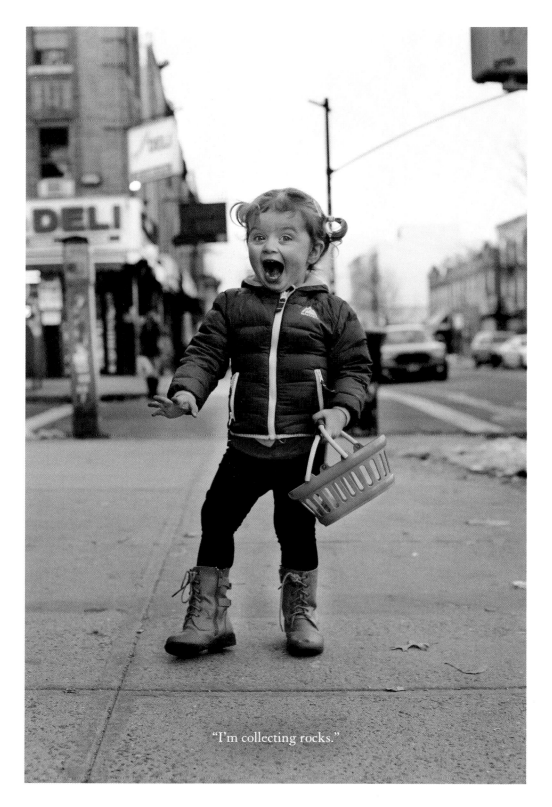

"I'm collecting rocks."

"There were six of us living in a small apartment. Mom had headaches the night before, so we were tiptoeing around so we wouldn't wake her up. Right before we left for school, my sister and I went into her room to say good-bye. Her lips were blue. We called my dad, and he made all of us scream Mom's name. It's like he thought she was sitting right next to her body, and we only needed to call her back."

"We broke up in a Starbucks. A week later, I walked by and the place had been completely bulldozed to the ground. I always thought that was the Universe doing me a favor."

"I've been feeling a bit unaccomplished lately. I recently met a kid in his twenties who figured out a way to power lights in rural India by generating electricity from human shit."

"A bunch of kids at school got suspended when the English teacher discovered that a minicomputer had been planted in a circuit box. They'd been using something called a rainbow table, which hacks through a vulnerability in Windows XP using brute force, to gain administrative access to the system. I know more, but that's all I can say."

"I want to either open a liquor store or a funeral parlor. I figure those are the two things that everyone needs."

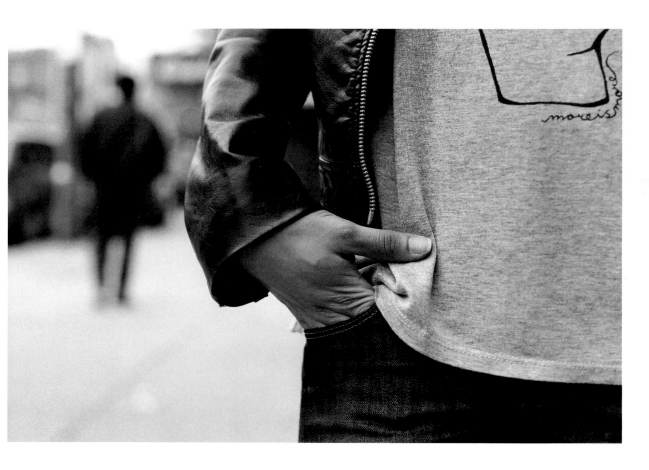

"I was tired of working retail, so I lied on my résumé and said that I had bookkeeper experience. I learned as much as I could from Google before the job interview and printed out balance sheets to practice on. After I got the job, I read as much as I could every morning on the train. It was nerve-wracking at first, but I presented the numbers at the end of the month, and everything checked out. May not have been the best way to get a job, but hey—I've got a son to look out for."

"My idol is the Hulk."

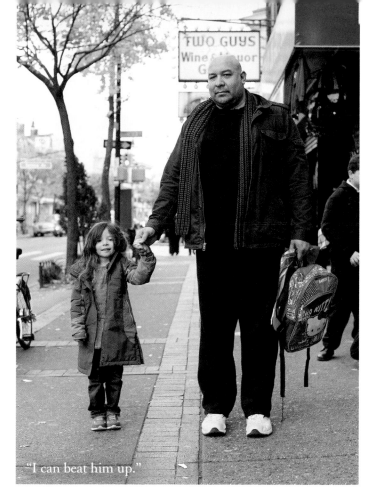

"I can beat him up."

"My Chihuahuas
are at home."

"Sometimes, when I'm going home to see her, I think: 'Nobody should be this happy on a Tuesday.'"

"At first we kept saying: 'We're going to beat it. We're going to beat it.' Then after a while we began to realize that we might not beat it. Then toward the end, it became clear that we definitely weren't going to beat it. That's when she started telling me that she wanted me to move on and find happiness with somebody else. But I'm not quite there yet. Not long ago a noise woke me up in the middle of the night, and I rolled over to ask if she needed anything."

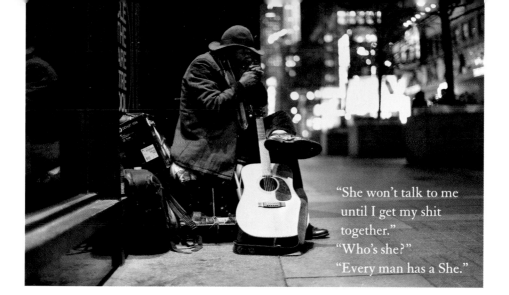

"She won't talk to me until I get my shit together."
"Who's she?"
"Every man has a She."

"I went to a psychic the day before I met him. She told me I was about to meet the woman of my dreams. I said: 'I'm gay.'"

"Had cancer six times. Beat cancer six times."

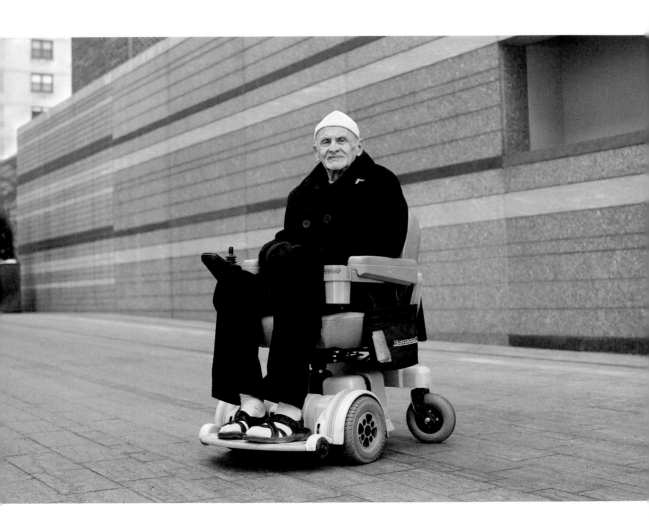

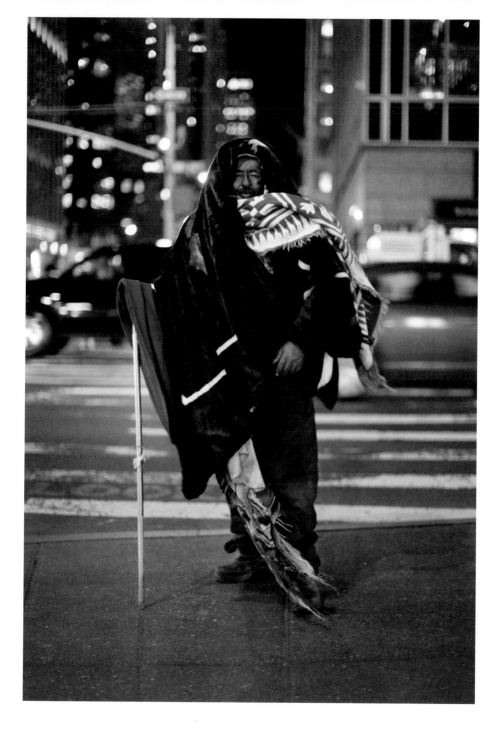

"I have ten cats. They live outside, and I have
been protecting them for seven years."

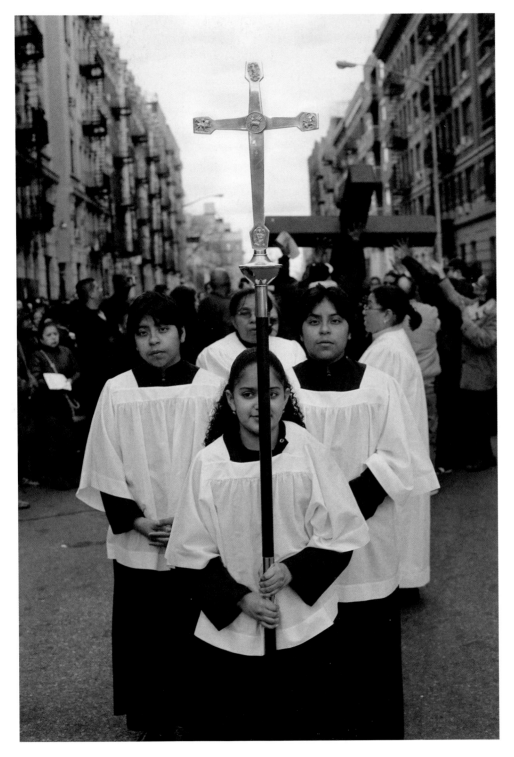

Seen in Washington Heights

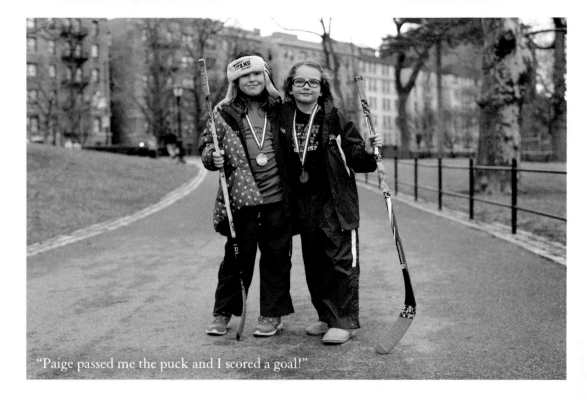

"Paige passed me the puck and I scored a goal!"

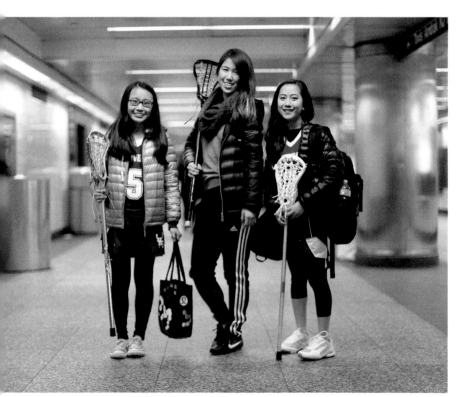

"The team lost 11 to 2."
"Whose fault was it?"
"Definitely not ours.
 They never put us in
 the game."

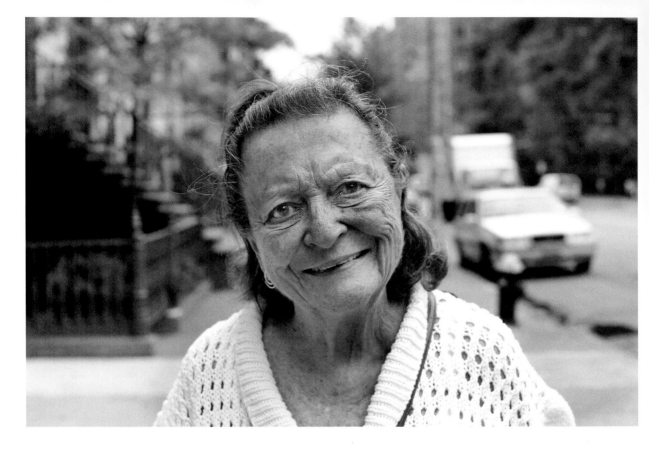

"My husband was an editor at *The New York Times*, so he'd work really late nights, and I'd sometimes get lonely. So I started letting this tomcat into our house every day. But my husband was horribly allergic to cats, so right before he'd get home, I'd let the cat back out again. But one night it was raining so hard that I refused to let the cat out, and my husband stayed up all night sneezing. And that's how I got a puppy!"

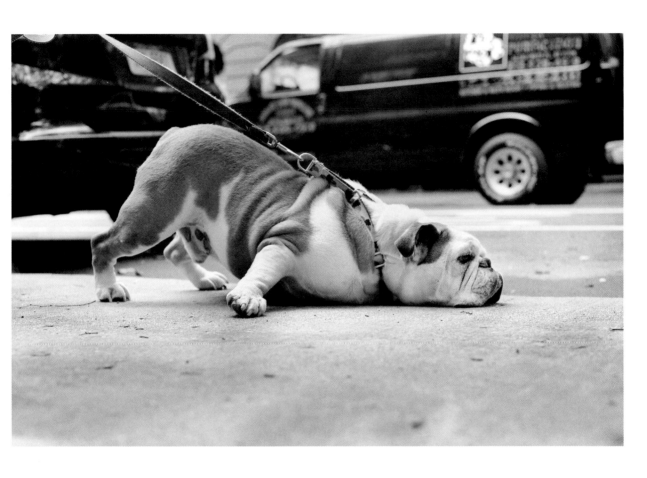

"He wants to go home."

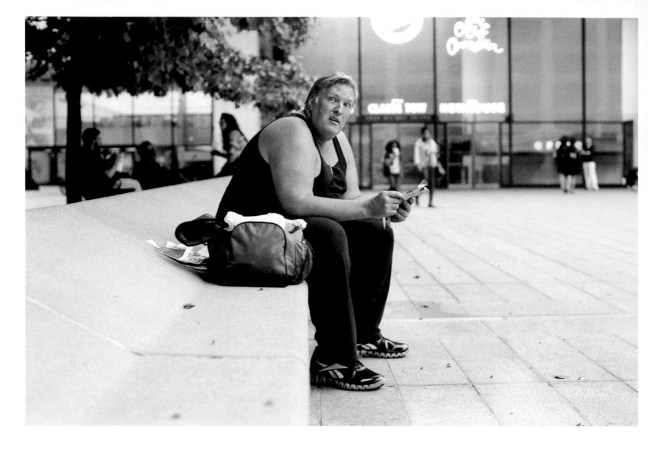

"I've struggled with my weight my whole life. When I was twenty-one, I decided I wanted to be skinny. I thought it was going to bring me love, happiness, everything I wanted. I barely ate. I exercised three times a day. I got down to 130 pounds and I was more miserable than ever. I hated myself. And after that I gave up on trying to be thin. Now I've gotten to the point where I have to lose weight again—but this time for my health."

"Are you lonely?"

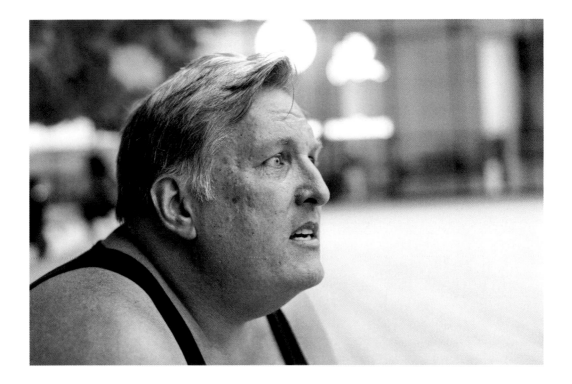

"It's been a lifetime of loneliness. I decided early on that I better get used to it.
I go to movies by myself. If the movie theater is completely empty, I'm even
happier. I learned early on that if I wanted to go to restaurants, I better learn
to go by myself. One benefit of being big is that people don't bother you. I'm
shocked that you came up to me. Nobody's ever done that. When I started to
go to therapy, it took me several sessions before I even spoke a word. I'd just sit
there and cry. And honestly, you caught me on a tough day. I was sitting here
feeling really bad about myself. Because I went to the doctor today, and I was
sure that I'd lost weight. But I'd gained some."

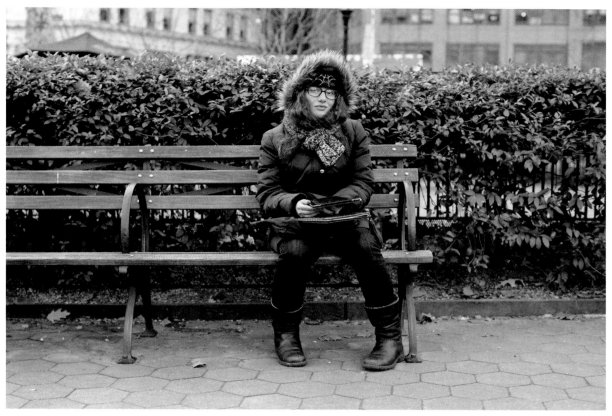

"I've got an hour break between therapy and family therapy."

"If I've put off an assignment until the last minute, the logical thing would be to just do it. Instead, I think: 'Maybe I should not go to school, not talk to anyone, curl up, and be a little ball of sadness, forever.' I don't want to be happy because I don't think that's realistic. But I would like to be able to deal with life."

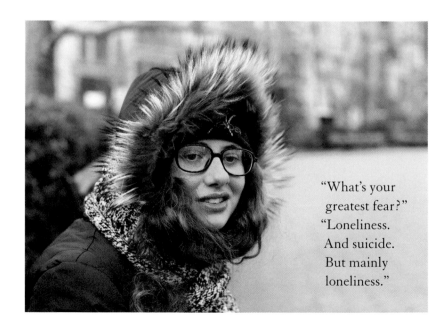

"What's your greatest fear?"
"Loneliness. And suicide. But mainly loneliness."

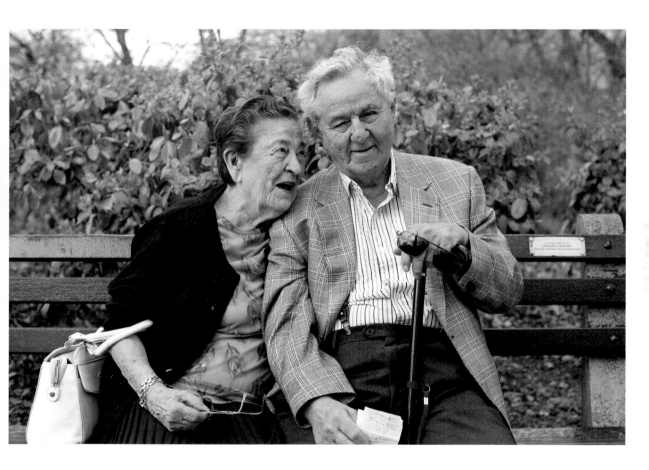

These two were acting like complete teenagers. When I walked up, she was nuzzling her head against his shoulder. She giggled the entire time I talked with them, while he kept a big goofy grin on his face. And whenever I asked about their relationship, she clutched his arm, looked at him just like this, giggled, then said: "We're not telling!"

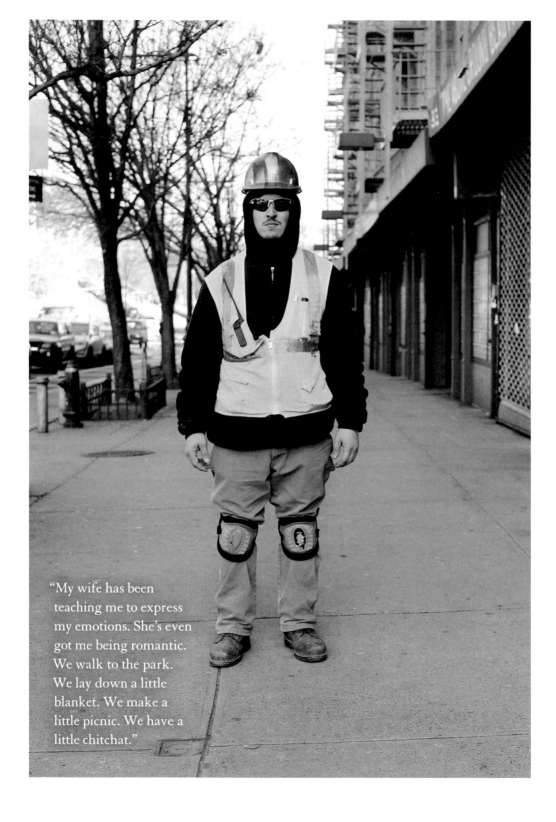

"My wife has been teaching me to express my emotions. She's even got me being romantic. We walk to the park. We lay down a little blanket. We make a little picnic. We have a little chitchat."

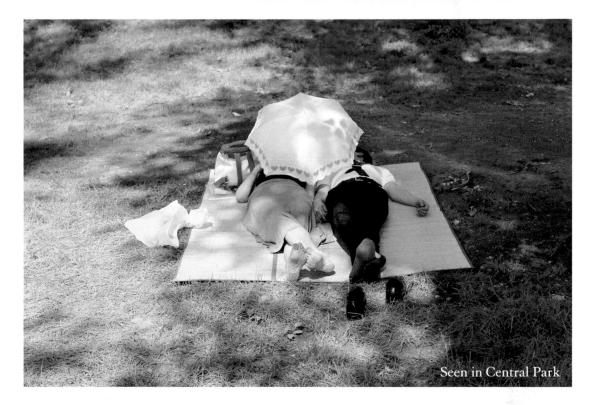

Seen in Central Park

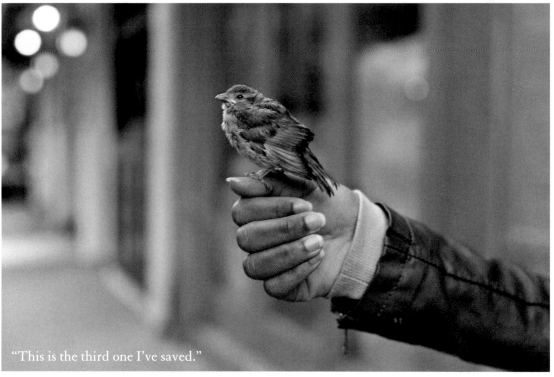

"This is the third one I've saved."

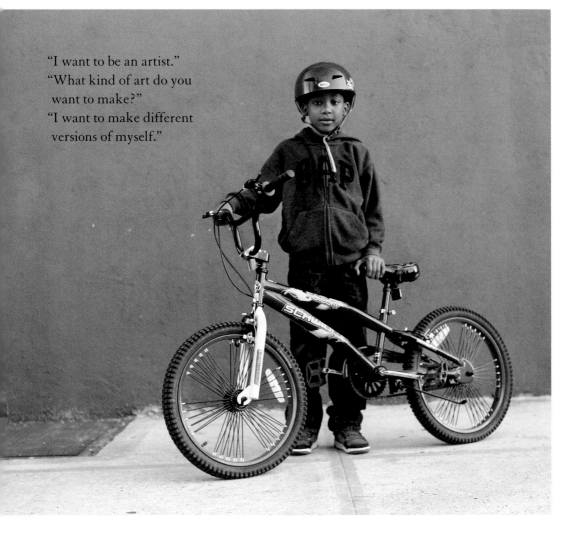

"I want to be an artist."
"What kind of art do you want to make?"
"I want to make different versions of myself."

"I wish I'd partied a little less. People always say: 'Be true to yourself.' But that's misleading because there are two selves. There's your short-term self, and there's your long-term self. And if you're only true to your short-term self, your long-term self slowly decays."

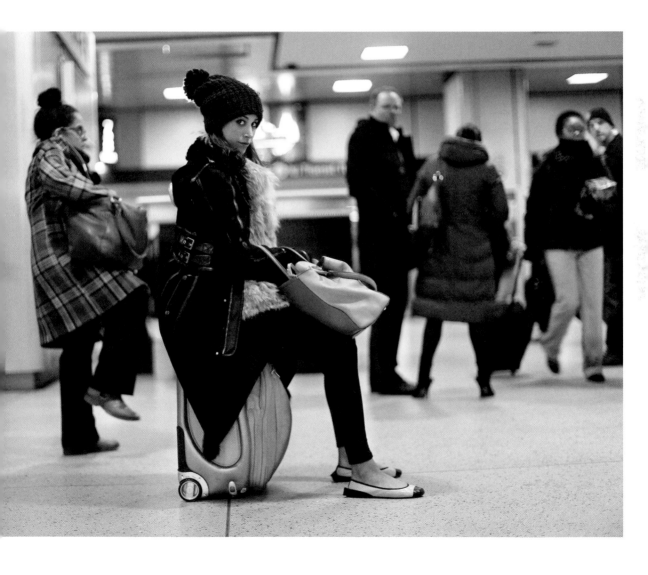

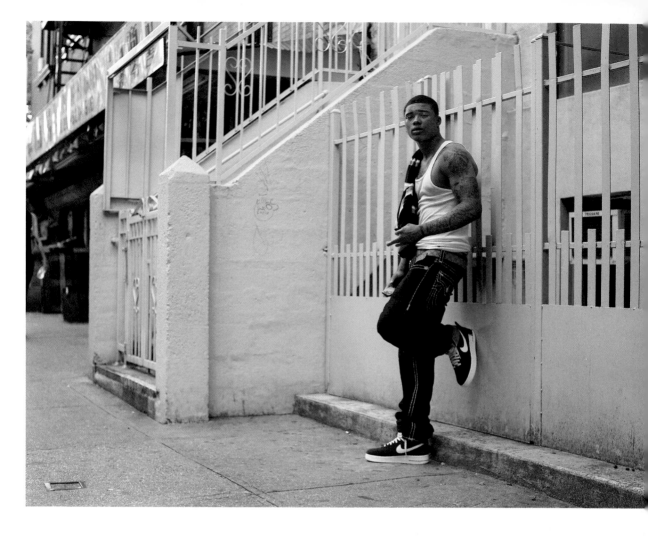

"I'm a street pharmacist."

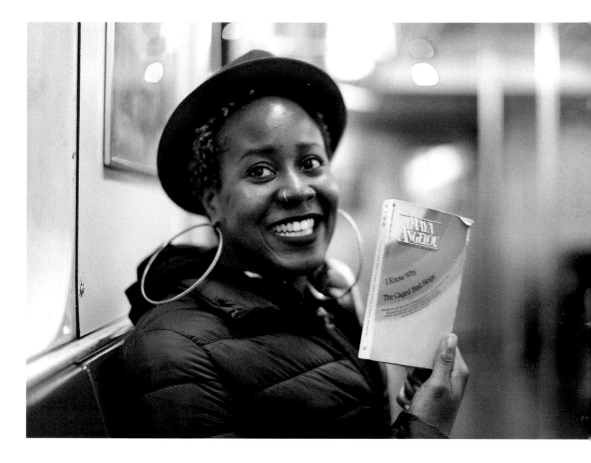

"I tend to be cynical about a lot of things, but Maya Angelou is somebody that no matter how much I pick her apart, she still has integrity. She was a victim of incest and rape, and she worked as a stripper. And now she's a literary icon and Nobel laureate. It goes to show that life is cumulative, and you can't devalue any type of experience."

"When you live here, you don't have too many fears. You've seen pretty much everything that life can throw at you. When I was nine, I saw a guy get pushed off the roof of that building right there."

"Who's influenced you the most in your life?" "My principal, Ms. Lopez. When we get in trouble, she doesn't suspend us. She calls us to her office and explains to us how society was built down around us. And she tells us that each time somebody fails out of school, a new jail cell gets built. And one time she made every student stand up, one at a time, and she told each one of us that we matter."

"This is a neighborhood that doesn't necessarily expect much from our children, so at Mott Hall Bridges Academy we set our expectations very high. We don't call the children 'students,' we call them 'scholars.' Our color is purple. Our scholars wear purple and so do our staff. Because purple is the color of royalty. I want my scholars to know that even if they live in a housing project, they are part of a royal lineage going back to great African kings and queens. They belong to a group of individuals who invented astronomy and math. And they belong to a group of individuals who have endured so much history and still overcome. When you tell people you're from Brownsville, their face cringes up. But there are children here that need to know that they are expected to succeed."

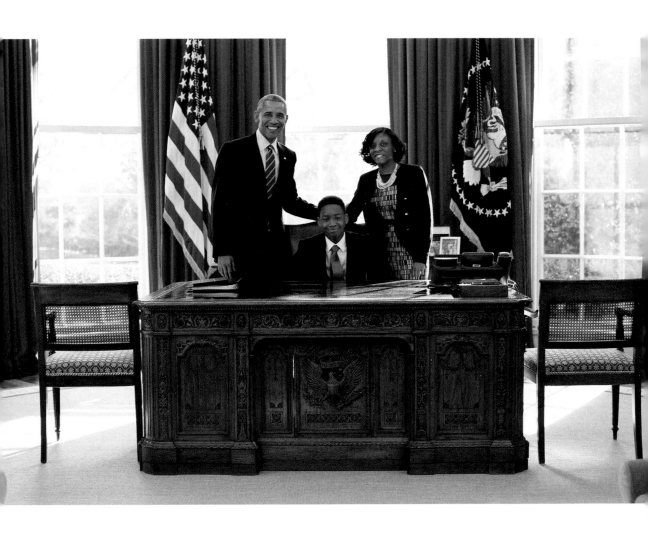

"Who has influenced you the most in your life?"

"My mother. She had me when she was eighteen years old, and my father left when I was one year old, so I never really knew him. Like a lot of single moms, she had to struggle to work, and eventually she also struggled to go to school. And she's really the person who instilled in me a sense of confidence and a sense that I could do anything. She eventually went on to get her PhD. It took her ten years, but she did it, and I watched her grind through it. And as I got older, like everyone else, I realized that my mother wasn't all that different than me. She had her own doubts, and fears, and she wasn't always sure of the right way of doing things. So to see her overcome tough times was very inspiring. Because that meant I could overcome tough times too."

"Money is the most important thing. Family is not a close second. Neither is love. And don't rely on God to help you. I've tried that way too many times."

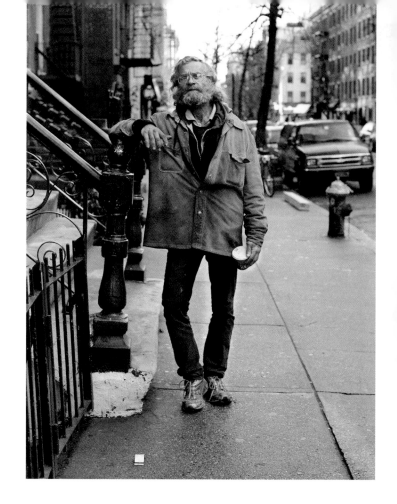

"The saddest moment of my life was when I found out that I didn't have what it takes to make it in this world. I just don't have it in me. All this stuff that I've been talking about is just ingrained in me. I don't have any drive. Beyond that, I find it pretentious to have any drive. I don't want any toys and I don't need the fixings. Or maybe I just settle for meager because I know I don't have what it takes to get what I want. Maybe I would like a nice house like my sister. Maybe I'd like cable TV so I can watch anything I want. I don't want to talk about it anymore, I'm getting distressed."

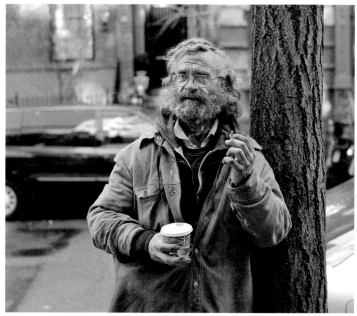

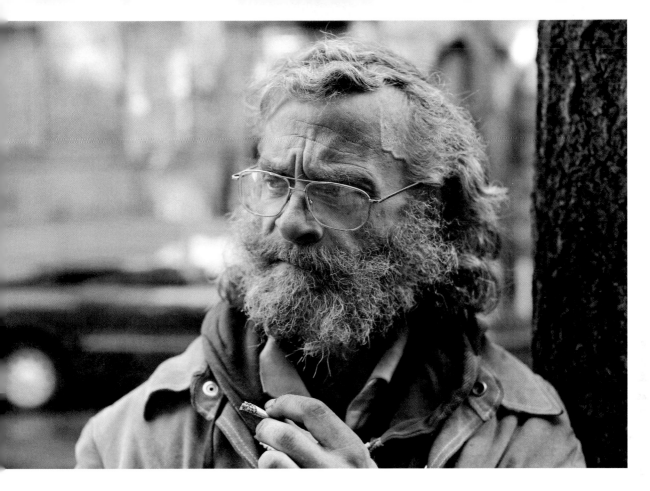

"Humans are idiots. There's no such thing as heroes. Heroes are a creation of the media. 'Hero cop gets shot.' Whoopty fuckin' doo. 'Hero fireman dies in blaze.' That's his job. If there's a fire, he's supposed to put it out. You're not a hero if you do your job. We're all just grains of sand. The act of living is a farce and it's ridiculous. No, it's not ridiculous. It's a horror. Get up and do it again. Get up and do it again. Do your best to take care of your body while it falls apart anyway. People say: 'Have a good day.' There's no such thing as a good day. You can do some things during a day that might give you a little joy and a little gratification, but a day is a day. Only nights are good because that's when you get away from people. Your best hope is to have a purpose, because that provides a distraction from the fact that life is a ridiculous farce and a horror. When you're distracted, you don't have to sit around thinking about all this stuff like I do. If you don't have a purpose, you're just going to be one of these shitheads sitting around on SSI, watching TV, eating Burger King, and jerking off."

"My husband got a rare brain tumor called acoustic neuroma, which required surgery. We started out as being recovery minded. We put all this energy into healing, and trust in Western medicine, and believing that everything was going to be just fine. Then at some point we had to accept that it's not going to get back to normal. And it's not going away. And it's not that we aren't trying hard enough. It just is."

"I have stage-three melanoma, which puts me at a 48 percent chance of survival over the next five years. However, I have the ability to speed-read very technical material, so I went to the library at Duke and read over eight hundred papers on melanoma, which doctors just don't have the time to read. I found one very promising study that suggests chloro quinine, combined with the deprivation of a certain amino acid, has shrunk tumors in mice to almost nothing."

"We're hoping to get some funding from angel investors before telling our parents we aren't going to college."

"My sister was never scared. In fact, she was always comforting my mother. Even while she was getting chemotherapy, she'd be patting my mother on the arm, and saying: 'Everything is going to be okay.' The night she died, we knew something was wrong because she asked to read with us. She'd normally choose to play with toys while my mother read to me. But that night, she asked if she could read with us."

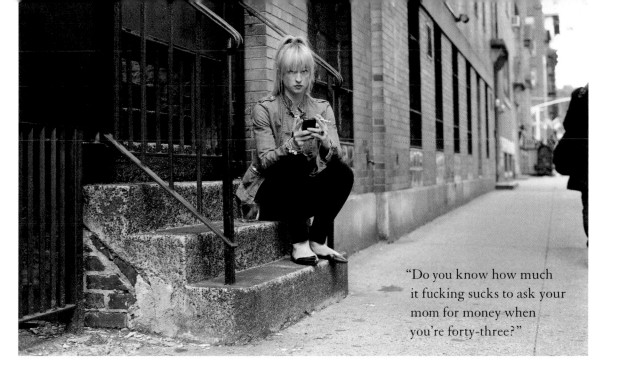

"Do you know how much it fucking sucks to ask your mom for money when you're forty-three?"

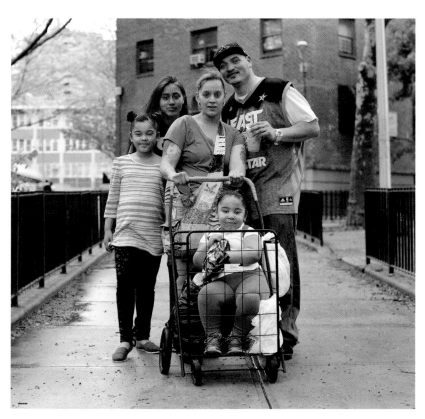

I asked the parents what their greatest struggle was, and they said, "Living in the projects." When I asked them to tell me the most difficult part of living in the projects, the young girl on the far left spoke up. "You get labeled," she said.

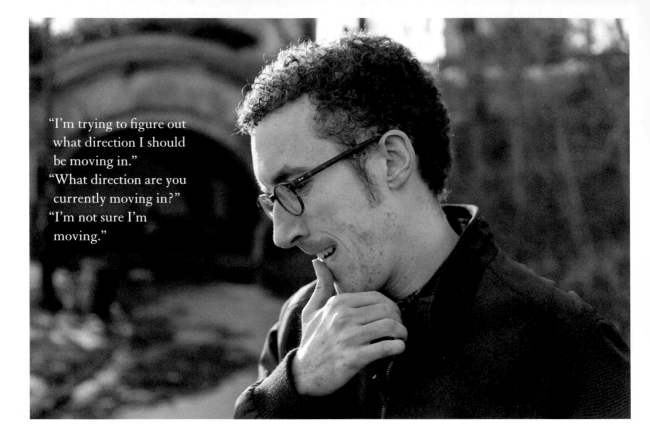

"I'm trying to figure out what direction I should be moving in."
"What direction are you currently moving in?"
"I'm not sure I'm moving."

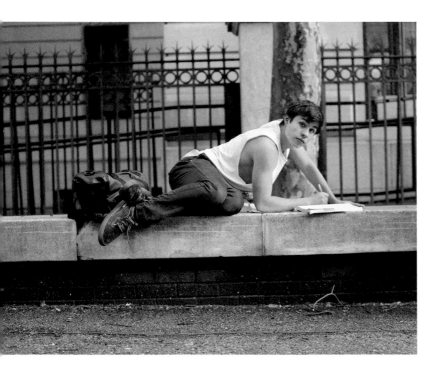

"The college admission process prioritizes American citizens, so the remaining spots for international students are very competitive. Plus there's no way that my parents will be able to pay tuition, so I've got to get a scholarship. But I think I've got a good shot. My grades are good. I kicked the most field goals in the city last year. And I'm growing 180 liters of algae down the street. Oils extracted from algae can be converted into biofuels."

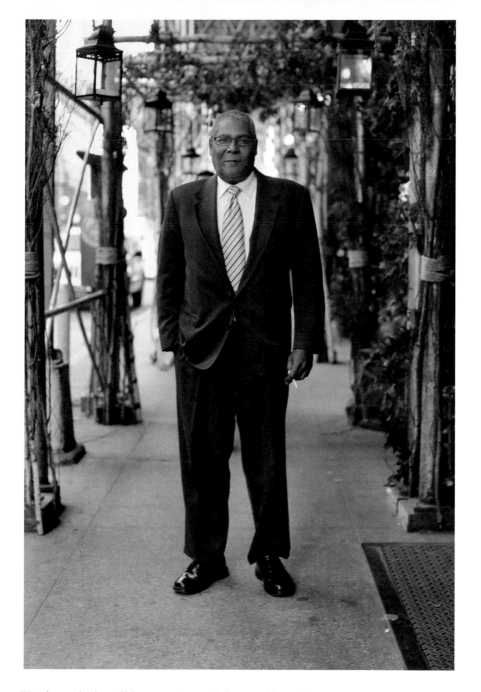

"Both my kids will have graduated from college in four and a half years, and I'm heading to Mexico. I'm not kidding. Social Security goes a long way down there. For three hundred dollars a week, I could have a place to stay, a satellite dish, a fishing pole, and some rum."

"I smoked weed for the first time when I was eleven. By the time I was twelve, I was doing coke with my older friends on the weekends. I started taking Vicodin as a teenager when my tonsils were removed. When I ran out, I started buying OxyContin, then moved on to heroin because it was cheaper. I just snorted it for a while, because I was scared of needles, but eventually it stopped working and I wanted to feel that rush again. I got up to thirty or fifty bags a day. I was driving a dealer around, so I got it for cheap. After a while, I wasn't even doing it to feel good anymore. I just did it so I wouldn't feel sick. I started stealing from my family and doing other things that I don't even want to talk about. If I didn't have any, I'd just sit in bed all day, too anxious to lay down, but too tired to stand up. Fifteen months ago I stopped when my best friend died. I'm actually going to get my methadone refilled right now."

"It takes a hell of a lot of pills to keep me going."

"What's been your greatest
accomplishment?"
"Keeping in touch with
distant friends and
relatives."
"Why is that important?"
"It's important to always
have people who
remember you at various
stages of your life. It's
especially important as
you get older, because
there are less of those
people around. And they
remind you who you are."

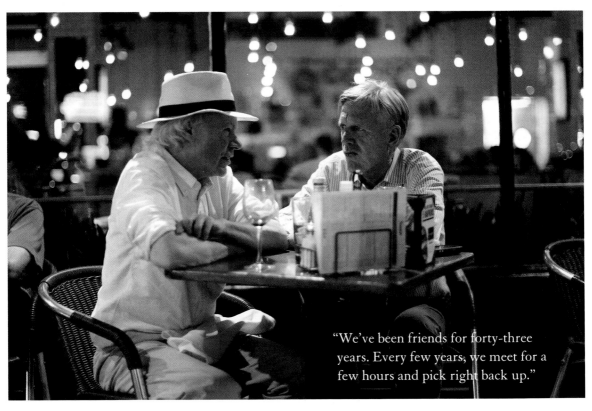

"We've been friends for forty-three
years. Every few years, we meet for a
few hours and pick right back up."

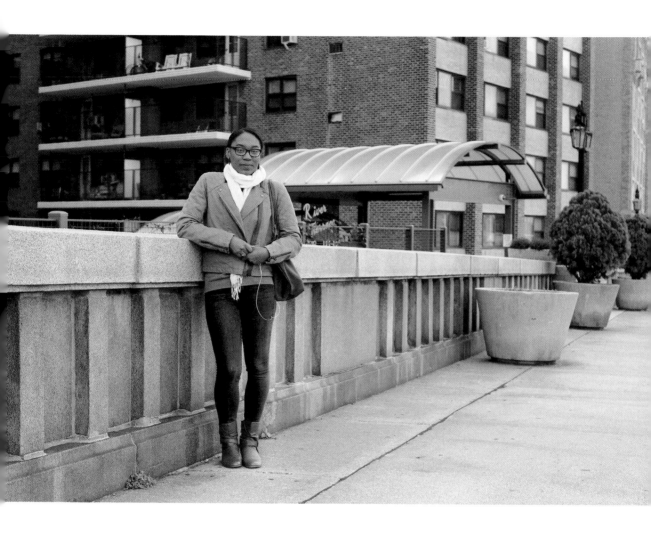

"My parents had me young, so my grandmother raised me. She was already retired when I was born, and started working again just so she could provide for me. Her favorite thing to say is: 'I've got your back.' Whenever something really good happens, or something really bad happens, she will send me a card that says: 'I've got your back.' We live together, but she actually mails the cards to me."

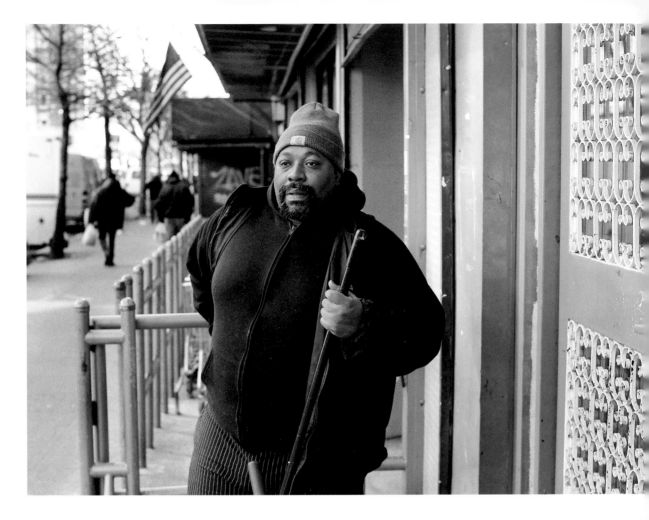

"It always starts out fun, but the moment they start to feel comfortable, they change up and become like your mother."

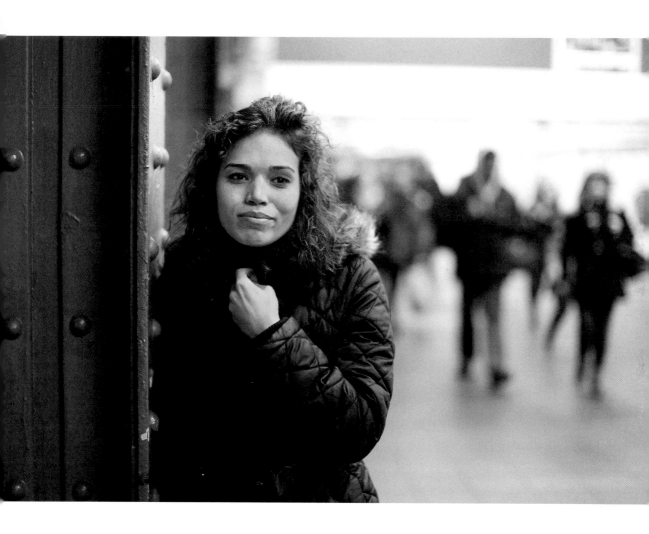

"I felt like a nagging mom trying to get him to do things. At first I tried to be positive and encouraging. I'd say, 'I'll help you do this.' Or, 'We can do this together.' But eventually I grew less encouraging, because I wasn't in a place to participate anymore. I was living my life and half of his life."

"The police is always against us."

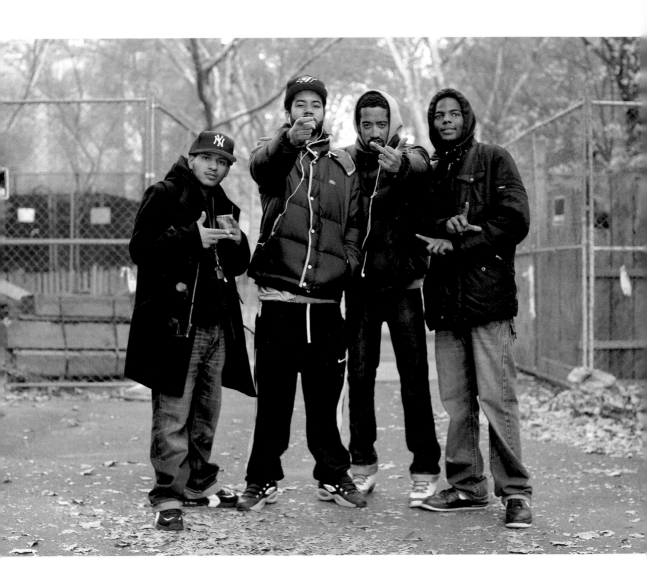

"When I came home from Iraq, I was really depressed. I remembered how much I used to love performing in high school, and thought I'd pursue it. I've been to hundreds of auditions over the last eight years. I did some Off Broadway. Some Off-Off-Broadway. I got a lot of 'under five' roles—that's what they call roles that have less than five lines. But then recently I auditioned for a recurring role as Detective Alvarez on the show *Gotham*. I was in Puerto Rico, celebrating my thirty-ninth birthday, when I got a call from my manager. She said: 'I need you to sit down.' I said: 'What's going on?' She said: 'Are you ready for this, Detective Alvarez?' I said: 'What are you talking about?' She said: 'You're Detective fucking Alvarez!' I just started crying and hugging my kids and thanking my wife for never giving up on me. With this role, I might not have to be a cop much longer."

"The whole reason I joined the Marines was to get away from a bad situation at home. My older brother was one of the leaders of the Latin Kings gang, and he got sentenced to twelve years in prison. He actually got out of prison just as I was going through the police academy, and he even came to my graduation. You know what he told me one time when I visited him in prison, right before I deployed for Iraq? He told me: 'I'm older than you. But you're my big brother.' That was so honest of him, it really fucked me up."

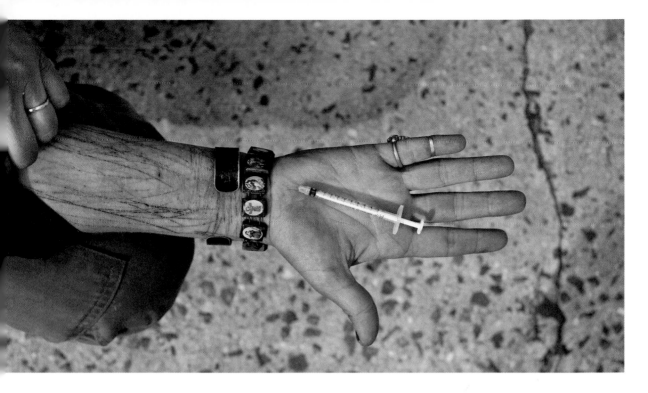

"I scratch myself every time the cops come because they don't like to deal with you if you're bleeding."

"It might be a cultural thing, but I was always scolded for showing emotion. Sadness was met with anger. My mother doesn't believe in depression. She thinks it's all for attention. Any time that I tried to get out of the house, she'd say: 'If you were really depressed, you wouldn't be doing that.' When I tried to kill myself, she said: 'If you'd really wanted to kill yourself, you would have done it.'"

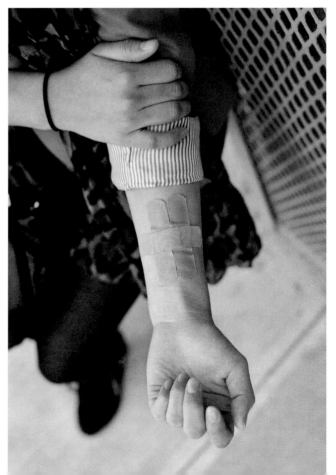

"Three thousand years
ago I had a disagreement
with Zeus about the
Trojan War, and he's been
harassing me ever since."

"I was in the CIA for twenty-seven years, but then I was institutionalized."

"I have a lot of mental illness right now. Half of my energy goes into taking care of myself. I've been daydreaming about shaving my head fully 'cause then I'll look as sick as I feel."

"I make stop-motion animations with miniature busts of human heads."

"I've completed a series of monumental-sized drawings in ballpoint pen of girls who've killed their mothers."

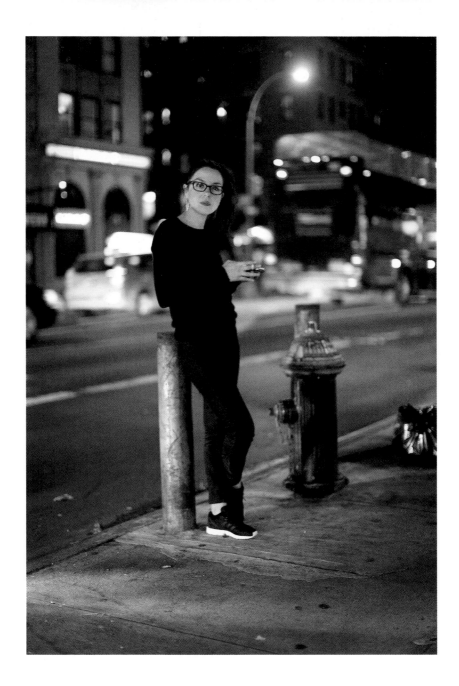

"I'm a spiritual healer. My mom was a spiritual healer. And her mom
 was a spiritual healer."
"What's one thing about yourself that you haven't been able to heal?"
"I'm sterile."

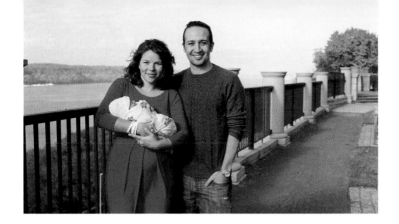

"He's one day old. I still can't believe that he's real and that he came out of me."

"My wife and I have been married sixteen years. But I was just never sure I wanted to have a child. And I always thought that with a decision that big, it was better not to guess and be wrong. I've just always had this anxiety about fulfilling myself and accomplishing my dreams. I love kids, and I love my friends' kids, but I just didn't think there'd be room in my life for a child. Some of the parents I know think that not having a child is a selfish decision to make. But then again, a lot of those same people, after two or three beers, have told me that they envy my freedom."

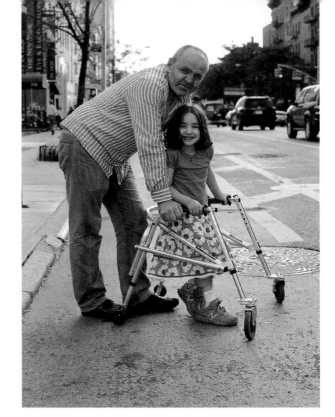

"We go to four appointments every week, but I don't mind. She's my blood."

"I have a special-needs brother who just moved out of the house today. It's the first time I've really been alone. And to be honest, I can't say whether I'm sad or relieved."

"My biggest fear was that I'd end up having to be my brother's caretaker. When I was twelve years old, my mother made me promise that I'd always take care of him. He had cerebral palsy, and ever since we were kids, I always was the one who took care of him. He could barely speak, and I was the only one who could understand him. So I did everything for him—I changed him, I fed him, I took him to the bus. But I had my own dreams and wanted my own life.

When I decided to leave, my mother started crying and kept reminding me of the promise I'd made when I was twelve. My brother was so upset that he wouldn't even look at me. But I had my own dreams. The worst part is that every time I came back to visit, he'd atrophied a little bit more."

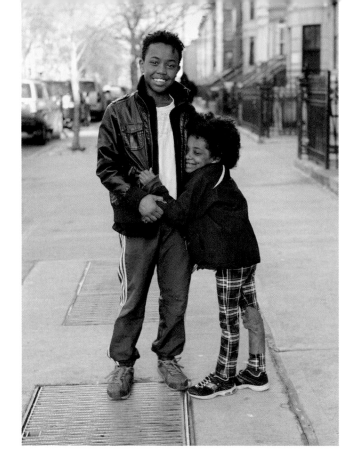

"What's your favorite
thing about your
brother?"
"Well . . . well . . . well,
the WORST thing is
when we argue!"

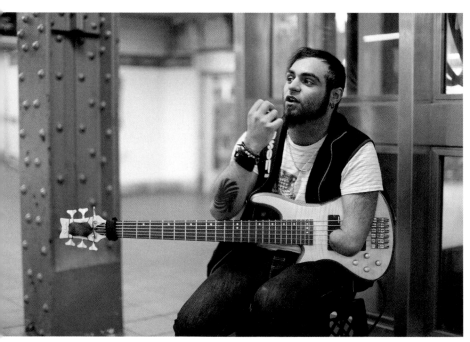

"I got to be one of
the highest-ranked
Guitar Hero
players in New
York State, so I
thought I'd switch
to a real guitar."

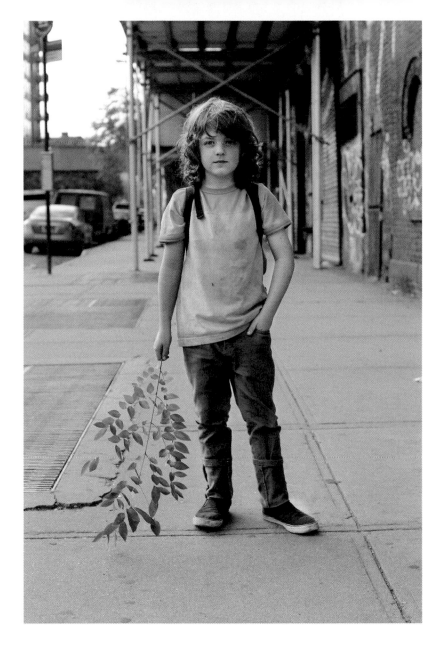

"I'm going to be an inventor. I already have some good ideas. I had an idea for an electronic cigarette with a whatchamacallit in it that makes mist so you feel like you're smoking but you really aren't. And also a toothbrush where you put the toothpaste in the bottom and it comes out the top when you're brushing."

"Those are some good ideas. Anything else?"

"A fart gun."

I asked her what she felt most guilty about, and she said: "I can't say it, because it will make me cry. And I don't like people to see me cry." I told her that was fine and changed the subject, but after a few minutes she typed it out on her phone and handed it to me:

"When I was eleven years old, I got in a fight with my twin brother and told him that he was going to die before me because he had a brain tumor."

"Is he still alive?" I asked.

"Nope."

"When my sister's having a manic episode, she thinks she has superpowers. She'll go outside and strip off her clothes. She'll develop all these conspiracies about the government being out to get her, and she'll think that something she's done has made our whole family unsafe. Sometimes she thinks that I'm not me, but an avatar of myself, and I'll have to do all these things to prove that it's really me. One time she stole someone's bike off the street because she thought she was in a movie and was in a race to the Statue of Liberty. Luckily someone stopped her and took her to the hospital. It's hard to see her like that, and it's hard to say that there's anything nice about it, but then again, I can't help but feel that she has a certain freedom that I envy when she's having an episode. I feel like everyone's a little crazy and we all walk around with this armor of sanity, and she's just able to cast it off completely. I'd almost like to join her and run around the city if only she could keep it from spinning out of control."

"During one of her depressive episodes, my sister laid in bed so much that she developed bed sores, so I had to bathe her. She wasn't eating at the time so she was all skin and bones. The saddest part for me was how easily she accepted it. For her whole life, she'd been so shy about anyone ever seeing her naked. But now she didn't even have the energy to care that I was washing her."

I found these two in Central Park. After I took their photo, I began to ask Dad some questions but ended up getting some clipped responses:

"What was your happiest moment?"

"When my daughters were born."

"What's the proudest you've been of your daughter?"

"I'm always proud."

"What was the saddest moment of your life?"

"I'd rather not say."

After a few more attempts, I resigned myself to the fact that he wasn't going to reveal any details about his life. When I got home, there was an e-mail in my inbox:

I saw you in Central Park this evening with my daughter (redhead). You asked me about my happiest day—I told you when my daughters were born (I meant it). You asked me what the saddest day in my life was—I told you I'd rather not answer. Well, it was August 12, 2006. On that day, my wife and I lost our first baby—she was 36 weeks pregnant (his name was Peter). It was horrible. But now we have two beautiful little girls, so I'm grateful. The reason I was unable to provide a specific answer to questions about my happiest day or what makes me proud about my girls—because everything does. Thank you.

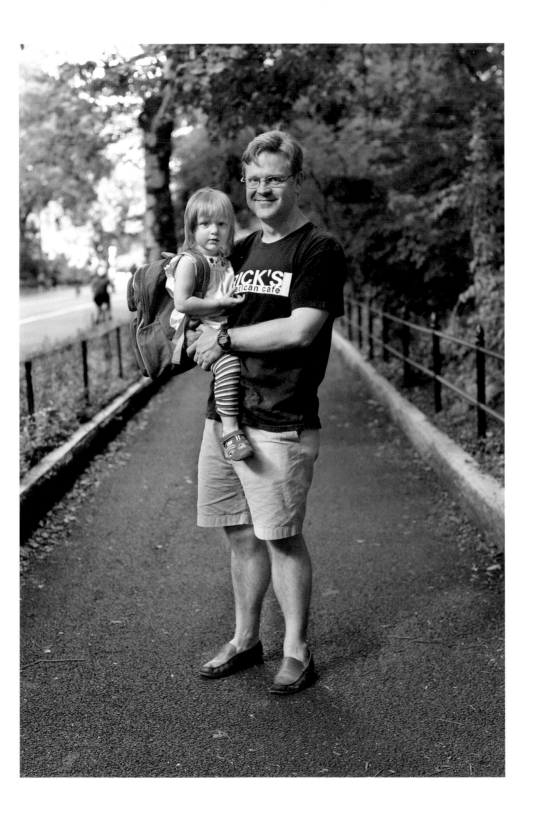

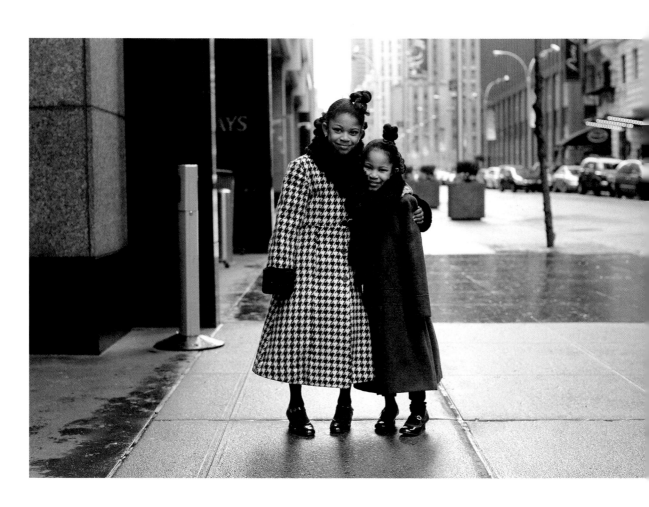

"Do you know what you want to be when you grow up?"
"A dolphin saver."

"I want to be a princess hairdresser."
"What's the hardest part about
 being a princess hairdresser?"
"Cutting Rapunzel's hair."

"What do you want to be when you grow up?"
"Fireman."
"Why do you want to be a fireman?"
"I said, 'Iron Man'!"

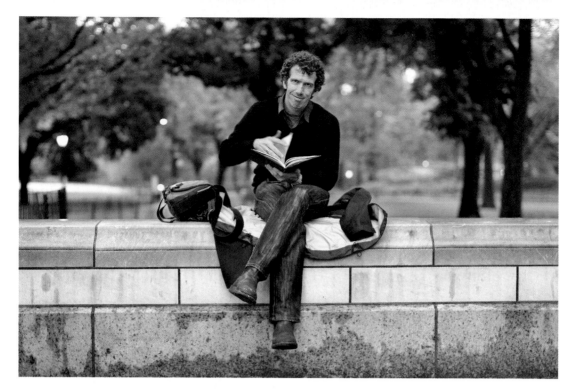

"I'm trying to determine how sensors can be used to collect information about soils and plants so that farmers in India can better manage their crops."

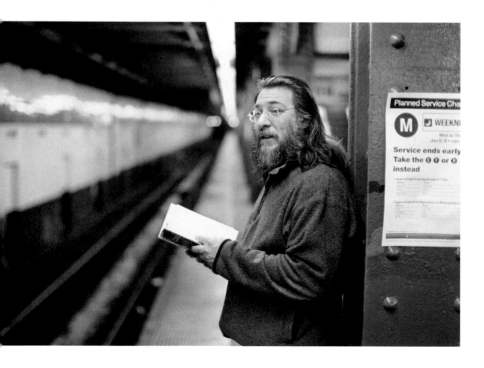

"I'm trying to figure out how to control magnetic ferrofluids more precisely. They could potentially be used to direct drugs in the body, resulting in more targeted and less harmful chemotherapy."

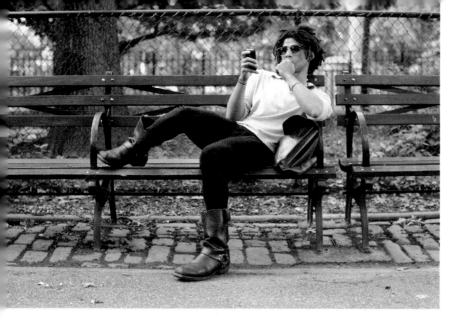

"I'm Gang Rapist number 37 on last week's episode of *Law and Order: SVU*."

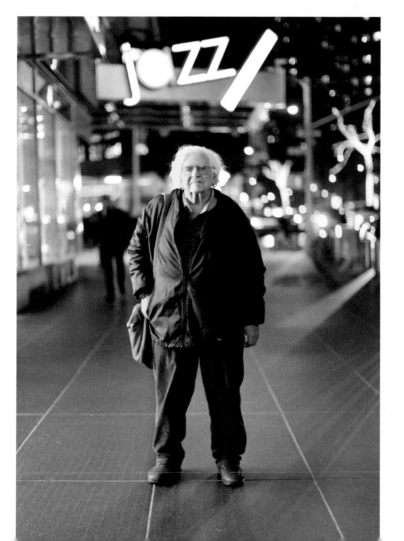

"I once crash-landed a plane in a desert in Tunisia. I wasn't even the pilot. The pilot got hysterical and I had to grab the controls."

"Sometimes I stay up late without asking."

"What do you feel most guilty about?"

"Not finishing my novel. I've already built the room where I'm going to write it at my house in Sag Harbor. The walls of the room are painted Venetian red. It has shelves filled with every book I've ever read. There's a scallop-striped Victorian chair. A little pine desk—two feet by three feet, with all my pens lined up, and an eighteenth-century *sang de boeuf* vase lamp. And there's a French door with a step that goes out onto the roof so I can look at the clouds. I have everything I need. Except the time."

"Five years ago I got hit by a jeep on my bike. I woke up in the hospital with my
face all messed up. I was on lots of morphine, and my family had all gone home
because they'd been told I wouldn't wake up that night. I was really scared. The
next few weeks, while I was healing, I told myself that if I ever got better, I'd
never live a mediocre life."

"And what are you doing now?"

"I got a BS in mechanical engineering and now I'm getting a Ph.D. in biomedical
science."

"What are you going to do with it?"

"I'm going to save humankind, of course."

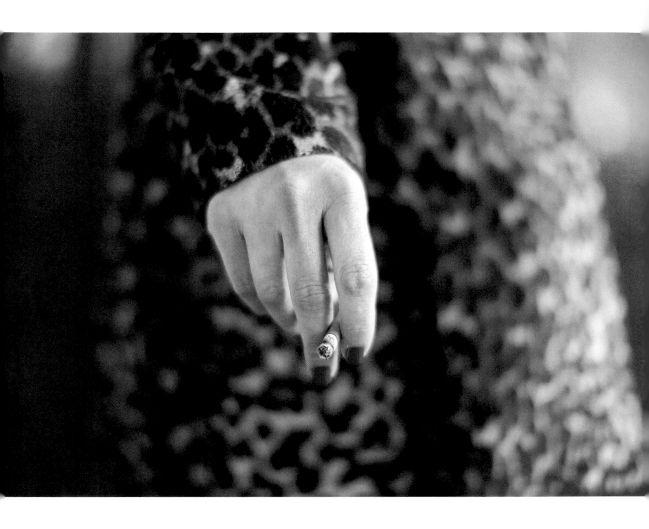

"My mom died a few weeks ago. But she had brain tumors for years, so she wasn't the same mom I grew up with. She went from being really active to not being able to cook her own food to not even being able to feed herself. Her personality changed, too. She used to be very outgoing and caring. Toward the end, when I told her I'd graduated from college, she didn't even have a reaction. She just changed the subject."

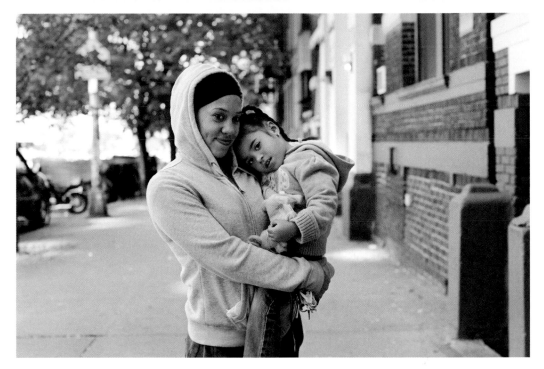

"You do your best to teach her values, but you can never control what the outside world shows her. She's already learning things from the kids at day care that we'd never allow: yelling, pushing, sticking out her tongue . . ."

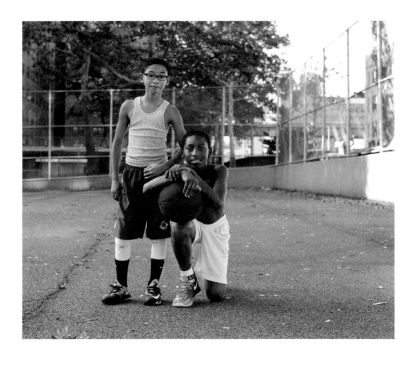

"What's the hardest part about being a basketball player?"
"Controlling your emotions."
"What's the hardest part about controlling your emotions?"
"Sometimes you get hacked and it don't get called."

"It went through my rib cage and stopped against my spine."

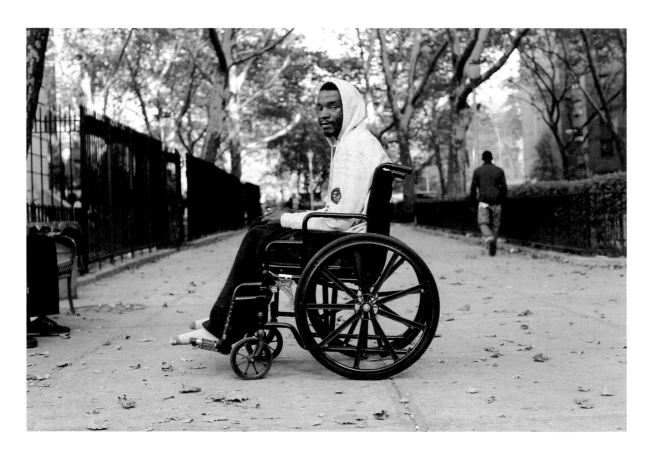

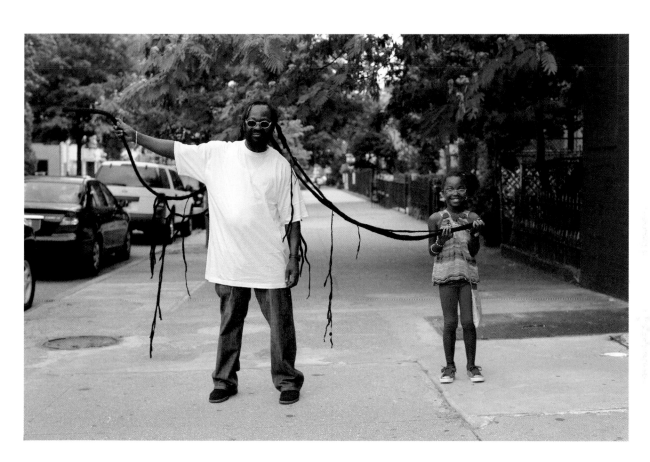

I asked if he remembered the moment he was proudest of his daughter. He started speaking in a thick Jamaican accent: "Just seeing her born. That moment when my seed was brought forth onto this earth. It was magic."
Then the girl, who up to this point had been quiet, screamed: "Preach!"

"I just always wonder if people are going to look at me
normal and treat me normal."
"Do they?"
"Most of the time. Sometimes strangers stare at me.
But if I stare back, they usually look away."

"I'm really into conspiracy theories. I read a lot online. And I feel bad for everyone because we're all fucked. I'm not a religious person by any means. I only believe in God and the Devil and aliens. But we don't have to worry about the aliens, because Eisenhower made a deal with them. They can take cattle and some humans in exchange for technology. Also, we're a trillion dollars in debt. Have you ever thought about who we're in debt to? And I read recently that J. P. Morgan was supposed to sail on the Titanic, but he canceled at the last moment. Doesn't that tell you something? Obama hired fifteen hundred Russian troops, because something big is going to happen."

"After I finish my shift at the bakery, I start my shift at Starbucks. I work ninety-five hours per week at three different jobs. One of my sons graduated from Yale, and I have two more children in college. And when they finish, I want to go to college, too. I want to be a Big Boss. I'm a boss at the bakery right now, but just a little boss. I want to be a Big Boss."

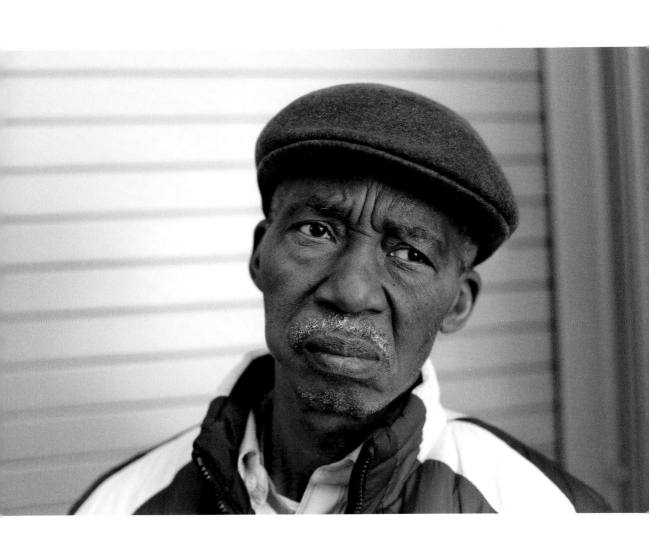

"That's my boss. Gotta go."

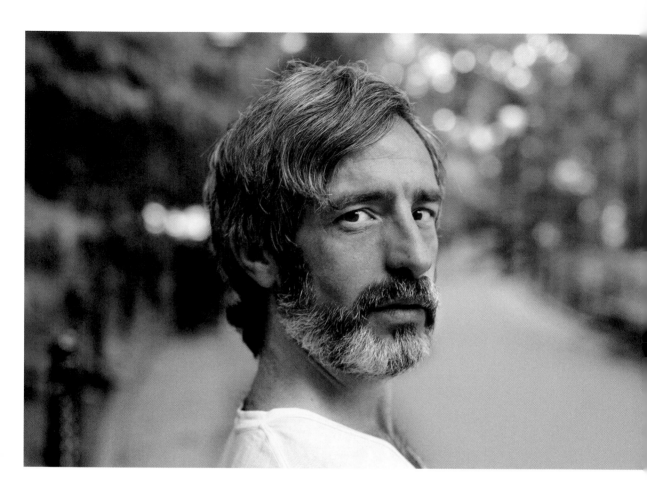

"I'm a Brooklyn assistant D.A. I work on domestic violence cases—many of them homicides. Some of the crime scenes are just gruesome. It's the same stuff soldiers see in a war. I see this stuff, I smell this stuff, it's hard to get out of your mind. And even when I win a case, it's hard to feel like I'm making a difference. It's a never-ending cycle of violence. The offenders are so likely to offend again. And the women are likely to go right back to them, or find themselves in a similar relationship. The work is so tough, and it feels like I'm not even making a dent."

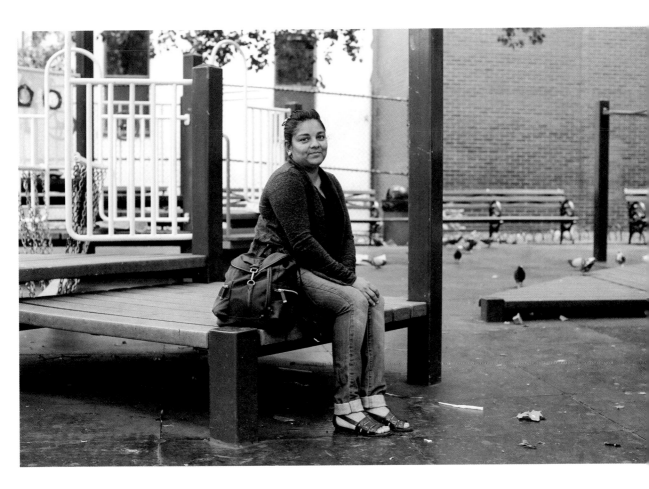

"I fell into the wrong arms. I had no family here, and he was the one to say that he loved me. The hitting got worse and worse, but each time he'd come back saying that he was sorry, and crying, and begging me to forgive him. So I just kept praying about it. Until one night it got so bad that I had to jump through a window."

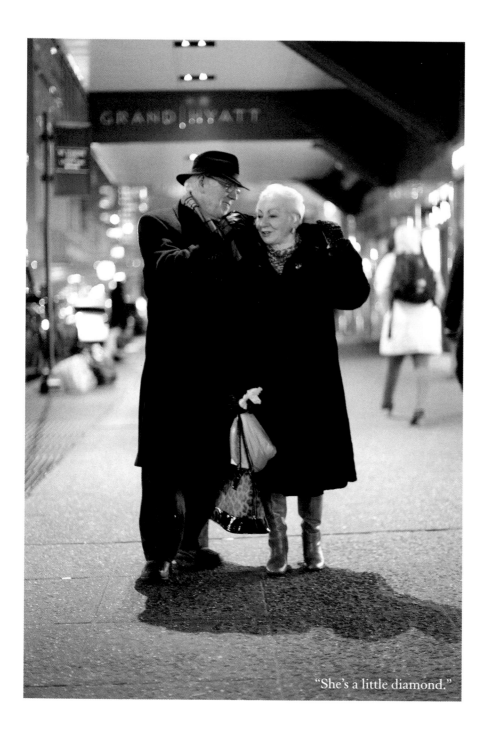

"She's a little diamond."

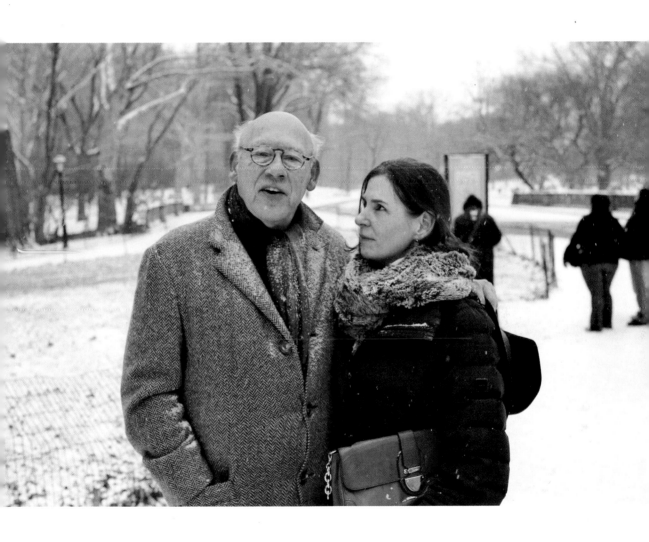

"We met six weeks ago. And no offense to my
deceased wife, but this is the love of my life."

"If you're opening a business just for the money, you'll fail. There's too much work before the money comes. Your heart needs to be in it."

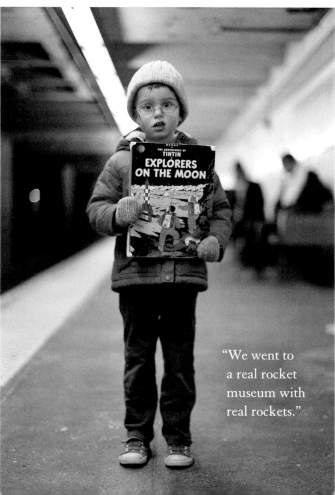

"We went to a real rocket museum with real rockets."

"I'm eighty-six. And that's about enough. I'm ready to go."

"Aren't you afraid of death?"

"Why would I be?"

"Isn't that sort of a natural condition of living?"

"Not when you miss your husband as much as I do."

"My wife and I are divided about whether it was inevitable, or if something caused it, but we do have video of Jackson at eighteen months, coming up to the camera and talking. But soon afterward his language stopped developing, and eventually he lost the language skills he already had. He stopped responding to his name. You could even bang pots and pans behind him, and he wouldn't respond. But when we tested his hearing, it was fine. People would say: 'Boys develop later.' Or: 'Don't worry, my daughter didn't begin talking until she was three." But we knew it was something more. This was twenty years ago, so the doctors didn't even know what to tell us. The head of pediatrics at Columbia met with us, and said: 'Let me do some research on autism and I'll get back to you.' We started to worry that Jackson might never progress. Around this time, I overheard some acquaintances worrying that their four-year-old son might be gay. It made me so mad. I thought: 'Give me a fucking break. You know that your child can grow to be happy, independent, and fall in love. I'd trade anything for that knowledge, and you're freaking out that your son might be gay.'"

"We're all better people because Jackson is in our family. I've seen my other son choose his friends based on how they treated his brother. My daughter asked us if she could invite an entire special-needs class to her tenth birthday party. My wife and I have become advocates and started charities. But we've all been tested too. Everyone is needy, and when you have a special-needs child, it's hard to give everyone the attention they deserve. I wish I could have given my other two children more parenting. And I wish my wife and I had more time to focus on each other. But sometimes we were too busy with Jackson. It could be like crisis mode all the time. I'd be fighting the school board. My wife would be up until 3 A.M., every single night, watching videos of Jackson's therapy, trying to decide what was working. In many ways, all of our worlds revolved around Jackson. And sometimes we didn't have much left for each other."

"Jackson lives in a group home. He's never going to be completely independent, but he does have some independence. He does activities, and does volunteer work, and we pick him up every weekend. He loves to draw. I try to look at his drawings to understand his brain. I wish I could get in his head, even for a few minutes, so I could better understand his world."

"What do you know about his world?"

"It's a very cartoony world. He loves the same things now that he loved twenty years ago. He loves Disney characters, and muppets. There's no war in his world. There's no financial crisis, or crime, or unemployment. There's no racism. No rich or poor."

"What was the hardest part about raising a child with autism?"

"Not being sure if your child loves you."

"Do you know now?"

"Yes."

"How?"

"I know that he understands we are important to him. And I know that he understands he is important to us."

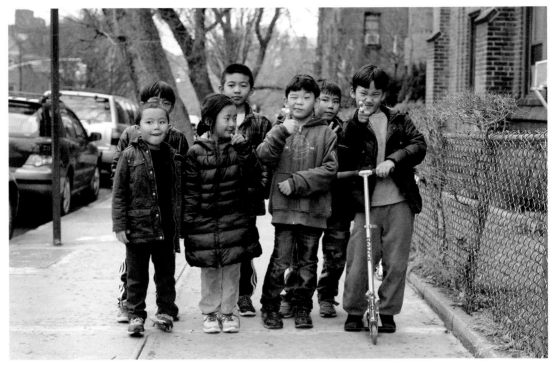

"Yesterday I found a penny in the park, and now it's in my pocket."

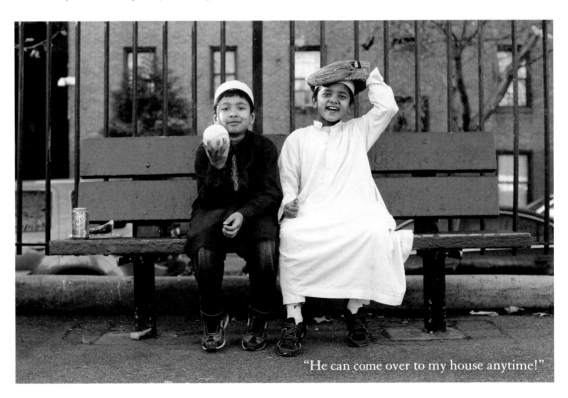

"He can come over to my house anytime!"

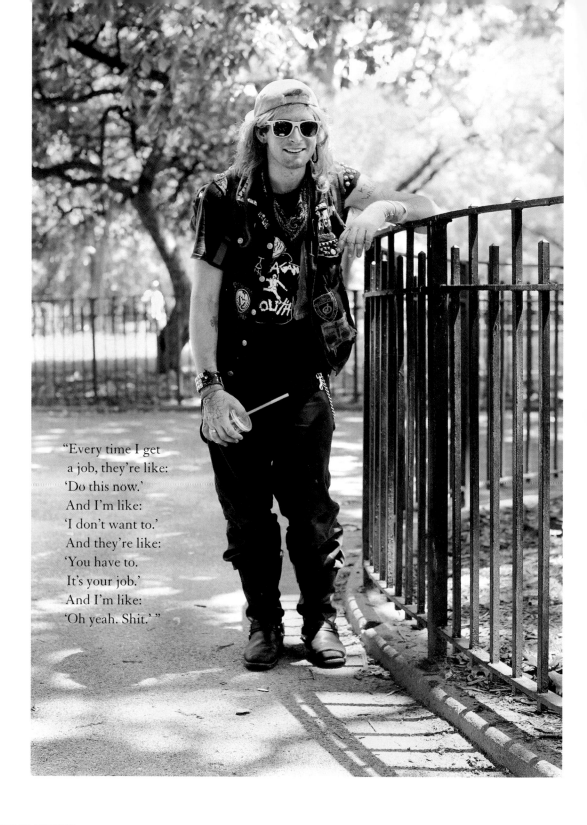

"Every time I get
a job, they're like:
'Do this now.'
And I'm like:
'I don't want to.'
And they're like:
'You have to.
It's your job.'
And I'm like:
'Oh yeah. Shit.' "

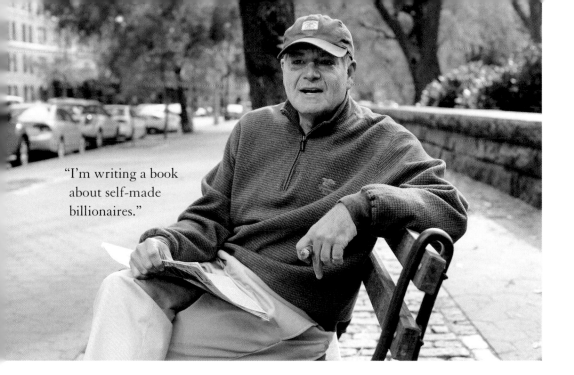

"I'm writing a book about self-made billionaires."

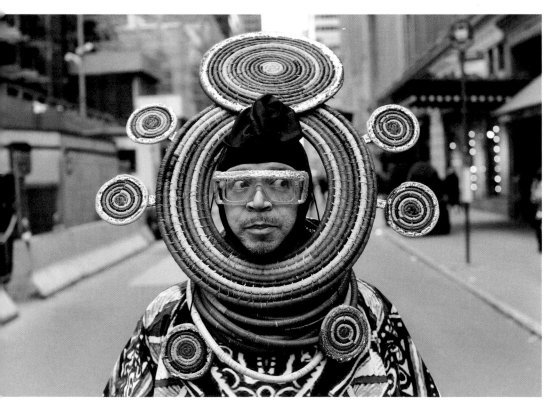

"I'm trying to get back into the workforce."

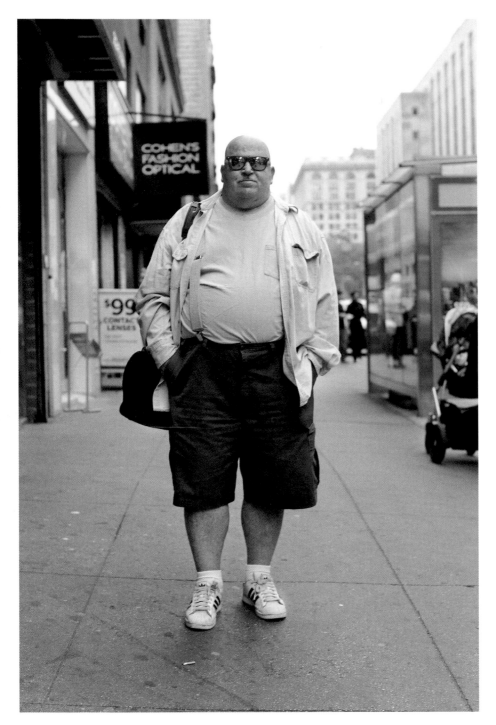

"My first memory was when I was three years old. My dad set me up on the dresser and said: 'Jump to Daddy!' Then he let me fall and said: 'Don't trust anyone.' He was twisted like that. I'm pretty sure that's why I'm a loner."

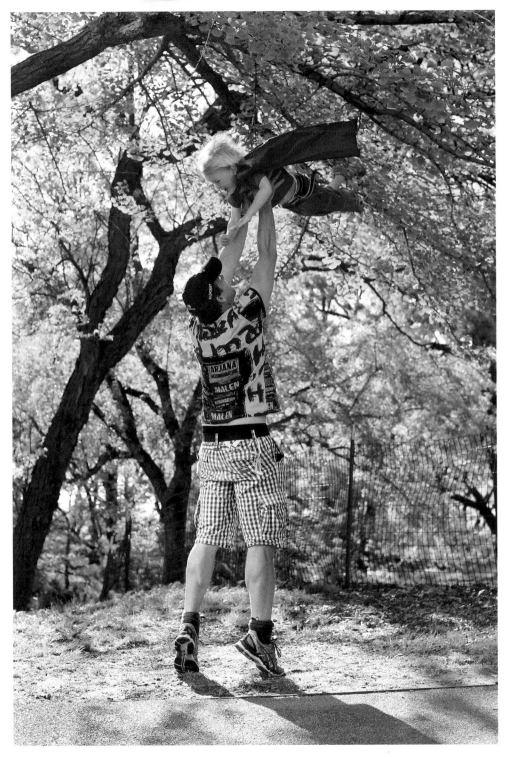

Seen on the Upper West Side

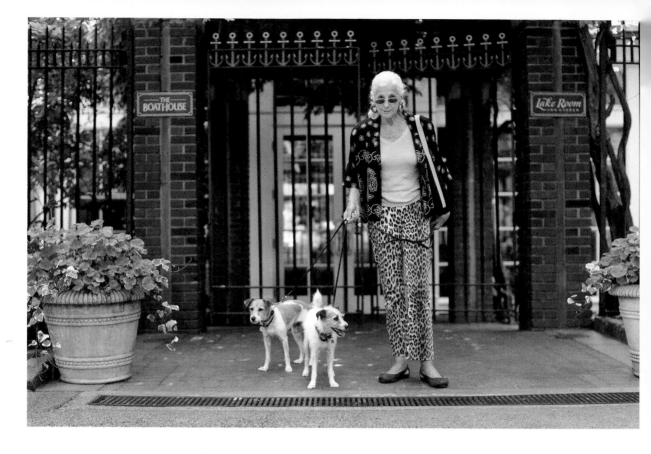

"They were filming that show *Gossip Girl* across from my apartment. I marched right up to the crew and said: 'Do you have any idea what you're doing to the youth of America?' I've actually never seen the show. But gossip is horrible. It ruins lives."

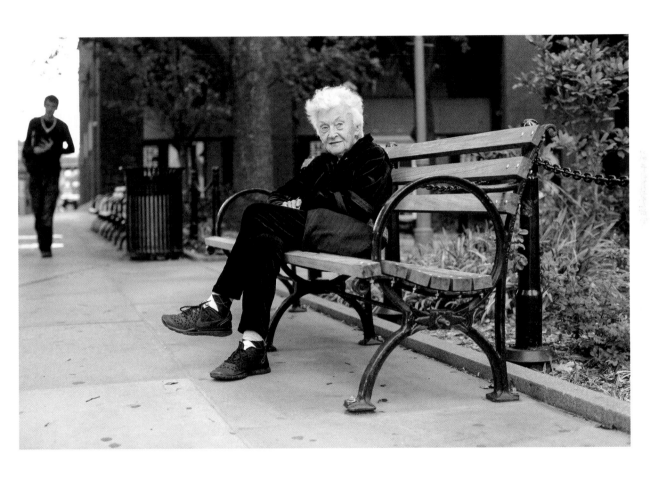

"Don't tell me what to do, and I won't tell you what to do.
That's my motto. I have a lot of feelings about the decisions of
my family members, but I don't ever offer my opinion unless
I'm asked. And that's why I'm still invited to parties."

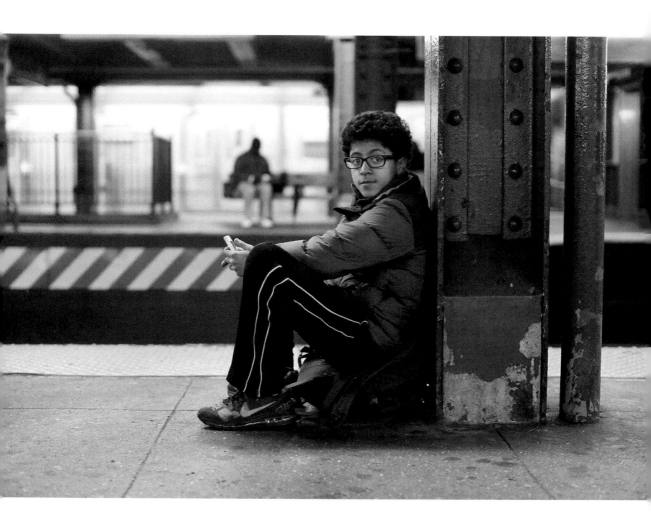

"I used to be a little bit of a bully. I was always putting people on the spot and trying to embarrass them. If people are afraid of you, they don't really feel like they have a choice when you ask them to do something. And the more power you have, the more things go the way you want."

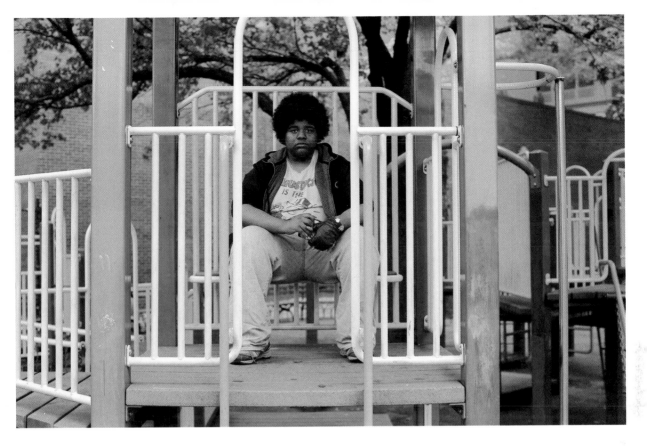

"They say that you're supposed to stand up to bullies, but there's not much you can do when the whole class is like that."

"Why do they make fun of you?"

"Let's see. My weight, obviously. The fact that I read for fun. Mostly sci-fi and fantasy. I watch Nova. I don't like sports. You know those loud, obnoxious kids you see hanging out in groups, screaming at people? That's my whole school."

"So what do they do to you?"

"Just yell at me and throw stuff at me. But I am proud of one thing. Most kids who get picked on completely spaz out at some point and get violent. That hasn't happened to me yet."

"I got it when I was young. I made the mistake of
 trying to stop someone from picking on me."

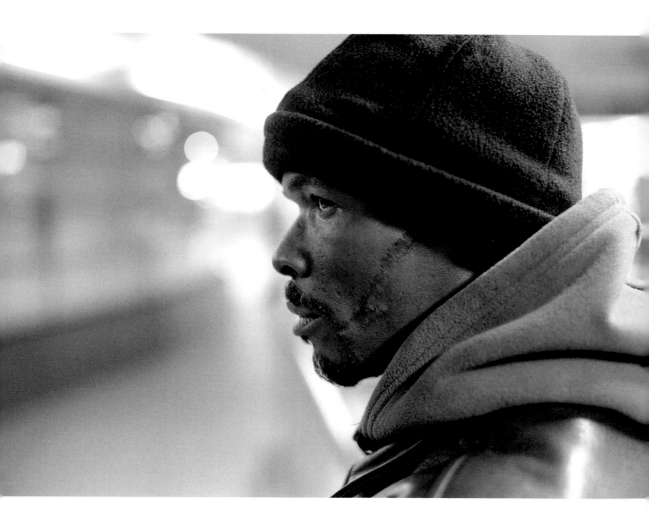

"Right after I lost vision in my eye, I was so bad at walking that I ran into a girl eating ice cream, and knocked her cone out of her hand. She screamed: 'Are you blind!?!?' I turned to her and said: 'I am blind, actually. I'm so sorry, I'll buy you a new cone.' And she said: 'Oh my God! I'm so sorry! Don't worry! It's no problem at all! I'll buy another one.' So we walked into the ice cream store together, and the clerk said: 'I heard the whole thing. Ice cream is free.'"

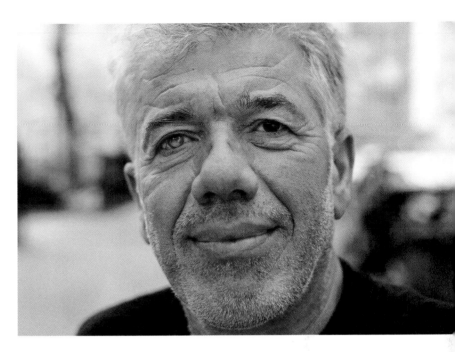

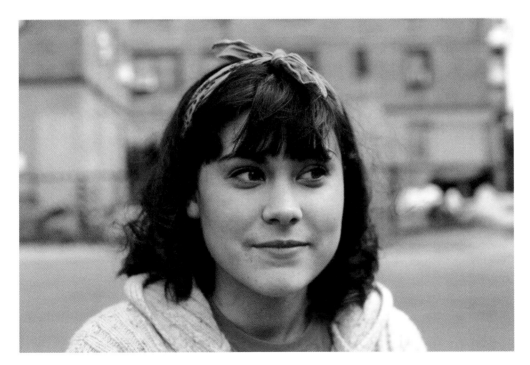

"For the longest time, I was so focused on being deaf in my left ear that I almost forgot my other ear was perfectly fine."

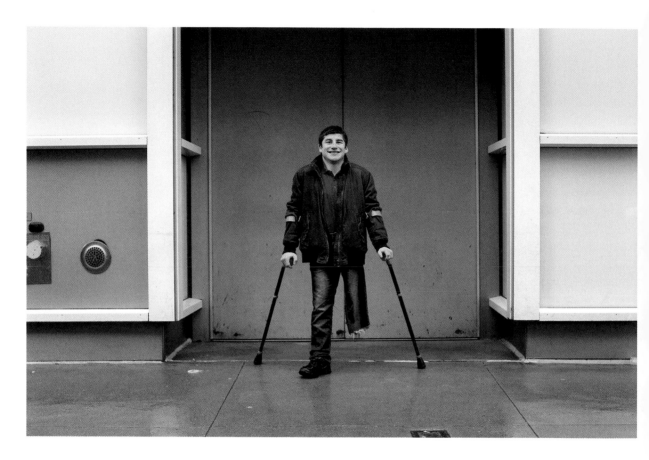

"After I was born, I was the subject of a forty-five-minute dissertation at Columbia University. Almost all of my organs were born externally, and had to be sewn into my body. I don't have a belly button … only a scar where my feeding tube used to be. My mother even tells me that she wasn't sure if I'd ever be able to stand, eat, or drink. But now I can rollerblade. I can do a handstand on my crutches. I've got a core group of friends, a girlfriend, a college degree, and I'm helping to manage a radio station at the age of twenty-three."

"My father has a lot of flaws. He showed me both the father that I want to be, and the father that I don't want to be. There were times when it all got to be too much for him and he couldn't handle it. But he was always the one that pushed me. He decided at an early age that I was going to run, and he signed me up for races. My first race was a pee-wee race when I was two years old. The crowd made me so nervous that I laid down in the middle of the race and started crying. At the age of three, he took me to an ice skating rink, hung my crutches on the wall, and pushed me around on a skate. When I got older, we ran a 5k together every year on Father's Day. Because of my disabilities, it made other members of my family nervous that my father pushed me so hard. But he taught me persistence and he taught me survival."

"My mom was always the nervous one. She was the worrier. They had fights about how to raise me, because my dad thought I was invincible and that I could do anything. My mother wanted me to understand my limitations, and to know that some things could not be overcome. She wasn't as exciting as my dad. But she was the one that made sure I took all my medications, and got all my medical supplies, and kept every appointment to get my esophagus stretched. She was the one that always drove me to the hospital, and kept track of my entire medical history so that she could tell it to every new doctor we had. And if that's not love, I don't know what is."

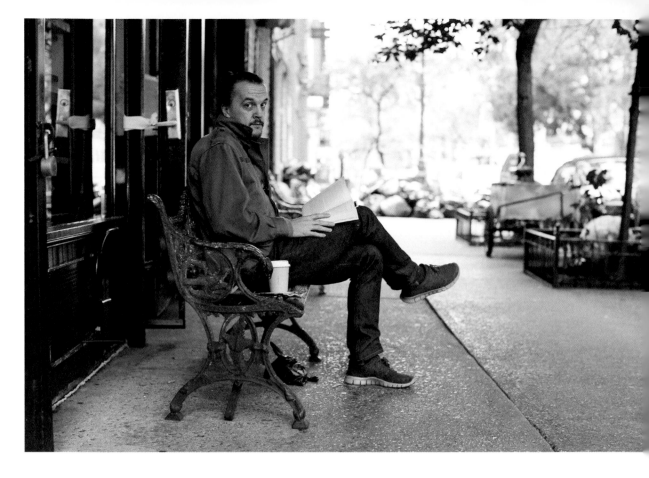

"Ever since my relationship ended four months ago, I've been reading a lot of
 spiritual and metaphysical books."

"What caused the relationship to end?"

"If I knew the answer to that, it probably wouldn't be so painful. At some
 point the sense of having a joyful shared space seemed to evaporate. Instead of
 investigating it as a team and going deeper, we chose not to speak about it, and
 things got shallower."

"Why didn't you speak about it?"

"Because it's painful to bring those things up. You build up your ego with a story:
 'My girlfriend loves me unconditionally.' And it's extremely hard to set aside a
 moment to examine if that story is true."

"Was there a moment when you realized the relationship was coming off its peak?"

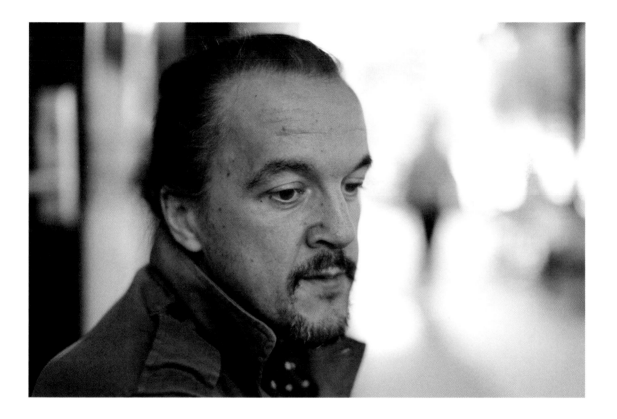

"It's not a moment. Some relationships end because somebody does something wrong, but others just dry up. The texts become less sweet and less frequent. There was one day when we had breakfast and coffee together, and I just walked out of the kitchen and cried because I knew it was slipping away. It wasn't anything in particular. It was just a feeling. I was really hit by the impermanence of everything in life. Most of the time impermanence hits you when someone dies, but it can hit you in life as well."

"She died in front of me. I was seven years old, and I was helping her make the bed, and she just collapsed on the bed and never woke up. Two days later, I moved to America to live with my aunt and uncle. They didn't tell me it was a suicide until I was old enough to begin dating. My aunt felt like I should know that my mom had killed herself over a man, because they didn't want me to do the same thing."

"I didn't even like patterns before I met her!"

"I lived in Somalia from '87 to '90. At one point we learned that the rebels were twenty miles outside of Mogadishu, so we quickly packed up all our stuff in a truck and started heading out of the city. On the way out of town, we drove past the main courthouse, where some political prisoners were being tried. There was a huge protest, and the police began opening fire into the crowd. Traffic came to a standstill. Our driver starting throwing the car into reverse, then forward, then reverse, ramming the cars in front of us and behind us, until there was enough room to turn the truck around."

"On the outside I'm a peaceful and diplomatic person, but on the inside I have a lot of rage. It's hard to walk around and not have a lot of issues. There's too many morons in this world. People are just living in alternate realities. Yesterday there was a crazy homeless man on the subway. I mean really crazy—he's grunting and waving his arms around. And some twenty-year-old white girl walks up to him and tries to explain how positive thinking can turn his life around. 'You don't have to be homeless,' she said. 'You can do anything you want if you put your mind to it.' She really had no idea that positive thinking was not going to get the schizophrenic man off the subway."

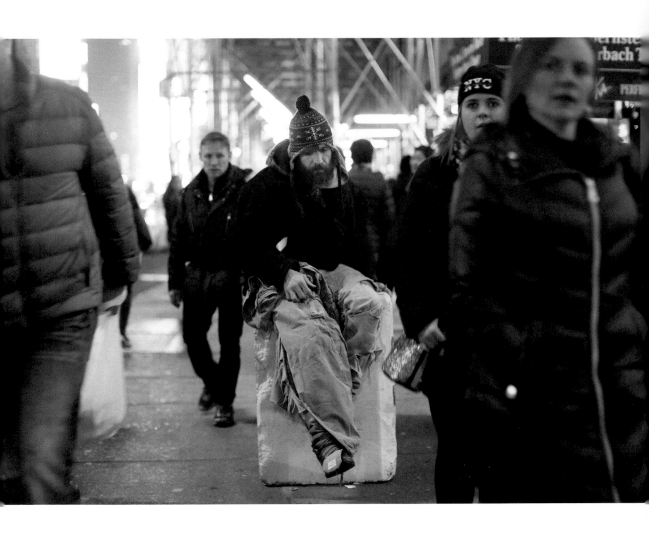

"Somebody's jamming my mind. I can't hear myself think. I can't hear myself think. I can't hear myself think."

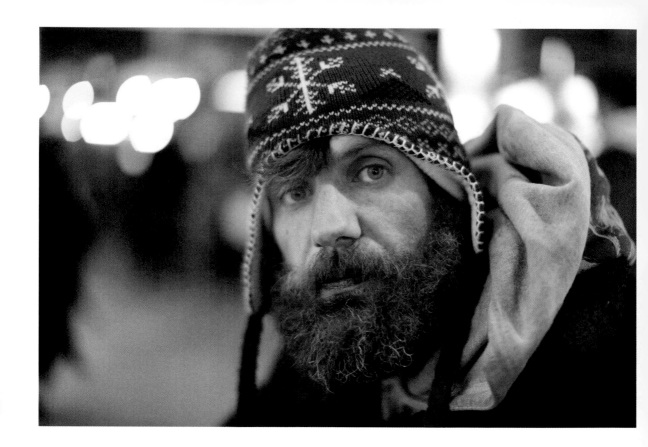

"I can hear them all the time but I've attached myself to their system so
I always know where they are. They are dangerous as a motherfucker.
They control the Internet and phone lines. They have systems that can
read our minds. The system is called Scorpion or Spider, I forget. When I
say words I don't think of the meanings so if they are listening they don't
know what I mean. They know that I am investigating them so they sent
two thousand people to follow me."
"Is it lonely to be the only one who knows about them?"
"Sometimes I wish I could just get away and let other people take over.
But I can't."

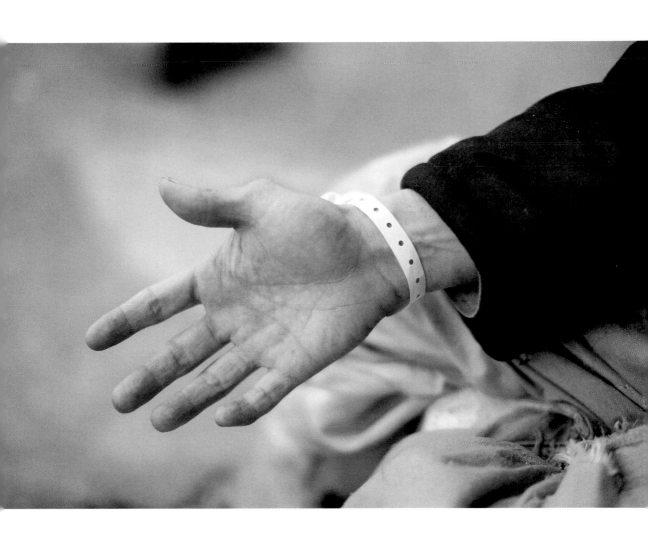

"They told me I was fine."

"I'm from Russia. If you see a doctor smoking, he's from Russia."

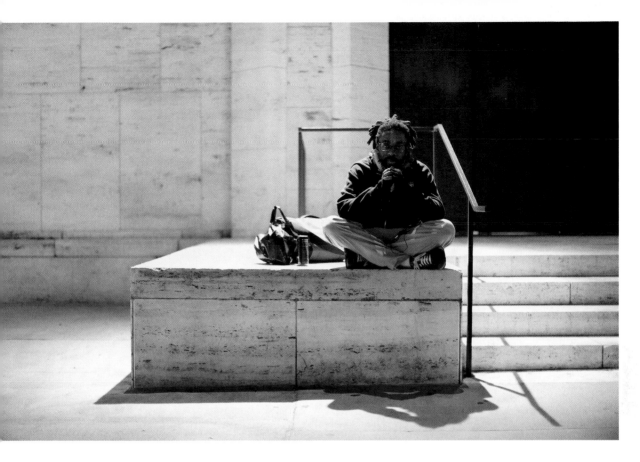

"I'm about to go to work. I'm an emergency room doctor and I work the 10 P.M. to 8 A.M. shift."

"What's been your proudest moment as a doctor?"

"Probably just the moment when I finally felt comfortable—it took about three years, and one day it just kinda clicked. Starting a shift in the emergency room is like the feeling before a giant battle in a movie like *Braveheart* or *Lord of the Rings*. You just have no idea what's going to come through the door. Sometimes, five serious cases can come in at the exact same time and you have a lot of decisions to make, and you have to know exactly how long each procedure takes, and what can wait, and what can't. I think my proudest moment was when I finally stopped feeling nervous, because I'd reached a level of experience where I could make the correct decisions without thinking about them."

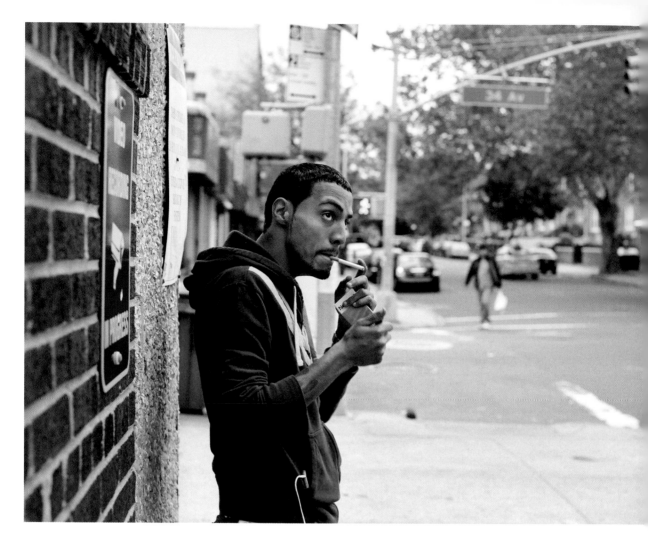

"My first year in California went well. I was going to auditions, getting a lot of jobs, I was even on a couple of TV shows. At one point a kid even asked for my autograph and I remember how good that felt. It made me feel like I was doing something important. But then I started doing meth. Once a week at first, then only on weekends, then five days a week, until eventually I wasn't even able to get out of bed without doing it. I started hanging out with old, washed-out celebrities who just live off their money and think that they're the same person they used to be. I got super skinny. In my mind, I felt like The Man. I felt like I was doing better than ever. But in reality, I was just a meth addict. I came back to New York for a bit to clear my head. But I've got to get back to California and start acting again."

"Do you think you'll do meth again?"

"Of course. But I'll keep it under control this time."

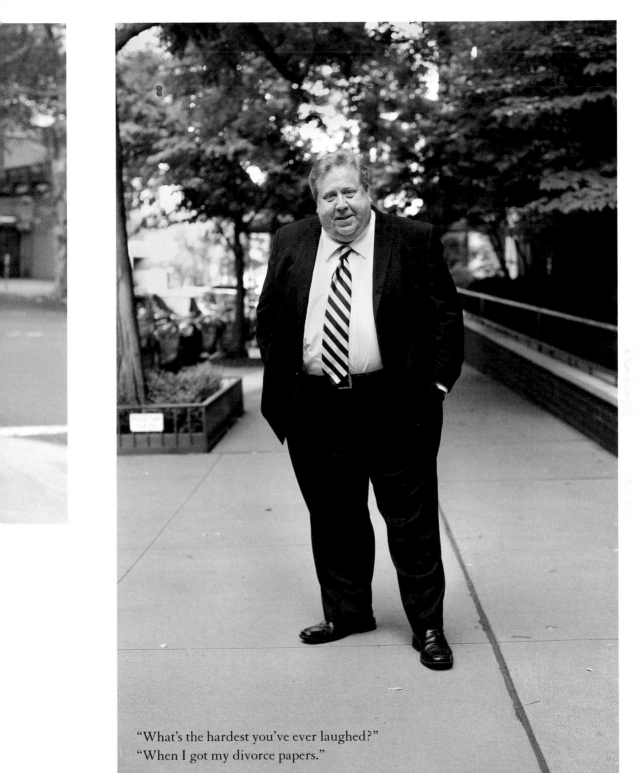

"What's the hardest you've ever laughed?"
"When I got my divorce papers."

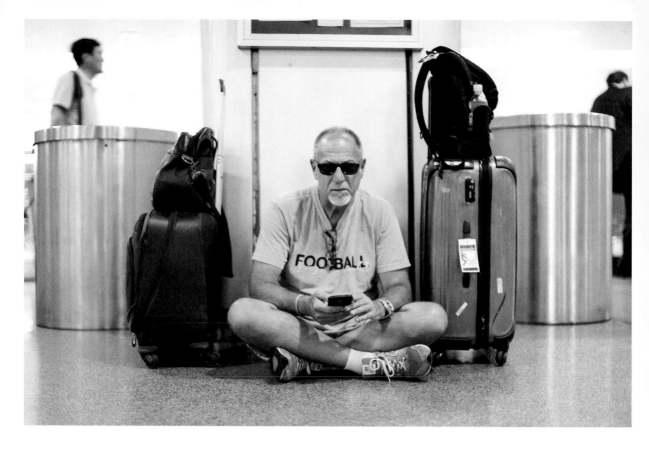

"We're getting divorced because we love each other, and we both realize that we don't have enough of what the other needs. When we decided to get divorced, I wrote a note with all the things I loved about her and gave it to her. She got very emotional and started crying. Then three days later, she wrote me a similar note. But here's the thing—she wrote it on the back of a recycled piece of paper. She wrote it on the back of an advertisement or something. So I called her out on it. And she said: 'I knew you were going to bring that up. If you cared, you wouldn't mind what it was written on.' And I said: 'Well, if you cared, you'd have gotten a fresh piece of paper.' "

"It's hard to adjust. You're reading a story to your daughters every night, then the next thing you know, you're only doing it once or twice a week. It's been hard letting go. It all happened without my consent. It only takes one person to want a divorce. And that person wasn't me."

"When I filed for divorce, she took my son and checked into a domestic violence shelter. When a woman checks into a domestic violence shelter, nobody asks questions. So she hijacked the system and turned it completely against me. She got an order of protection against me, so I was completely cut off from my son. She got free legal help. Eventually a court-appointed forensic psychologist determined that it had all been a lie, and I got full custody. But it was the most hellish five months of my life. Everyone believed her. People stopped saying hello to me on the street."

"I'm a little bit separated with my wife right now."

"I was in prison for thirty-seven years for doing
 something I shouldn't have done."
"What was that?"
"Someone pushed me. So I killed him."

"We started as friends, then it escalated. Then recently it became:
'I need time' and 'I need space.' I didn't want her to get away
with breaking up over text, so I asked to meet. She's on her way
to meet me now."
"What are you hoping to get out of the conversation?"
"Honestly? Part of me wants her to say it to my face so she'll have
to hurt as much as I do."

"I got pregnant when I was nineteen. We decided to wait on
getting married until we could afford a wedding. Just because
we had an unconventional baby, it doesn't mean that I don't
deserve a traditional wedding. I'm waiting on my fancy little
ring, and I want to wear my mama's dress down the aisle."

"Why are you wearing a pilot's outfit?"

"I wear it every day."

"Do you want to be a pilot when you grow up?"

"No, I want to be a teacher."

"Why aren't you wearing a teacher's outfit?"

"I don't have one."

"I'm the original John Lennon! I was born eighteen months earlier."

"There was a long period when I was pretty directionless,
and she always had a way of putting a positive spin
on things. Whenever I got down on myself, she could
convince me that I was working for assholes and everyone
else was an idiot."

"Sometimes it's hard not to fall in love with your friends."

"I think I may be a disappointment to my family."

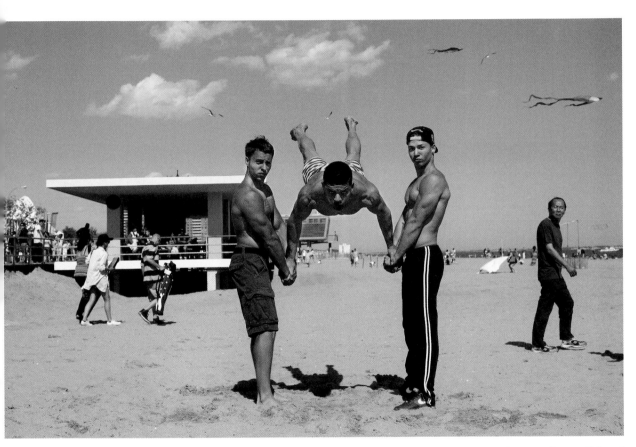

Seen at Coney Island

"Before I entered seminary, I fell in love with God. A few months into seminary, I fell in love with philosophy. Two years into seminary, I fell in love with a girl."

"I cured myself of schizophrenia."
"How'd you do that?"
"I stopped listening to the voices."

"My sister taught me how to ask for money from my parents.
First you give them a compliment. Then you talk about your day.
Then you tell them about your grades. Then you ask for money."

"I cried the first time I did heroin. I'd never wanted to do it. I always spoke out against it. But I was 245 pounds at the time, and I was with the first guy who had ever showed any interest in me. So I did it to feel accepted. Now I'm always waiting for my next fix. Even when I manage to get clean, the demon is always on my back. I always thought I was too smart to be an addict. And I am smart. I sing, I write poetry. There was so much I could have done. And I cry every day of my life. Because I'm too smart for this to have happened to me."

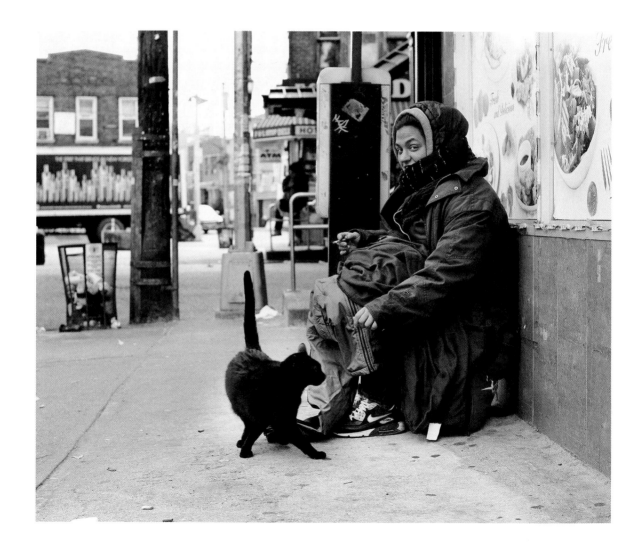

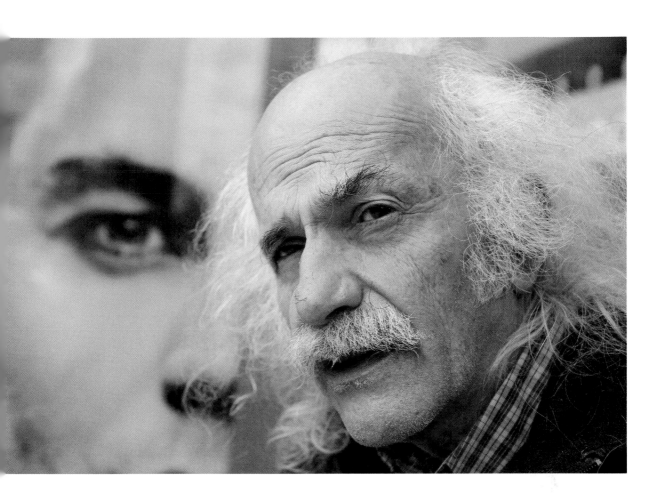

"What do you feel most guilty about?"
"All the people I drifted away from."

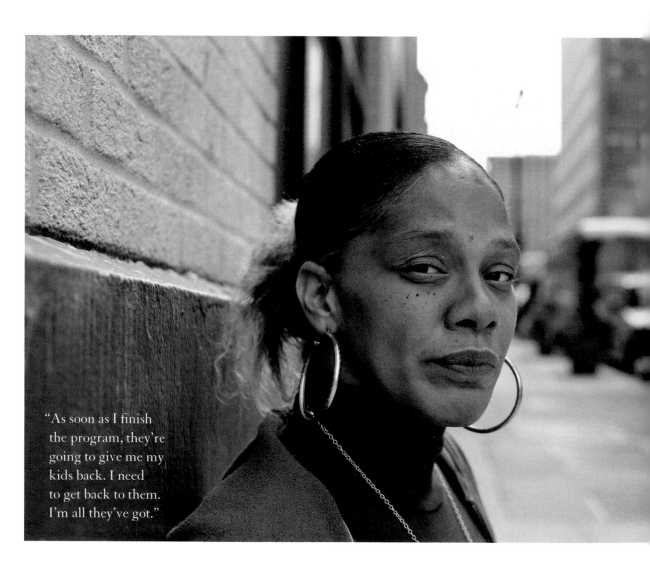

"As soon as I finish the program, they're going to give me my kids back. I need to get back to them. I'm all they've got."

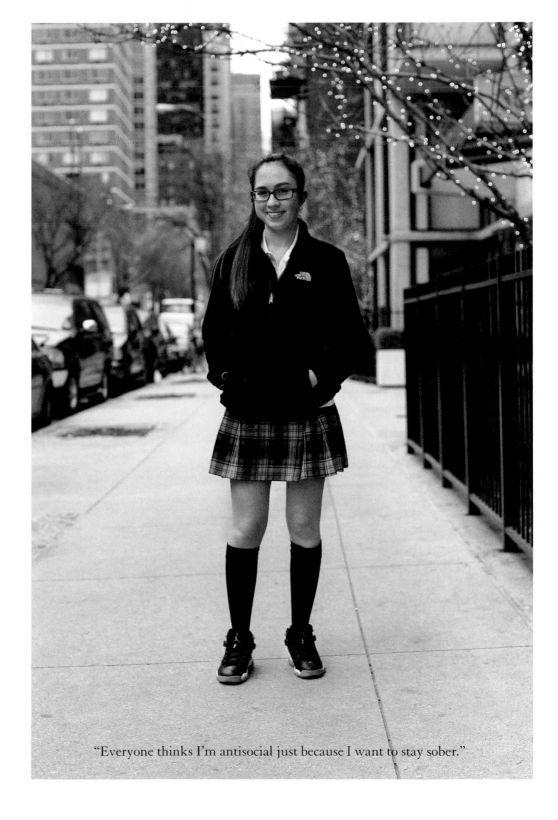

"Everyone thinks I'm antisocial just because I want to stay sober."

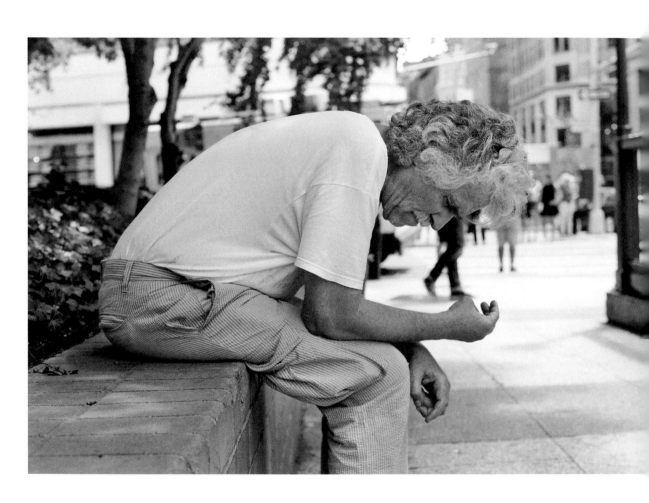

"I don't want to live anymore."

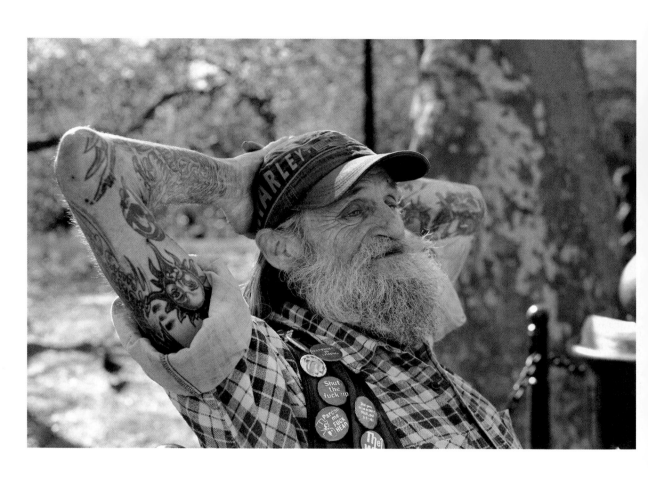

"I'm happier than a pig in shit."

"Should I do my
 dinosaur face?"
"Yes."

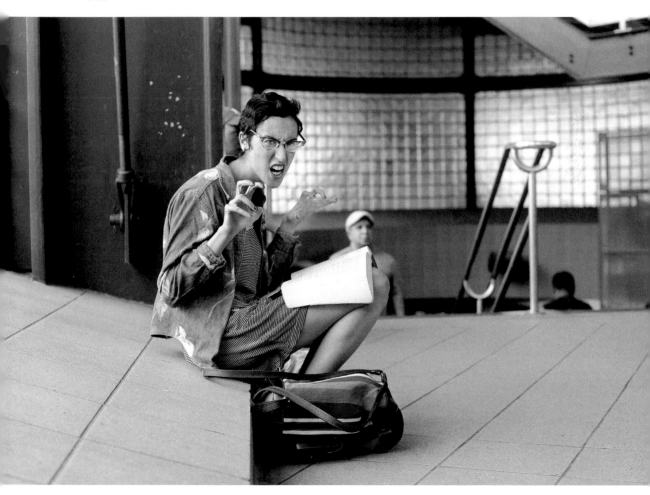

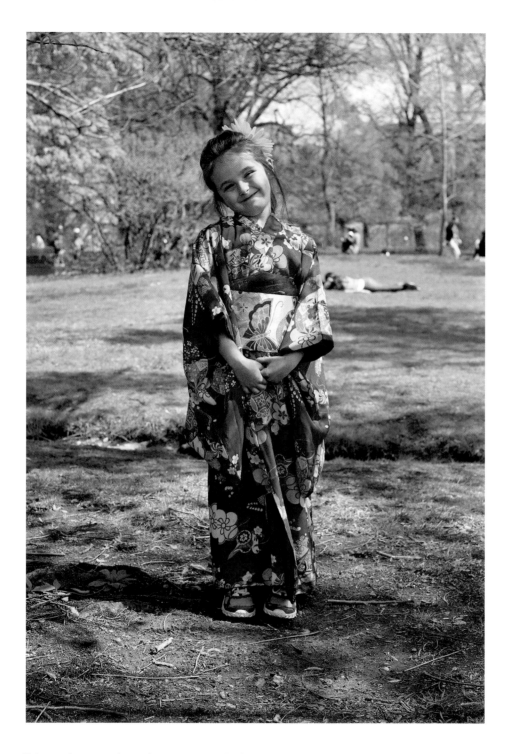

"Two other people took my picture before you, so I was already popular."

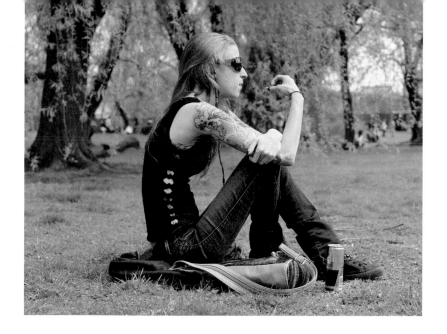

"So much of who I am
is because of Dr. Seuss."

"You have to be really
focused and find a rock
that is big but not too
big and you lift it up
and if there's not any
bugs you put it back
down. But if there is a
bug and you like it, you
put it in your bug jar.
But if you don't like it,
you put it back and put
the rock back down.
I found a ladybug, a
beetle, and a little tiny
bug that I don't know."

"My dad is fixated on the thought that I'm becoming my mom. They separated when I was two because she was such a bad alcoholic. My dad got custody of me, and my mom moved back to Africa. I didn't talk to her much, but I visited her for a month when I was eight, and there were times when she'd get really drunk and pull my hair and beg me to tell her I loved her. A few months after I went back home, she fell off a boat and drowned. My dad and I were very close when I was growing up. But now that I'm in high school, he restricts me a lot. He takes my phone away. My curfew is earlier than everyone else. He's convinced that I have the wrong friends and they are bringing me down. I just think I'm being a teenager, but he's convinced that I'm in some sort of downward spiral. He tells me that one day I will thank him."

"There's a lot of competition out here."

"I'm always checking the Wikipedia pages of
my idols to see where they were at my age."

"I try to spew my thoughts for ten minutes every day."

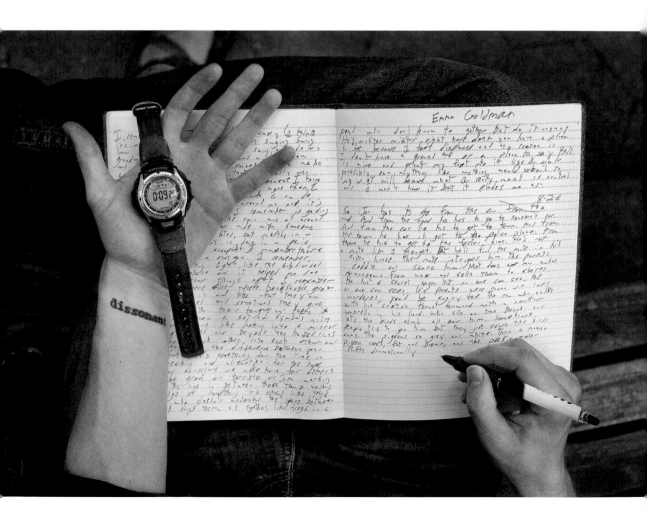

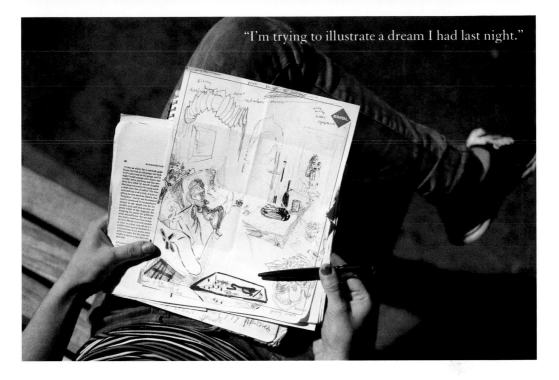

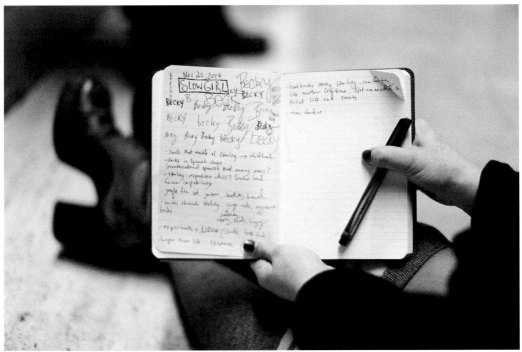

"I'm terrible at journaling. But I do it anyway, because I think that maybe one day I'll write something that I didn't know before, and suddenly it will all make sense."

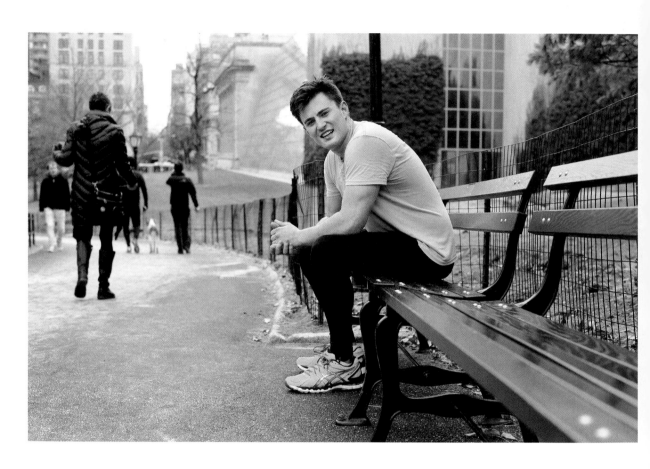

"I had an interview at Goldman Sachs. It was a total wipeout. It was really friendly for the first six hours, and I thought I was doing great. Then right at the end, when my brain was turning to mush, they brought in a math mastermind who crushed me."

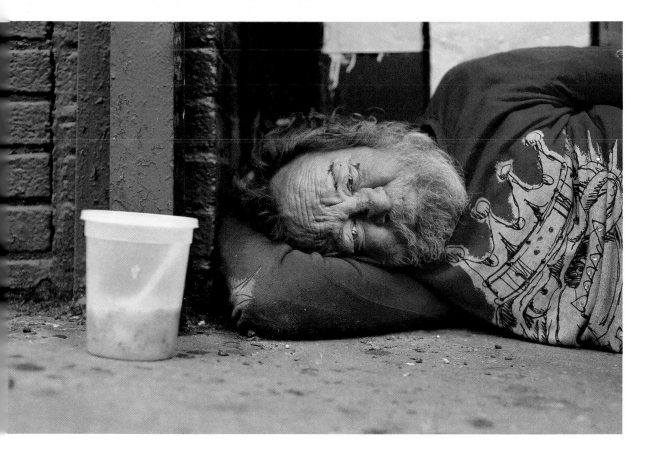

I asked him to tell me the saddest moment of his life, and he said: "I lost my children in a car accident. I was walking the four of them to school, and this truck—this asshole—hopped the curb and he killed my children. Only Naomi lived. Darrell, Joshua, and Jessica died. He killed my children." He started crying halfway through the story, and by the end he was crying quite hard. He was trembling. "I relive it every day," he said. "Why do you think I'm such a drunk?"

Later in the day I passed him again.

"Do I know you?" he asked.

"We just spoke," I told him. "You told me about Naomi, and Darrell, and Joshua, and Jessica." He began to get emotional again.

"I think about them every day," he said.

"Where are they now?" I asked.

"They all live in Los Angeles," he said.

"What about the car accident?" I asked.

"What car accident?" he said.

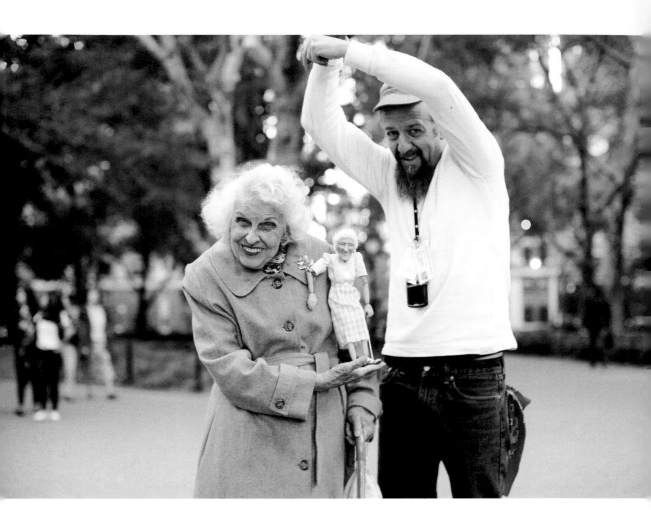

"Whenever I did a show in the park, Doris would come over and watch for a bit. Then one day, she came up to me, and without having ever spoken to me, handed me a clipping of an article that she'd found about me in *The Villager*. I thought that was the nicest thing. So I took a photo with her, printed it out, and gave it to her the next day. Then the day after that, she brings me another set of articles about marionettes. At this point, I'd really started to fall for her. So I thought: 'Doris keeps one-upping me. So I've got to do something really, really nice for her.'"

"Young children are in direct contact with reality. They experience the world through their senses. But as people grow older, we start thinking too much, and we form an 'idea of reality.' We lose contact with reality itself, because reality isn't an idea . . . it's reality. Luckily there's LSD."

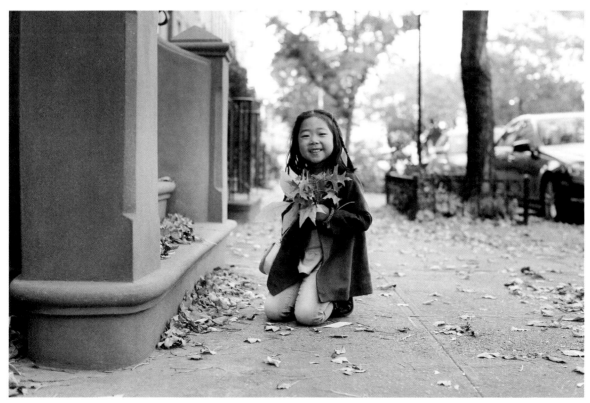

"I'm bringing leaves to my friend!"

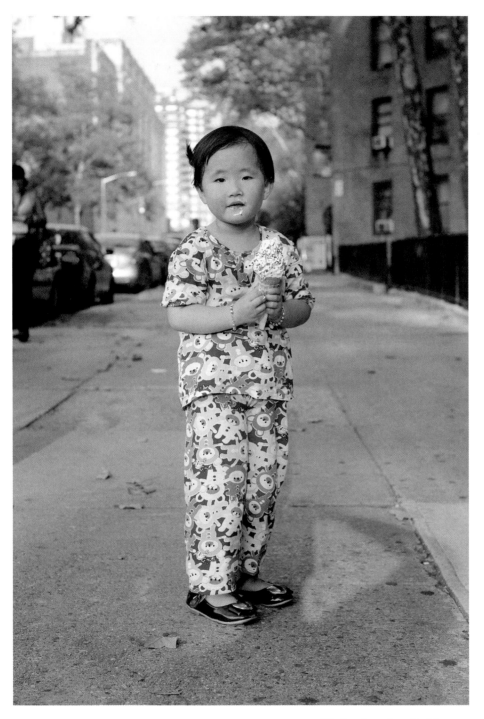

Today in microfashion . . .

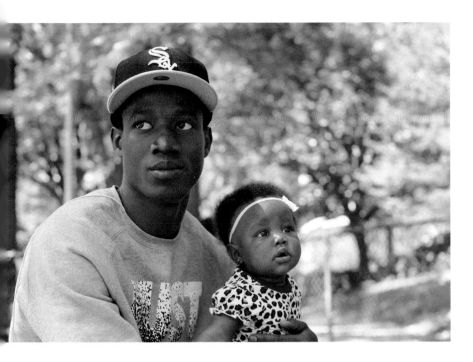

"I'm glad I had a daughter. Ever since my grandmother died, I've needed the female energy in my life. It's good energy. I mean, when things go wrong, another man can tell you that everything is going to be okay. But not like a woman can."

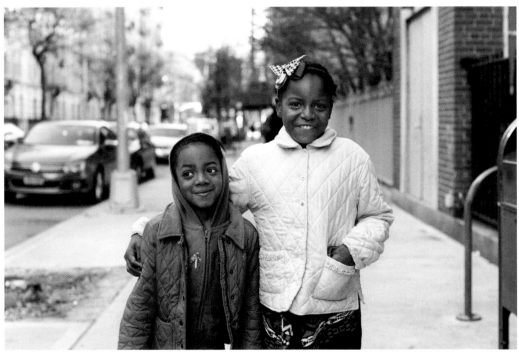

"She helps me with my math homework. When I run out of fingers to count on, she lets me use her fingers, too."

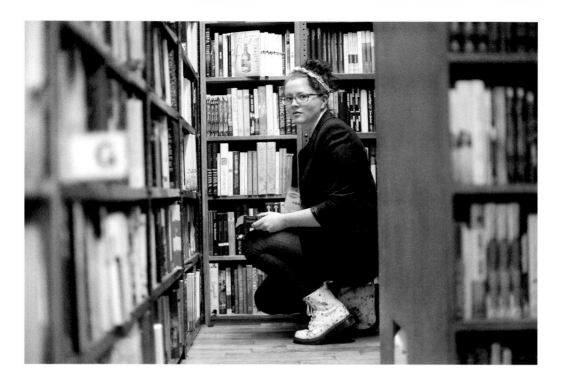

"I'm trying to
figure out what
my dreams are."

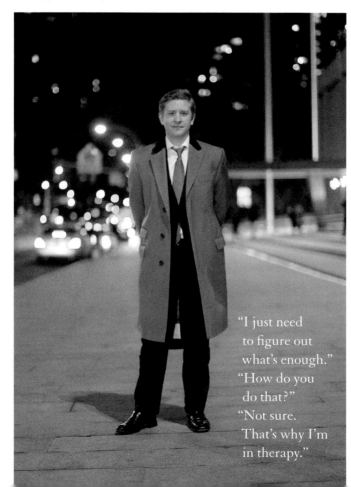

"I just need
to figure out
what's enough."
"How do you
do that?"
"Not sure.
That's why I'm
in therapy."

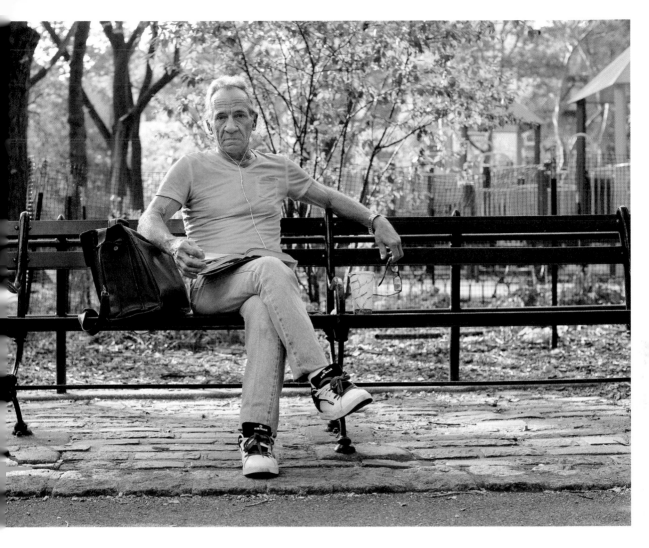

"If you could give one piece of advice to a large group of people, what would it be?"

"Try your best to deal with life without medicating yourself."

"You mean drugs?"

"I mean drugs, food, shopping, money, whatever. I ain't judging anybody, either. I was hooked on heroin for years. But now I've learned that every feeling will pass if you give it time. And if you learn to deal with your feelings, they'll pass by faster each time. So don't rush to cover them up by medicating them. You've got to deal with them."

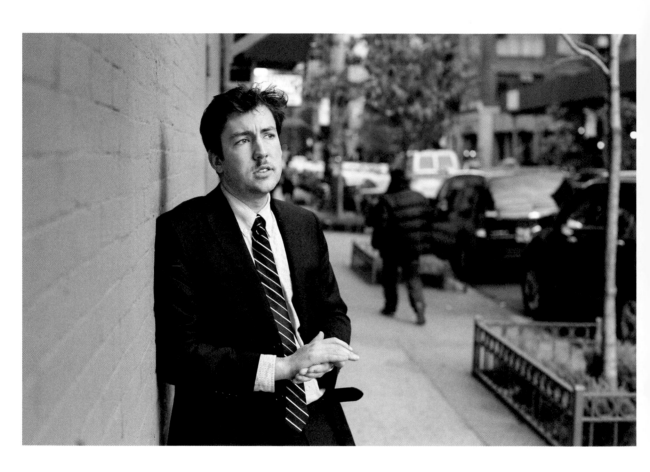

"It was a low point in my life. I'd gotten pretty heavy into drugs, and I'd recently had an overdose on acid and ecstasy. I felt like I'd disintegrated as a person. I didn't know who I was. One day I'd feel like this person, and the next day I'd feel like a different person. So one day when I was feeling especially low, I took a long walk from 137th Street to 34th Street. On the way back I stopped in a church on 122nd, and I just sat there for a long time, and I found God."

"He's not as adventurous as I am. He really enjoys his
routine. But if I ever want to try something new, like
this, he'll dress up and carry the picnic basket."

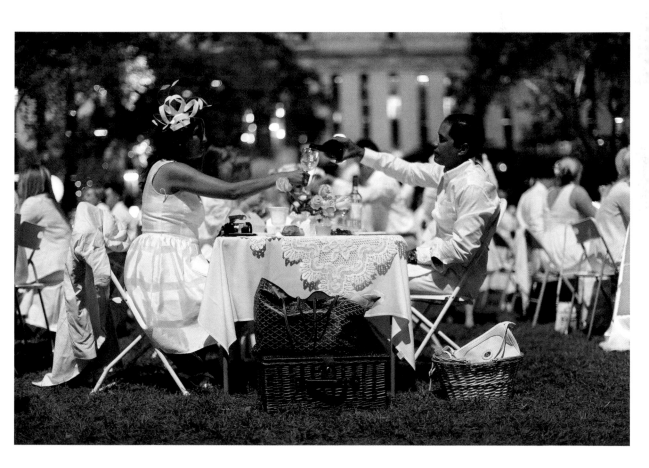

"I want to be a lawyer. But just a defense lawyer. Because I'm much better at defending people than I am at accusing people. But I'd only want to defend kind people. You can tell if someone is kind by their aura. Plus, I'm smart. I know so many math facts. Ask me any math fact. Try multiplication!"

"Here's a hard one. What's five times sixteen?"

"That is well within my skills. Eighty. Do you want a strategy for multiplying double-digit numbers? If you want, I can teach you a strategy for multiplying double-digit numbers."

"I have very little little little friends. I had one, but he went to the next grade. To make a friend, you have to talk to them, which can be very hard. Most of the time, when I try to talk to them, I fail. Everyone thinks I'm a geek."

"Louis is different. He's got two moms. He's an old soul. We live in the projects, and he doesn't know who Michael Jordan is, or anything about rap music. He dresses himself in the morning. He chooses a button-down and slacks, and sits in the kitchen with his legs crossed and reads the newspaper. But he's still got the heart of a child. Yesterday he had five dollars to buy himself a Halloween costume, and he saw a boy he knew while he was walking to the store, and he chose to buy him a costume instead. I always tell him: 'You're different, Louis. And that's okay.' When he wants to play, I walk him all the way down to Central Park, because I don't really want him to change."

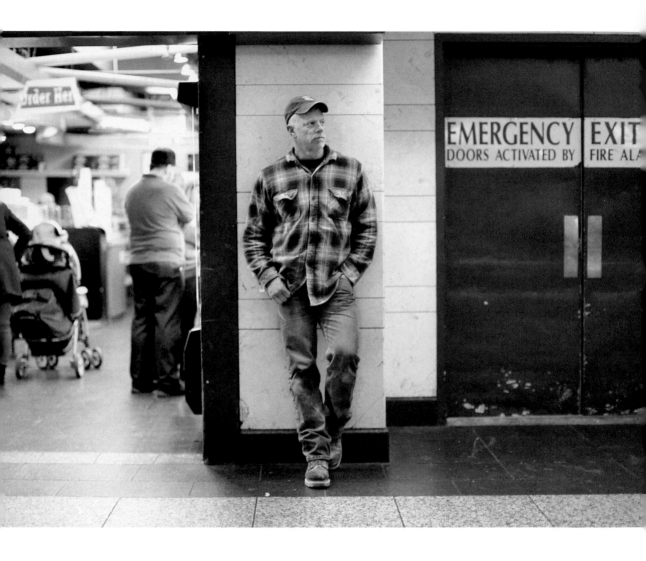

"I've been a union ironworker for thirty-four years. One year until retirement. I've worked on the World Trade Center, Citi Field, Museum of Natural History, Trump Tower, Penn Station. My fingerprints are on so many buildings in this city, it's ridiculous."

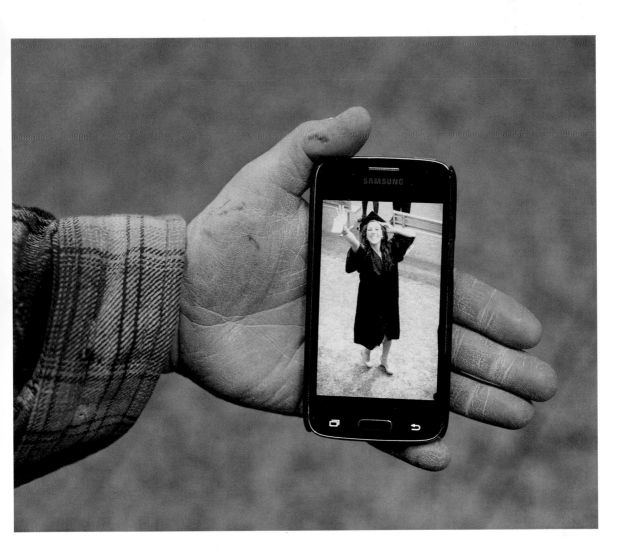

"Never laid a hand on her.
And that was huge for me.
Because it was always the
first thing my dad did."

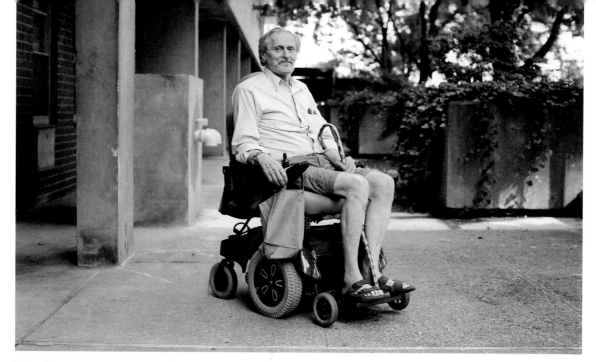

"I'm about to write my autobiography, actually. It's going to be called 'A Life Well Lived and . . . ,' 'A Life Well Lived and . . . ,' 'A Life Well Lived and . . .' Well shit, I forgot."

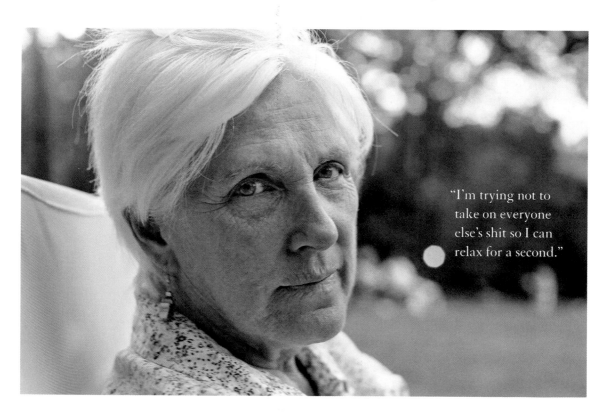

"I'm trying not to take on everyone else's shit so I can relax for a second."

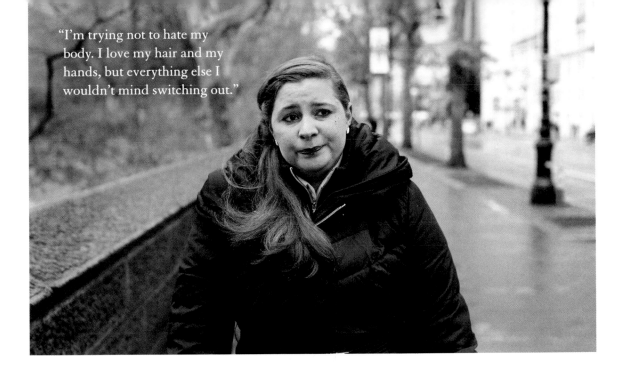

"I'm trying not to hate my body. I love my hair and my hands, but everything else I wouldn't mind switching out."

"If everyone in the room believes the same thing, I get worried."

"Nobody came to my tenth birthday party. I have a very vivid memory
of helping my mother set the table, then watching through the window
as the sun slowly set, before finally realizing that nobody was coming.
That moment pretty much set the themes for the rest of my life."

"Do you remember the greatest day you've ever spent together?"
"I'd say Christmas Eve in Kabul when we drank that bottle of
 champagne at the French restaurant, and you got drunk for the
 first time."
"I was going to say the time we were in South Africa during
 the World Cup and we went on that safari in the park near
 Botswana, and we came up on an oasis and every type of animal
 was there at the exact same time."

"We were dating for three or four years, off and on. I decided that I didn't want a serious relationship, but every time I tried to break up with her, she'd threaten to kill herself. Like if I didn't answer her text messages for a few days, she'd send me a video of her swallowing a bunch of pills, then later she'd tell me that she threw them all up. I was at a business meeting one night—it turned out to be a pyramid scheme, but I didn't know it at the time—and she started sending me text messages again, saying she was going to hurt herself. It was like the fifth time she'd done it, so I didn't even answer. That night she hung herself with a dog leash."

"What's your sister's best quality?"
"What does 'quality' mean?"
"What's the best part of her personality?"
"She doesn't really have a personality yet."

"My wife is much more of an intellectual than I am. She actually had one of her friends read a verse from *The Odyssey* at our wedding. I prefer comic books. I think it bugged her at first. I never wanted to read the same books as her, and I wasn't as well spoken, and she'd always correct me when I used double negatives. But I think she came to appreciate that I'm wise in other ways. I think I'm better at reading people, for example. So now she just does her intellectual stuff without me. I'll cook breakfast in the morning while she goes to the coffee shop and annotates James Joyce. I'm serious. She does it every morning."

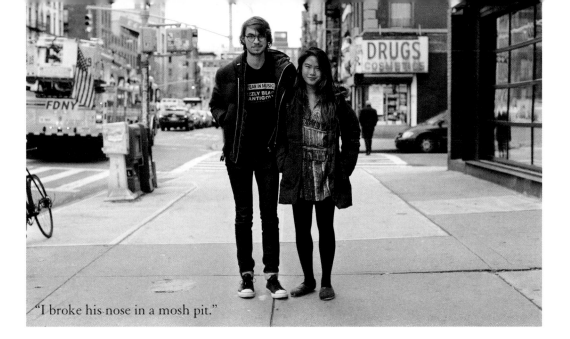

"I broke his nose in a mosh pit."

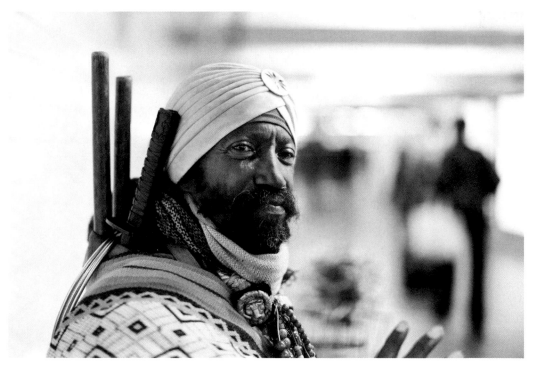

"I've got an idea for an exercise machine that's going to smoke the whole exercise machine market. It's called the Super Flow Flex 360 Infinity. It synchronizes you and lines up all your molecules to propel you into an inner dimension. It will literally take you out of this world. I've even got a slogan: 'Super Flow Flex, Better Than Sex.'"

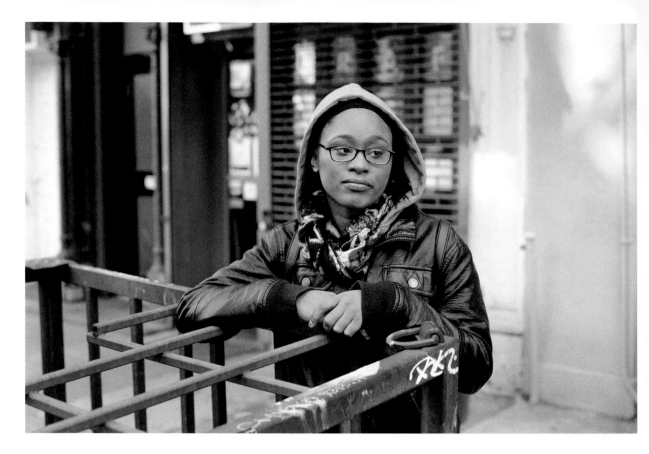

"I turned out okay because of the people in foster care who didn't go
anywhere when I tried to push them away."

"Anyone in particular?"

"There were a lot. But there was a counselor at one of my group homes
named Jenelle Bugue. And when I woke up crying at 3 A.M. because I
felt like nobody loved me, she would sit with me and tell me that she
cared about me, and she wasn't going anywhere. And she'd tell me that
God cared about me, and that God wasn't going anywhere."

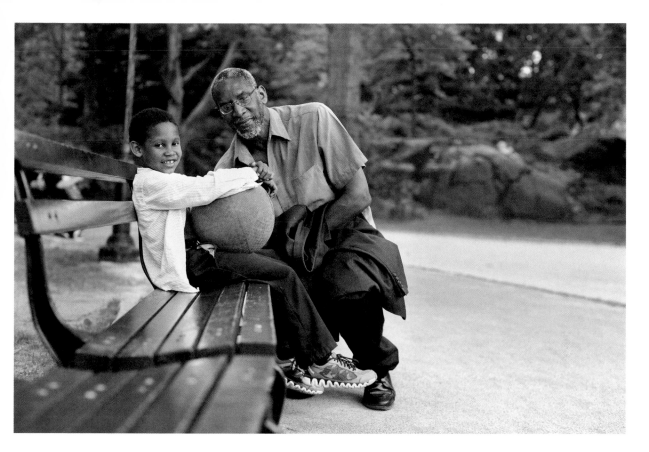

"His grandmother and I are raising him. I worry about putting him into the public school system. I was a teacher for many years. I've seen so much confidence destroyed by the standardized system. Every human is born with natural curiosity. I've never seen a child who wasn't inspired. But once you force someone to do anything, the inspired person is killed. I dropped out of school myself in seventh grade. So I know. I taught a GED course for years, so I've seen the end results over and over. I've seen so many kids who have complexes and insecurities because they were forced to do something they weren't ready to do, and then they were blamed when they weren't able to do it. What we call 'education' today is not organic. You can't take something as complex as the human mind, compartmentalize it, and regiment its development so strictly."

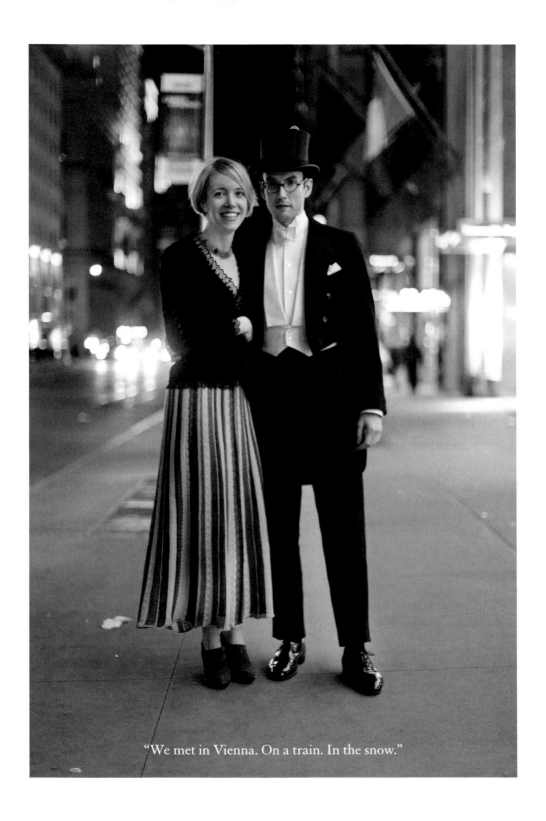

"We met in Vienna. On a train. In the snow."

"I've watched a lot of people who did worse than me in art school go on to have their own shows, and I've decided that some people just know how to make moves. I always hoped that after I graduated, someone would discover me, but it doesn't really work that way. You have to network and create opportunities, but I'm not good at that because I get nervous and overly quiet in social situations. I normally end up getting discouraged, and going back to my basement to paint."

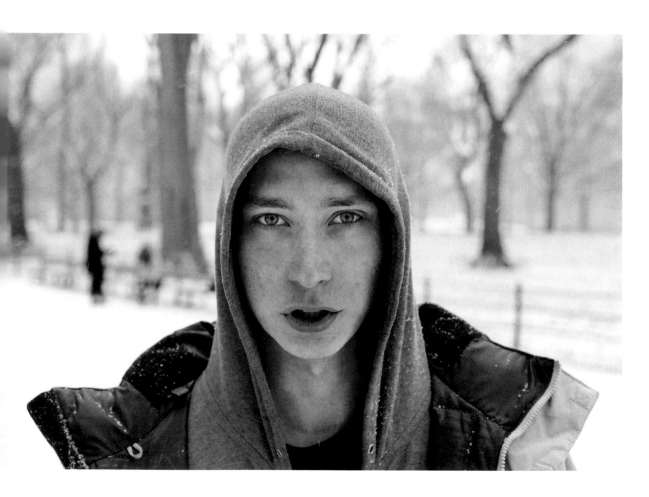

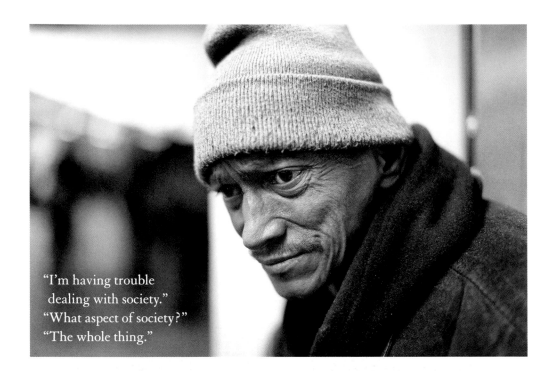

"I'm having trouble
 dealing with society."
"What aspect of society?"
"The whole thing."

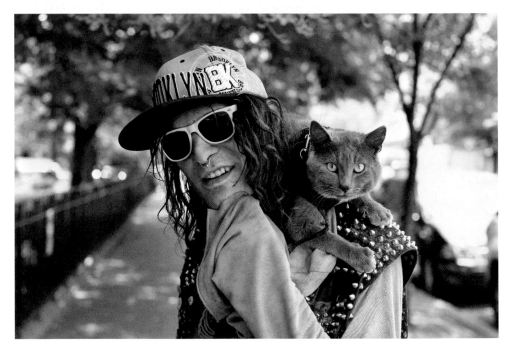

"I found him in the trash. I named him Shadow
because he followed me everywhere."

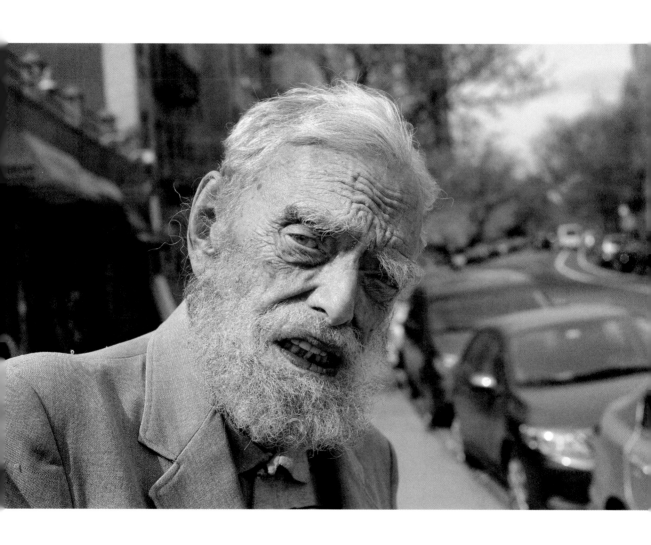

"You're not finding out a thing about me!"

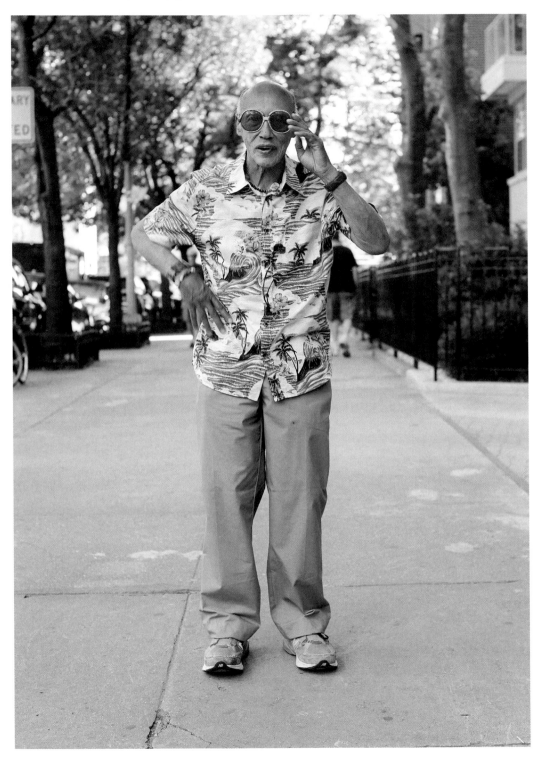

"The women love my glasses."

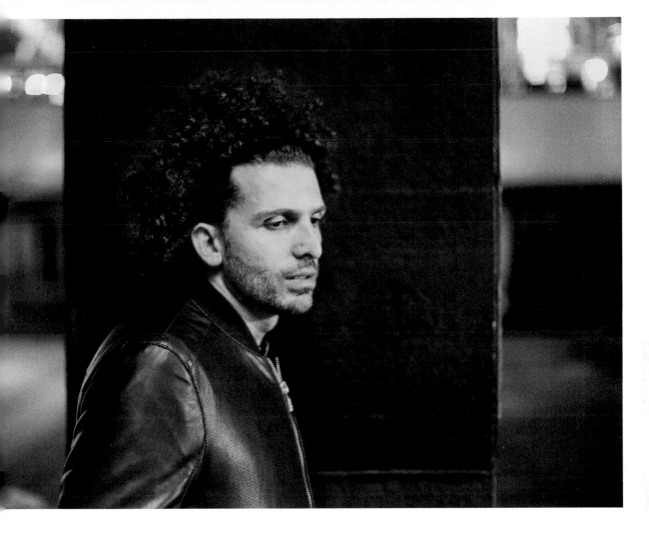

"She was young and healthy and we were very relaxed about the birth. We were even discussing having a natural birth at home. Then one evening, shortly before she was due, we were eating at a restaurant and we got a call from the doctor. He told us, 'Marwa's platelet count is very low. You need to pack a change of clothes and come to the hospital immediately.' We went to the hospital right away, and they put her in the bed and hooked her up to all these machines. Nobody seemed worried. Even the doctors didn't seem worried. But then Marwa said to me: 'If something happens to me, take care of our daughter.' And I burst into tears. 'Don't say that!' I told her. 'Why would you say that?'"

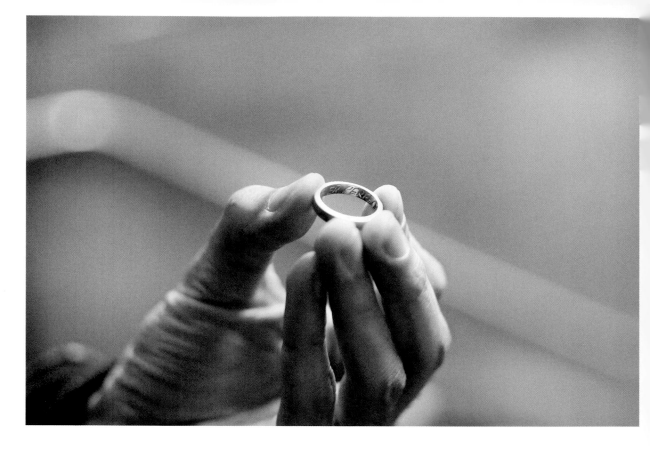

"I still wear my ring. I never thought I'd get married. Before I met her, I'd always been about non-attachment and freedom. We only had a short time together, but during that time, all I thought about was how to make her smile. I felt like I belonged. It was a 'finally home' sort of feeling—that sort of thing. I proposed in Amsterdam. I arrived before her, and spent all day looking at parks, and I found the perfect spot right before dark. So the next day we got on a tandem bike, and I'd mapped out a route all through the city, and it ended at that spot. And right before I proposed, we saw a boat moored in a nearby pond, and on the back was painted: 'Another Perfect Day.' So we engraved those words on our rings."

"The birth went fine. Teela was born early so they took her and put her behind glass under a blue light. For the next few days, I went back and forth between Marwa's room and the room where Teela was under the blue light. Eventually Marwa got better to the point where she could sit in a wheelchair, so I pushed her down the hall so she could meet our daughter. We all took a picture together. Later that afternoon we were preparing Marwa for a CT scan, and her sister was helping to take out her hair extensions. Suddenly Marwa sat up really fast, and she looked so scared, like she'd seen a ghost. She fell toward me and I took her in my arms and she started having a seizure. The doctors pulled me away and I started fighting with them, but they wheeled Marwa away to the ICU. They told me it would be fine, and I could go home, but I slept in the waiting room, and that night the doctor called my cell phone and said, 'Come now.' When I got to the ICU, they told me, 'We lost her for a bit, and if she comes back now, we don't know how much of her will come back.' It didn't feel real. It was like the movies. I was standing right over her and her heart rate monitor would go flat, and these two huge men would start hammering her in the chest, and she was so tiny, and her heart would beat for a couple more minutes and then it would go flat again. And then I heard the doctor say, 'Let's give it one last try.' And then I heard the doctor say, 'Time of death.' And then he turned to me and said, 'We'll leave you here. Take all the time you need.' And when they left me alone, I was like a madman. I didn't know what to do. I started taking photos of her hands, and her feet, and I cut off bits of her hair. And when I walked out of the room I felt so empty. Like I was nothing."

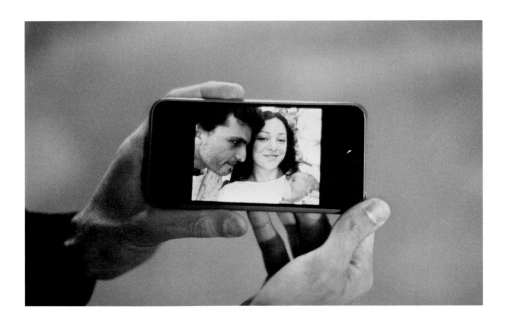

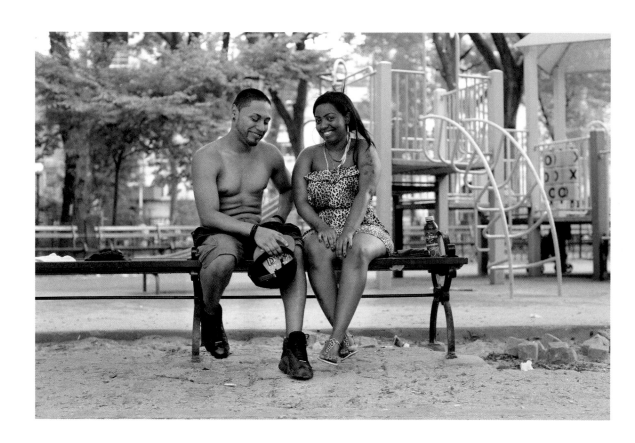

"We're working through some things."
"What kind of things?"
"Little things."
"What kind of little things?"
"Like when your girlfriend calls during the fourth
 quarter of a football game, and you say that you're
 gonna call back when the game is over, you can't
 forget to call back when the game is over."

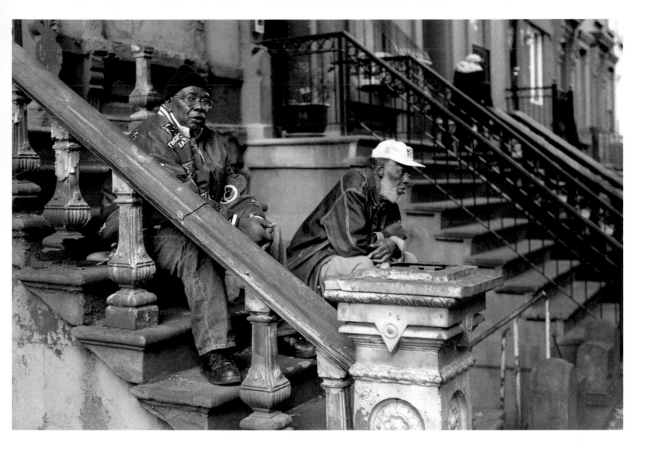

"There are two books in America: one for the poor and one for the rich. The poor person does a crime and gets forty years. A rich person gets a slap on the wrist for the same crime. They say that the poor person doesn't want to work and the poor person just wants a handout. Well, I picked cotton until I was thirteen, left Alabama, and got my education on the streets of New York. I drove a long-distance truck all my life and never once drew welfare, never once took food stamps, either. I sent four kids to college. But they say all poor people do is sit around with a quart of beer. Look in this bag next to me. I've got three things in this bag next to me: a Red Bull, a Pepsi, and Drāno, because my drain is clogged. But you see, even if I do everything right, I still have to play by the poor book."

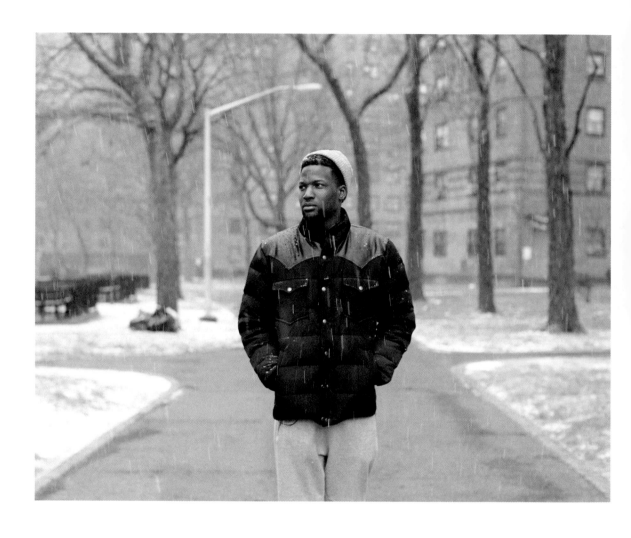

"I went to high school in a much nicer neighborhood. I played on the basketball team and we went to the state championship, so everyone treated me like a king. I never wanted to tell them where I lived."

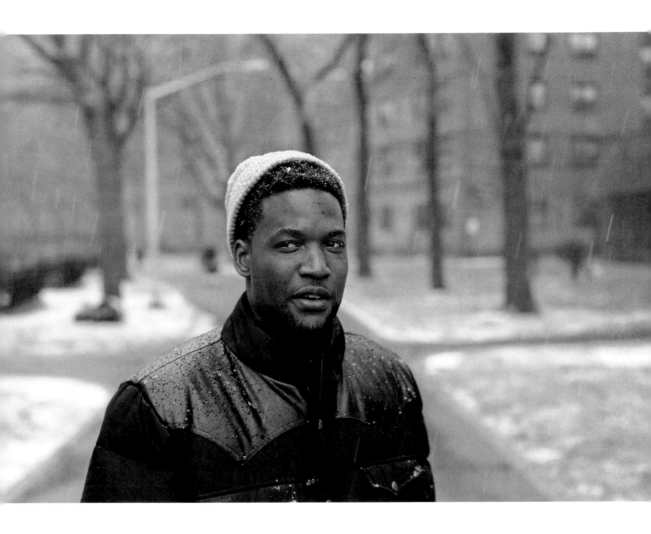

"I want to be a cop, but I don't share that very often with people in my neighborhood. I don't want them to look at me differently. The police around here seem to work under the assumption that you're a criminal. You get asked for your ID in front of your own building. You get asked where you're going. You get asked if you have drugs. You tell them the truth, but it gets misconstrued, like you're trying to cover something up, and they ask if they can search you. When I went to school in Riverdale, I got to see how differently the police acted there. If they see you walking, it's like: 'Oh. He's just a kid from the neighborhood.' "

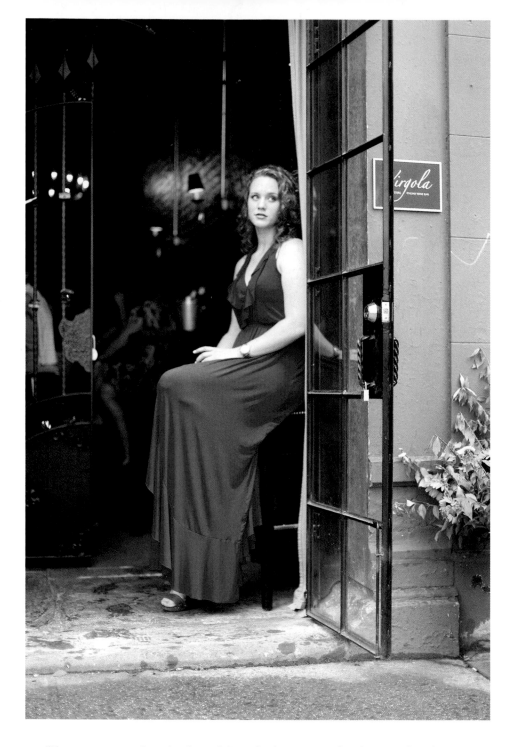

"I'm an actor, a plus-sized model, and a boxer. But for the next four hours I'm a hostess. Because I need a hundred dollars."

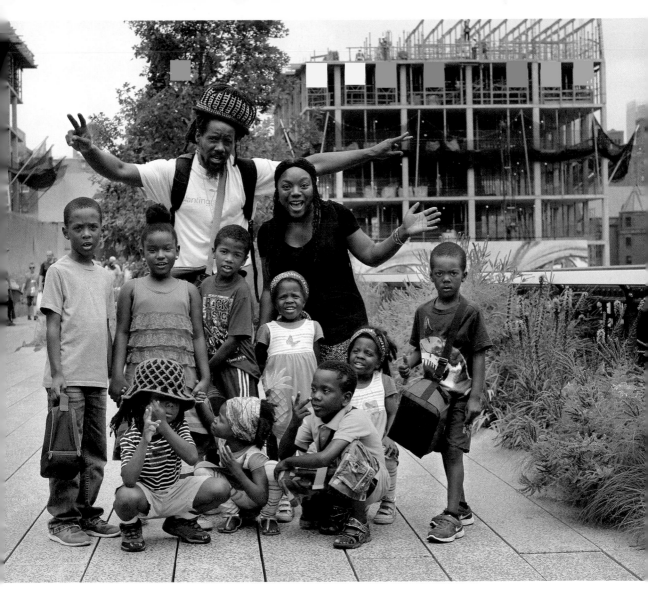

"We're the Eco Adventure Club! Every day we go on an adventure to learn about plants and animals in the city. Today is our eleventh adventure. We've been to Prospect Park, the Botanical Gardens, and today we're learning to use maps on the High Line. We're even growing our own garden. Everybody say, 'Raaassstttaaaffaaarriii!'"

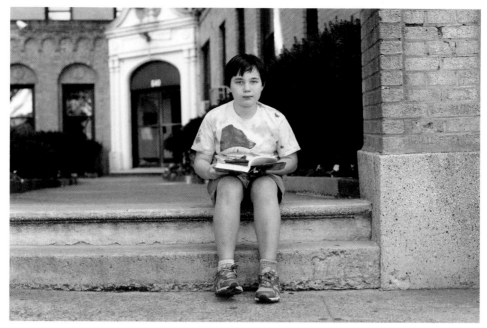

"What's your greatest fear?"

"Getting a lobotomy."

"This morning he asked me if he was still not allowed to say, 'What the fuck?'"

"This is my neighbor. She only speaks Mandarin, so we've never had a conversation. But she's brought me a handful of candy every day for twenty years."

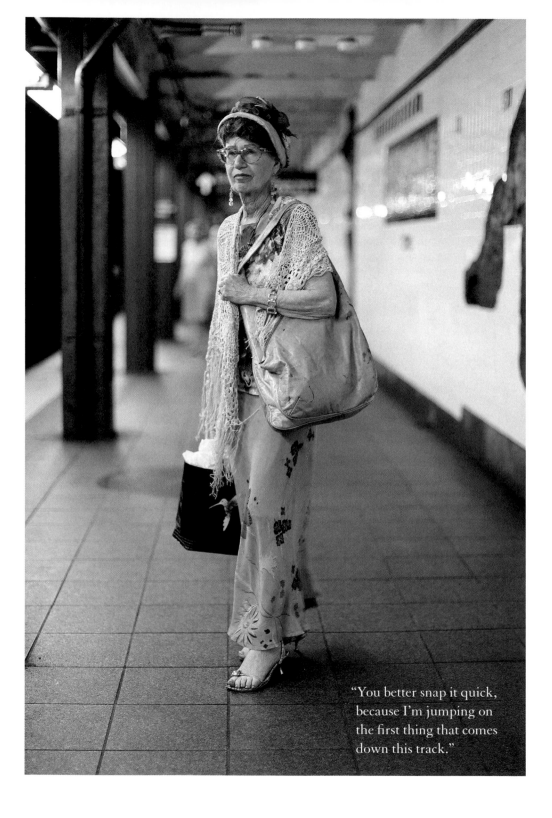

"You better snap it quick, because I'm jumping on the first thing that comes down this track."

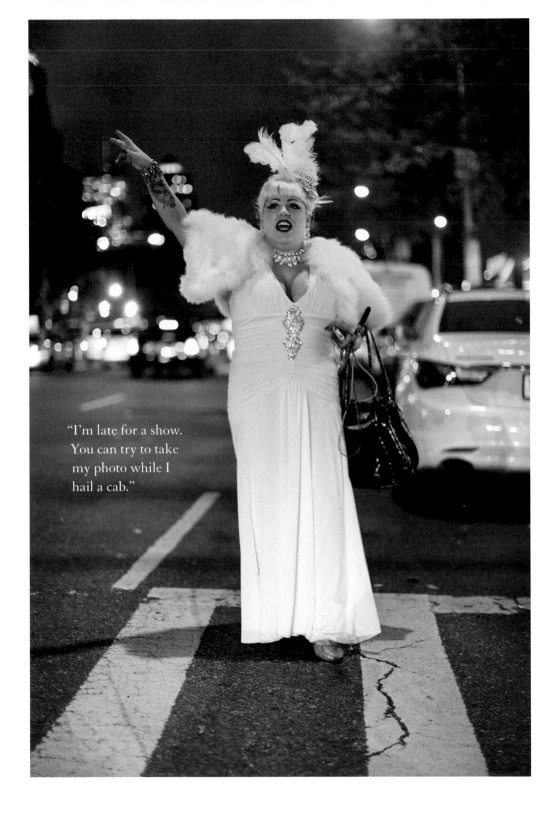

"I'm late for a show. You can try to take my photo while I hail a cab."

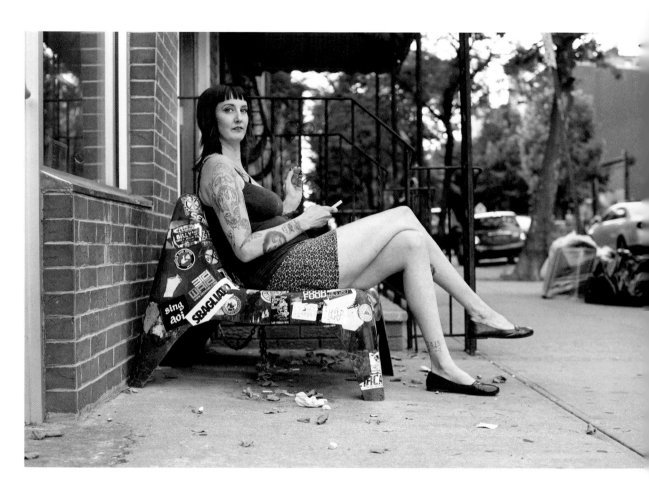

"You think that your children are going to grow up to be a lot like you, but then they develop into a completely different person. Yesterday my seven-year-old son told me that reggae was boring. That hurt a little."

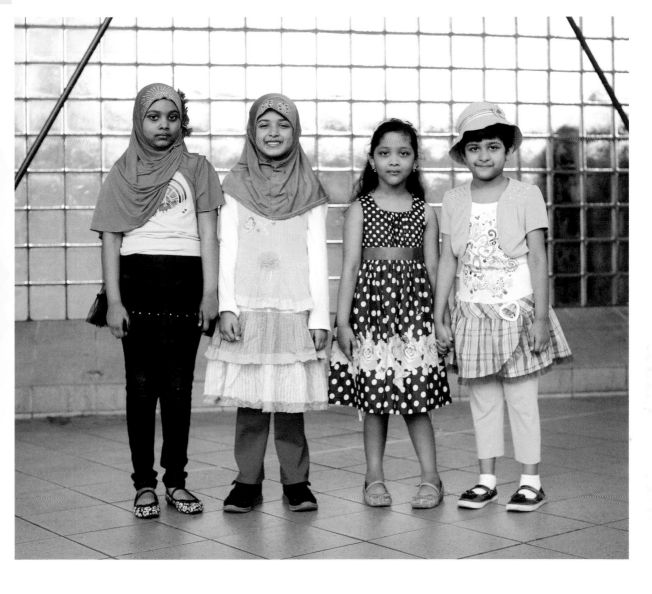

"My dad says I'm going to be a doctor."

"My parents think I'm here with friends. They'd freak out if they knew I was here alone."

"Why did you come to New York alone?"

"Well, I'm not exactly alone. I came here to see a guy. He's . . . fifty-five. I met him on the internet. It's a BDSM thing. Sort of a daddy / daughter thing. He's at work now. He's actually got a wife and two kids. I think I'm using this relationship to try to pull myself out of a dark, dark hole. At the very least, it's the ultimate support system."

"I think it started at an early age. My parents used to joke about how I'd tie up and beat my stuffed animals. They said it was like Disney in bondage. Little did they know how right they were. They're very religious. My father is the son of a missionary. My parents would always do room searches where they'd go through my stuff and take anything they didn't agree with, and break any CDs that they didn't think were Christian. I tried to hide things behind bookshelves. I even tried to create a hole in my wall. But nothing worked. I remember getting in trouble for leaning up against my friend at church. The youth pastor said we were acting like lesbians, and my mom said I was ruining her reputation. I've been on anti-depressants since I was in fourth grade, which is when my parents started taking me to psychiatrists to figure out what was wrong with me."

"I worry about going insane. Ever since I was young, I have periods where my thoughts make no sense and I get very impulsive and I hit things or bang my head against the wall. I just need to feel pain. It's the only thing that pulls me out of my head and calms me down and gives me something to focus on. I think about the number 110 billion a lot. I think that's the number of planets in the universe, or cells in the body, or grains of sand, or people who've ever lived, or one of those things. It makes me realize how unimportant I am. There have been seven times recently where I've had a knife to my wrist and I was trying to get the courage to kill myself."

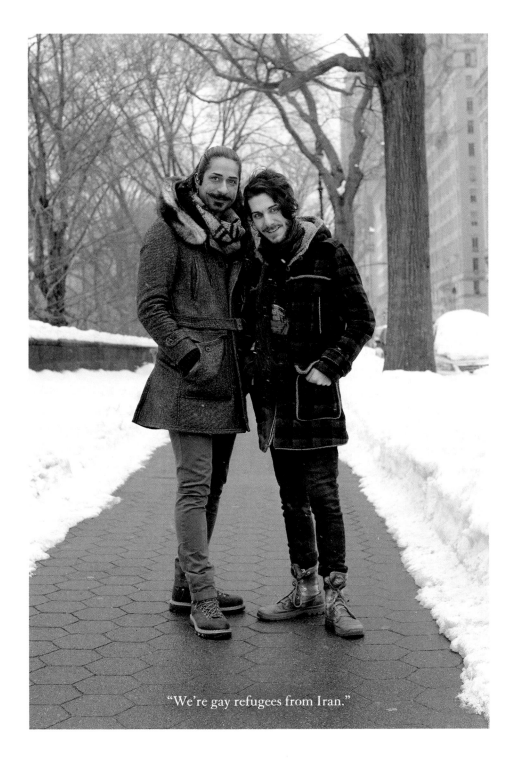

"We're gay refugees from Iran."

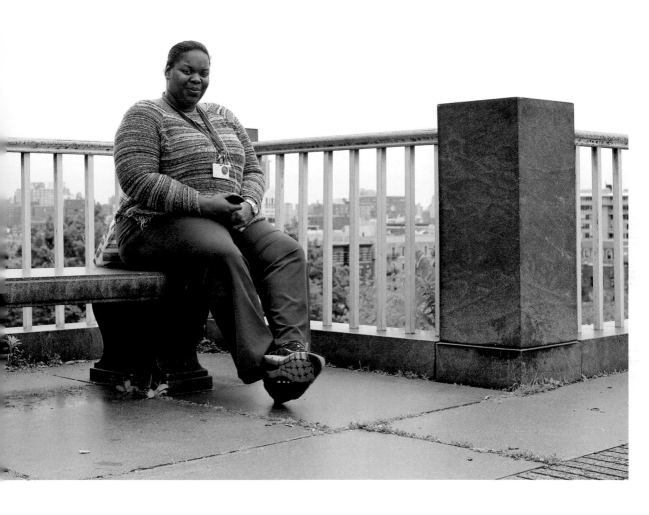

"My mom always left us alone and we never had any food in the house, so I only ate at school. And we never had any electricity. So every night I had to do my homework in the hallway."

"Do you remember the happiest moment of your life?"

"When I got my scholarship to Georgetown."

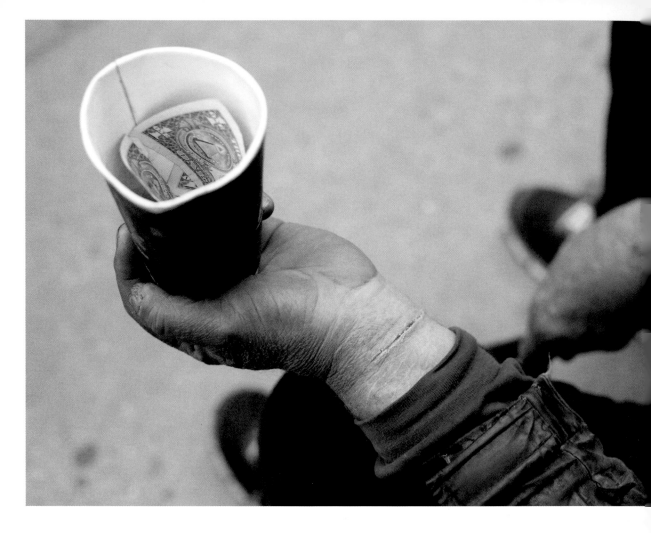

"I had forty acres and a new home out in California. I was working as a stonemason. I could bring in six thousand dollars cash some weeks. Then one night I was walking home and someone tried to kill me. My brain was damaged. I lost my sense of smell, my sense of taste, most of my hearing, and now I can barely stand without getting dizzy. I must have fallen and cracked my head open thirty times since then. Everything I knew has been washed out into the water. I've tried to commit suicide several times."

"What do you want to
be when you grow up?"
"A mom."
"What's going to be
the hardest part about
being a mom?"
"Bath time."

"We met forty-eight years
ago at a Halloween party."
"We were the only two not
wearing costumes."

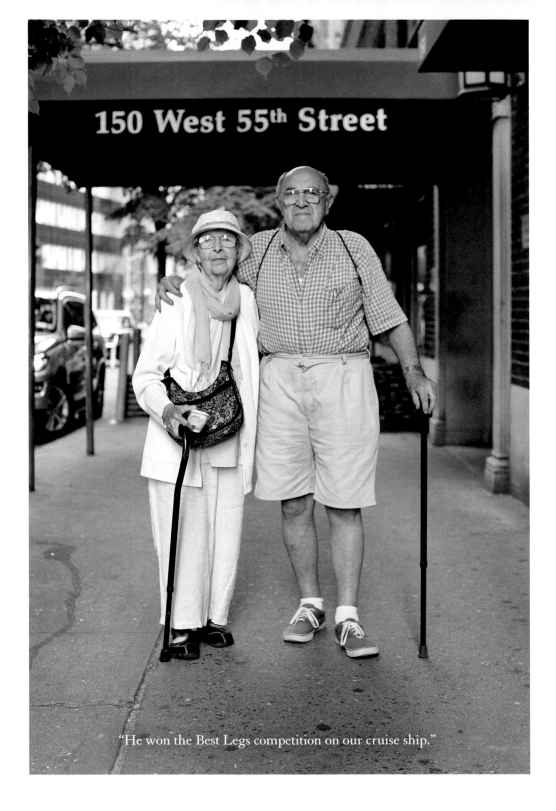

"He won the Best Legs competition on our cruise ship."

"As a dancer, I've always wanted to be an individual and do what comes natural. I've worked really hard every day to find out what works for me and to figure out how to present my strengths. But in the end, there's a certain aesthetic, size, and structure that they want, and you're constantly berated by critiques until you fit that mold. It's hard to not feel like a product."

"I found a mentor once. He was in his thirties, and had a career that I very much admired. I thought if I listened to him, I could be successful, too. He told me that everything I did was wrong—the way I stood, the way I moved, what I wore, even the way I warmed up. I did everything he said. Every time I was on stage, I could hear him chattering in my head, and I felt like I'd lost my own voice. It was like all the work I had done in my personal search had been invalidated."

"My father just isn't nice. He's always saying, 'You're not good enough.' Even when I do good on something, it's always: 'Why didn't you do better?' And he hits us. My sister gets the worst of it. She actually called ACS on him. On his birthday." "Did that get him to stop?" "It got him to stop the physical abuse."

"I see how much I love him, and I imagine that my dad loved me like that one day, and it makes me wish I'd been a better son."

"I've done a lot of whacked-out shit for money."

"In the seventies, I used to work out at this Gold's Gym in California, and one day this wrestling promoter comes in and says: 'I need a black guy, a Chinese guy, and an Indian'—he said Indian, but he meant Native American. I happened to be working out with a black friend and a Chinese friend, so I said: 'We can do it! I can be an Indian!' So we agreed, and he moved us into this empty warehouse to live. Then he gave us six hundred dollars per week to do a bunch of coke and beat the shit out of each other before Roller Girls events."

"I really enjoyed *The Mists of Avalon*, which is a retelling of the
Arthurian legends from the perspective of the female characters."

"Europe in the summer of 1959. I was nineteen. I'd just lost a hundred pounds and had a whole new set of clothes. I toured Paris and Rome and everyone was paying me so much attention. They were even asking for my photograph! Of course, inside I still felt like an awkward, overweight girl. It was all so overwhelming and wonderful!"

"Why'd you go to Europe?"

"To have sex, of course. And I did! I was the first in my whole group of friends. I came home and told everyone that I'd done it with a charming Frenchman. In reality it was some creepy dude from Chicago."

"People waste way too much energy taking things personally. That Facebook post is probably not about you. It was probably an accident that you weren't tagged in that picture. And the person you're dating is probably acting sad because that's how they respond to setbacks at work, not because of anything you did."

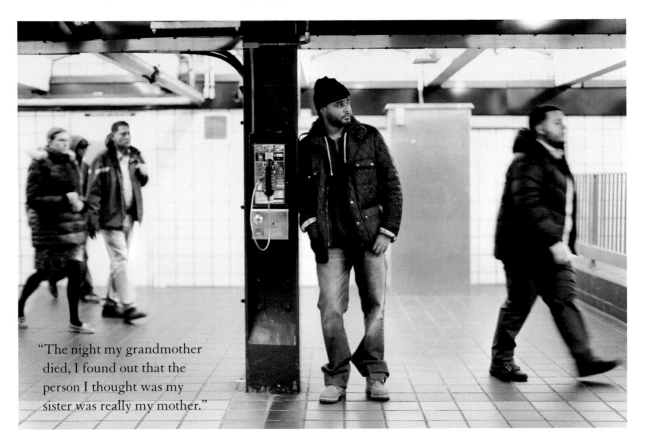

"The night my grandmother died, I found out that the person I thought was my sister was really my mother."

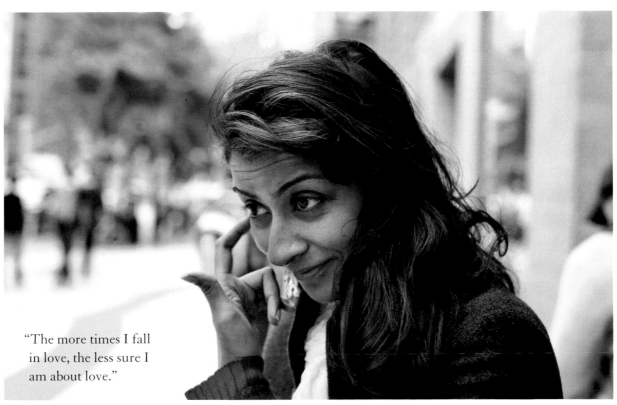

"The more times I fall in love, the less sure I am about love."

"A coworker asked for my number the other day. My friends overheard and said: 'He must have a thing for Indians.' I was like, 'Or maybe I'm just really fucking cool.'"

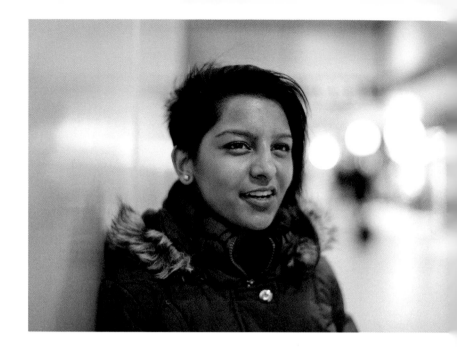

"I wonder why bad things happen to me. Probably because I'm a bad person."

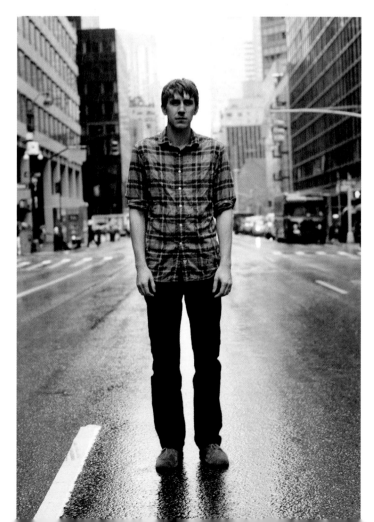

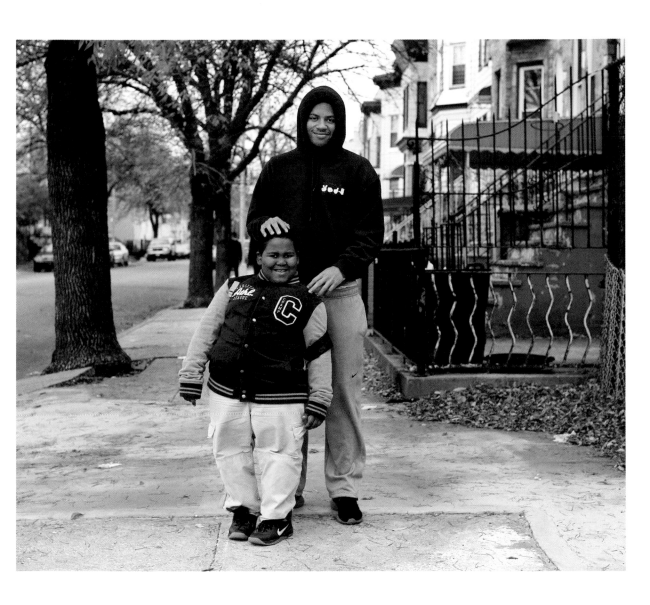

"His dad died a few months ago in a motorcycle accident. We were talking about his father a few days ago, and he asked me why the world is like it is. I didn't know how to answer him."

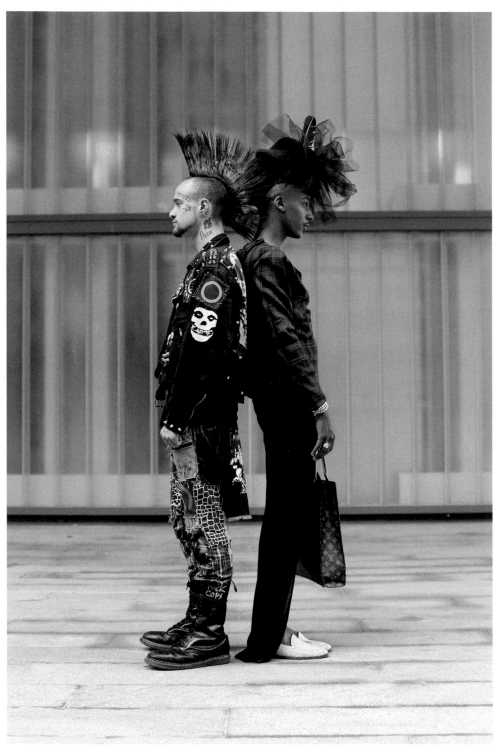

"We go to the same church."

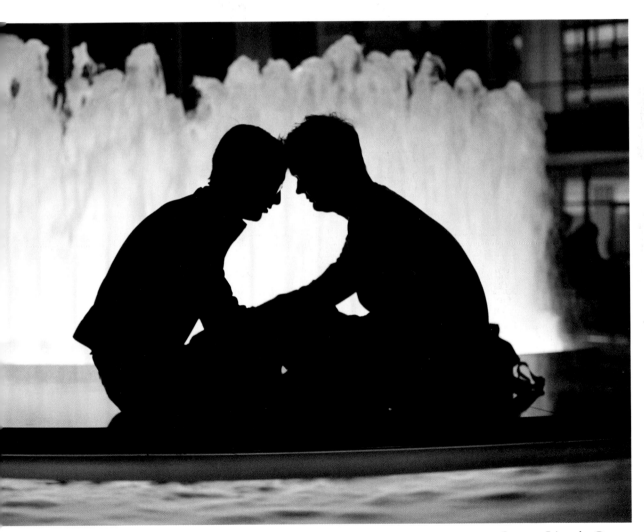

Seen at Lincoln Center

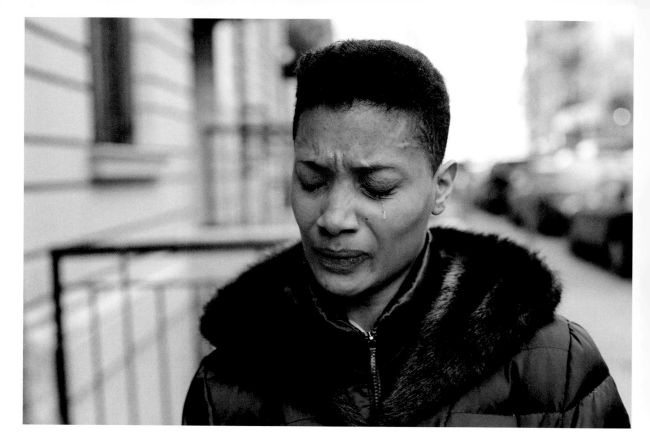

"My mom died of AIDS when I was twelve. She was goofy, and funny, and loving. She was also so nurturing. If she touched that tree over there, it would immediately start growing. And she had the greatest laugh—which I have too. She always wore the same perfume: Sunflower by Elizabeth Arden. I start crying every time I smell that perfume."

"How difficult were her final years?"

"Well, I wasn't with her the last few years. She left when I was nine."

"Why did she leave?"

"I don't know. I think she was ashamed of her illness."

"You described her so lovingly. Do you not resent that she left you?"

"I don't want to keep the bad."

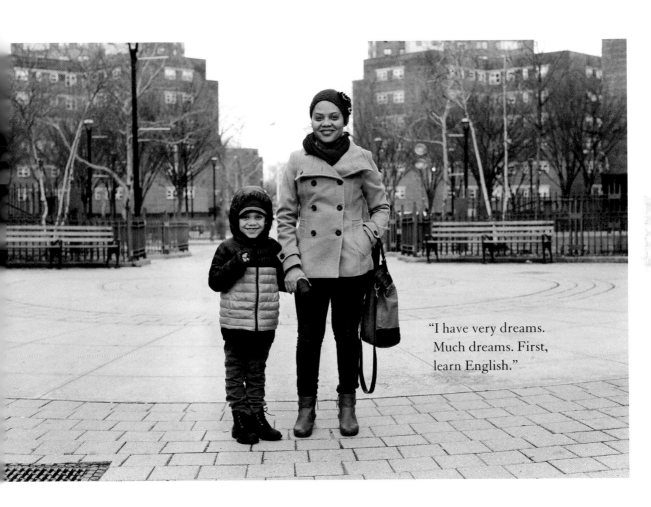

"I have very dreams.
Much dreams. First,
learn English."

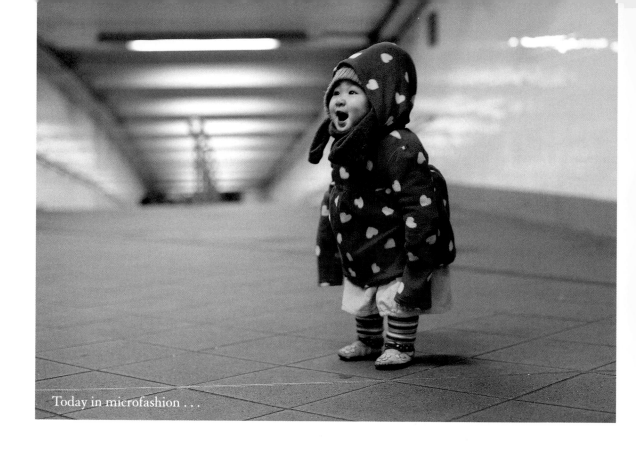

Today in microfashion . . .

"We're getting
married tomorrow.
For tax purposes."

"I didn't do drugs until I was thirty. I just always knew that I had an inclination, so I always turned it down. But at the age of thirty, my marriage was dissolving. I was depressed. Then I fell in love with somebody who had a history of addiction. When you're a couple in addiction, you're always a risk to each other. And I hate to say this, because I know it hurts my kids, but I'd rather die with him in addiction than be sober alone."

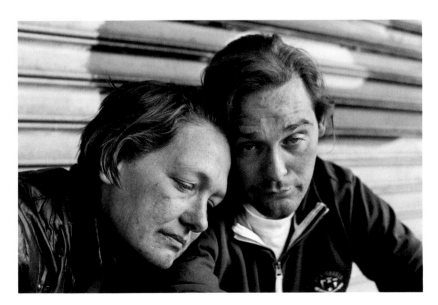

"What's your biggest dream in life?"
"We'd like a sailboat. We lost two kids to foster homes, and we'd like to make things right with them, but I don't really want to pull that out of my heart right now. So let's just say we'd like a sailboat."

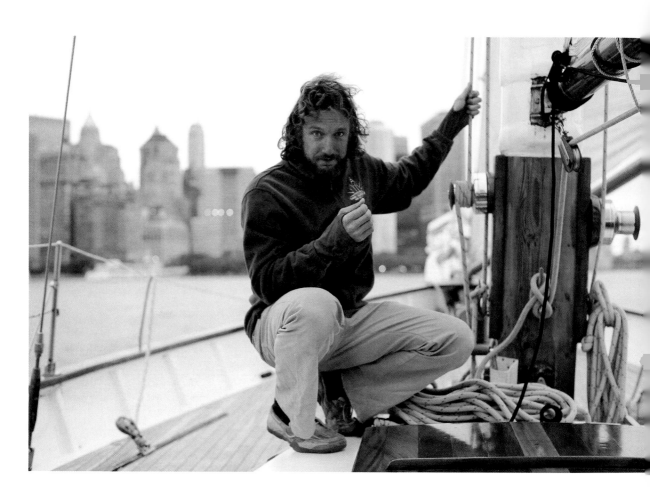

"I prefer maritime laws over laws on land. Maritime laws
only exist to guarantee safe passage. There are no loopholes
or biases to favor more powerful vessels. Every ship is equal,
and no one is more powerful than the sea."

"The great thing about New York is that if you sit in one place long enough, the whole world comes to you."

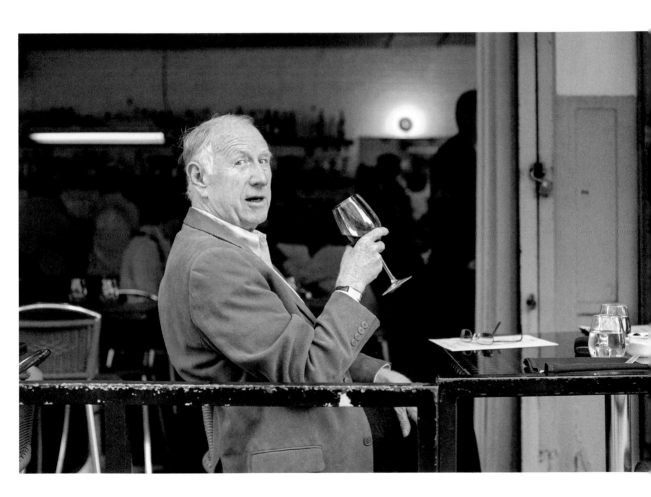

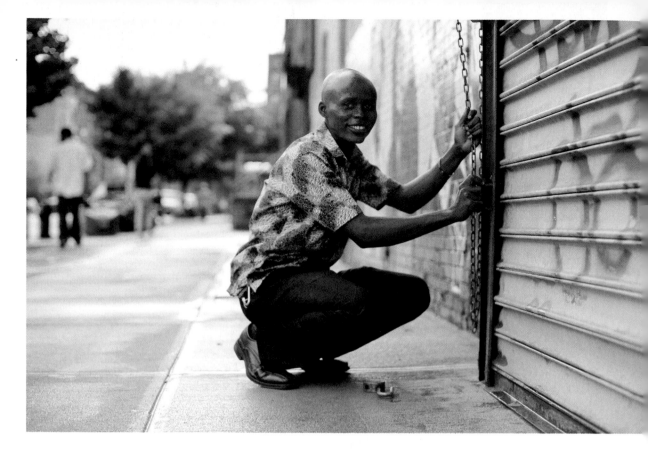

"I came to America about two months ago. I began working here shortly
after I arrived from Ghana. At this shop you must begin as a stock boy.
The work can sometimes be very hard, a lot of stacking and carrying boxes.
But I am a very hard worker. There is nothing I will not do if you tell me
to do it. They told me that if I did a good job as a stock boy, eventually they
would move me into sales. And thanks to the goodness of God, they have
just now chosen to move me into sales."

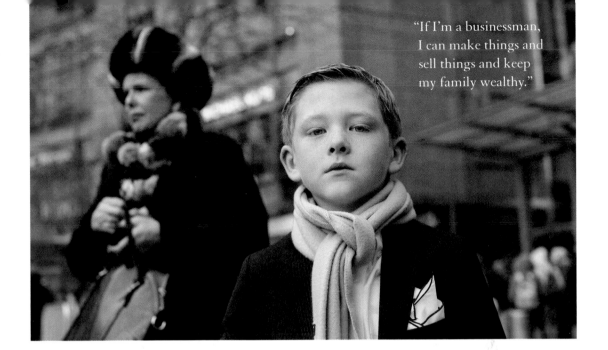

"If I'm a businessman, I can make things and sell things and keep my family wealthy."

"Facebook is telling me that everyone has a house, a kid, and a dog. So I'm just trying to calm the fuck down."

"The band broke up. It was a shitshow. But we found some new people.
And you know what? The band's even fucking better now."

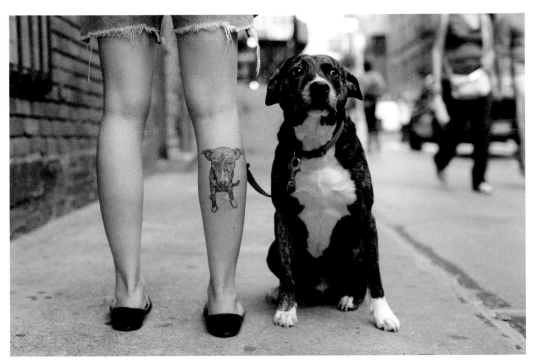

Seen on Broadway

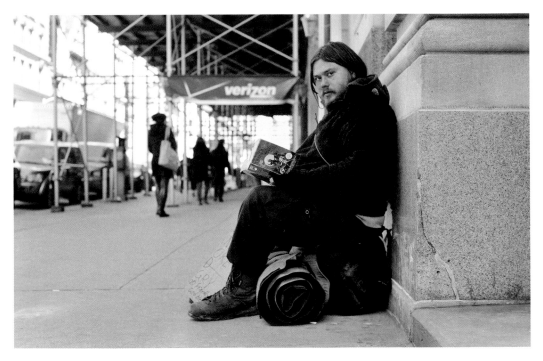

"I pretty much only read fantasy because
I've had more than enough of reality."

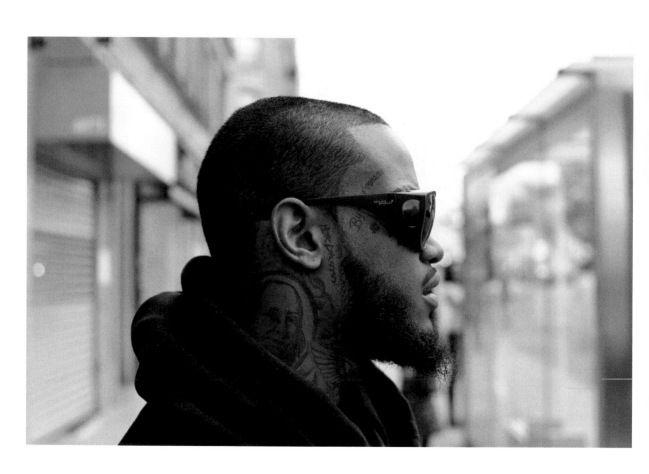

"My father was a crackhead. My mom was bipolar. It is what it is."

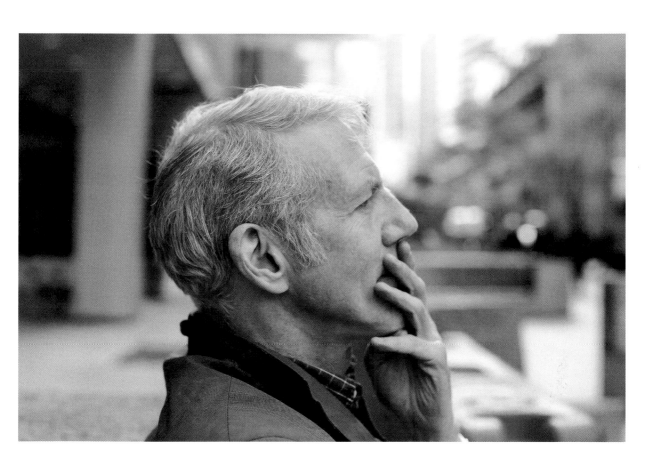

"I'm trying to look forward to this summer, while coping with my brother's death. He was an alcoholic. And he died a very sad, isolated death."

"How are you most like your brother?"

"We both like to be alone."

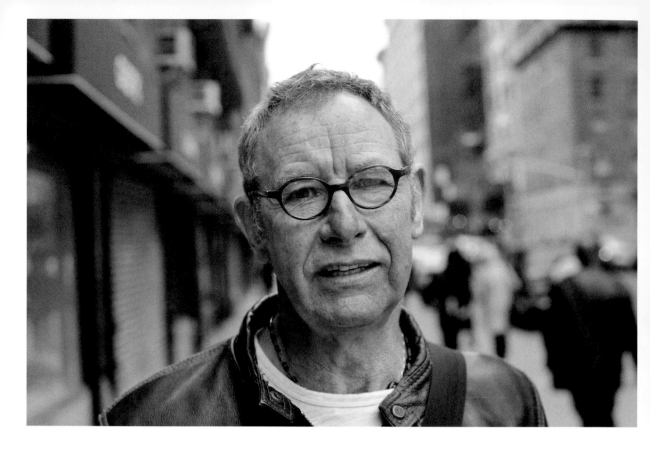

"We'd been having a sort of tacit conversation about it for a couple years. Then one day, his sister, who already knew, was teasing him about having a crush on a boy at school. And I heard him say: 'Well, maybe it's true!' So I said: 'Son, we've never really talked about this. Are you gay?' And even though he was six foot four, he came over to me, curled up in my lap, and just sobbed and sobbed. It was one of the most beautiful moments of my life, actually."

"My kids are teenagers now, and they're going off on their own. And you understand it, but it's hard for it not to hurt. Like the day you realize you're not allowed in your daughter's room anymore. Or when your son doesn't want you to show him how to do something. The relationship tends to ebb and flow between 'help me' and 'leave me alone.' But lately, it's been much more 'leave me alone.' "

"I want to go back to my island. I came from St. Lucia when I was a teenager, and it's been hard. Things are different here. Back home, everyone is always helping each other, everybody asks: 'How are you?' and 'How can I help?' Here, unless you have family or good friends, you're on your own. I lived my whole life as an undocumented citizen. Everything was against me. I worked for less than minimum wage, no benefits. When things were very tough, I took my son to try to get government aid and they turned me away because I didn't have a social security number. Everyone in line could hear. I was so humiliated."

"What are your happiest memories from St. Lucia?"

"Being a kid, sitting in a tree with my brother, eating fruit. And daydreaming about going to America."

"Her parents
know about me.
They just don't
know about us."

"I met Santa at my
mom's office party
and I gave him a
piece of candy."

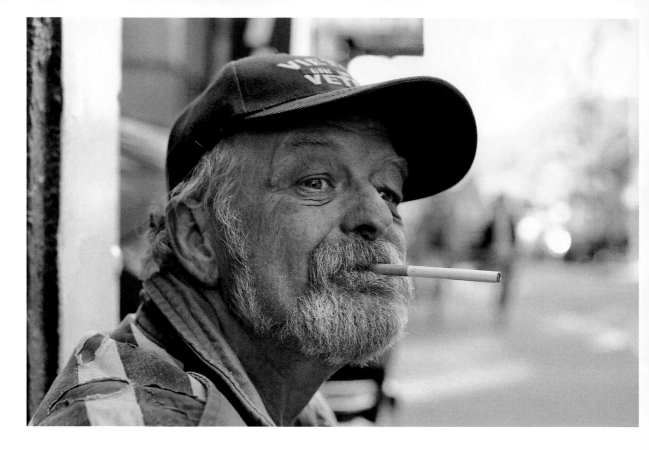

"Saddest moment? How am I supposed to choose between losing my parents and seeing my friends die in Vietnam? I don't categorize those things. Listen, a person is like a rubber-band ball. We've all got a lot of bad rubber bands, and a lot of good rubber bands, and they're all wrapped up together. And you've got to have both types of bands or your rubber-band ball ain't gonna bounce. And no use trying to untangle them. You know what I'm saying?"

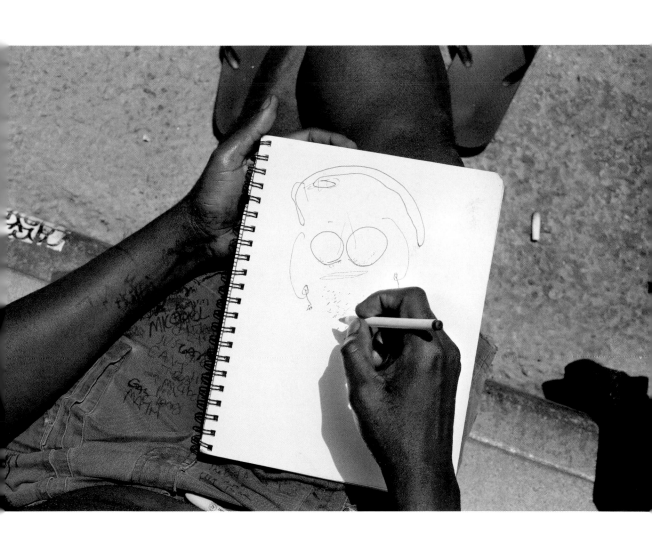

"I'm drawing the man who raped me."

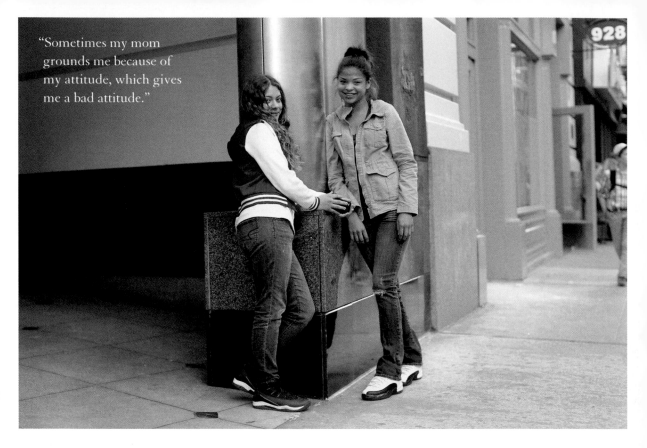

"Sometimes my mom grounds me because of my attitude, which gives me a bad attitude."

928

"Things are going good for me. I got a new job. I've just got to be better about my drinking. It's not even really about the drinking for me. It's about the loneliness. I go to a restaurant or bar because that's where the people are. Then if I'm at the bar, I've got to have a drink. Then the next thing I know, I'm drunk. Then the next morning, I'm two hours late for work because I got on the subway going the wrong way. I've lost a lot of jobs because of my drinking."
"How many?"
"About seven."

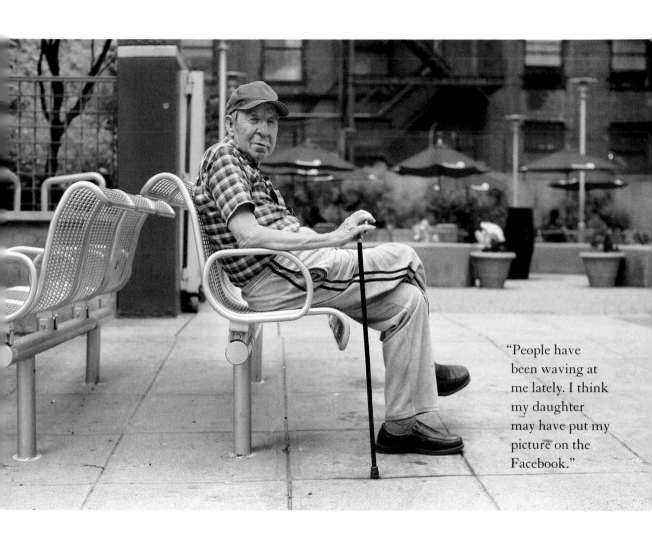

"People have
been waving at
me lately. I think
my daughter
may have put my
picture on the
Facebook."

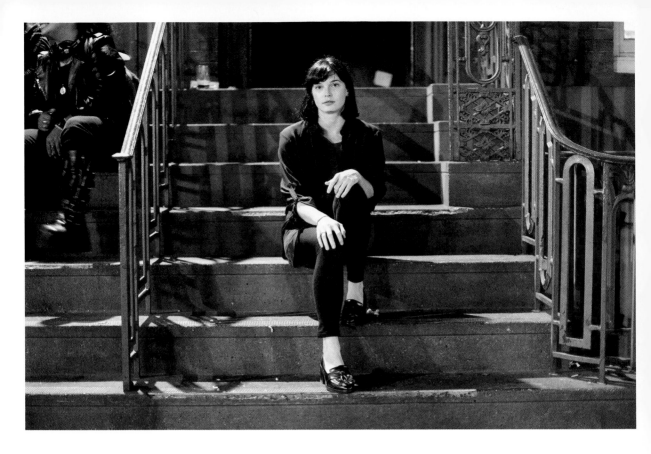

"I did my undergrad in law in Australia, focusing on domestic criminal work. Then I moved to the Hague in the Netherlands to work for the office of the prosecutor in the International Criminal Tribunal for the former Yugoslavia. Then I worked for an NGO in Johannesburg that uses the South African constitution to enforce human rights. Then I went back to Australia to clerk for a justice of the supreme court. Now I'm here studying international criminal prosecution, though I'm considering switching to transitional justice."

"What's the biggest crime you've ever committed?"

"I've never been a constant in anyone's life."

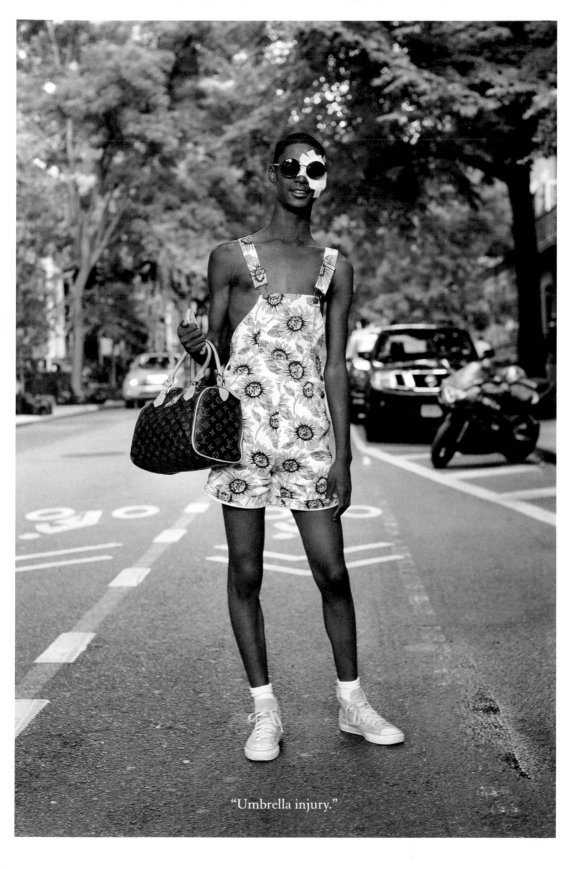

"Umbrella injury."

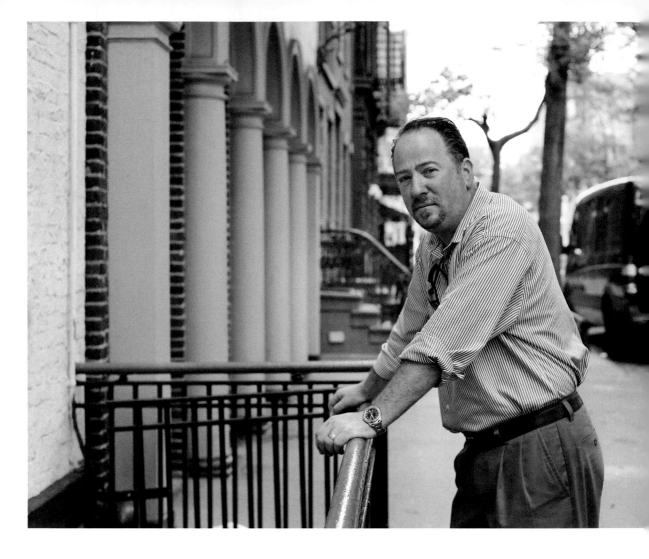

"Toward the end, my father let me fill out his patient history forms at the hospital. It was the first time and last time he ever let me help him."

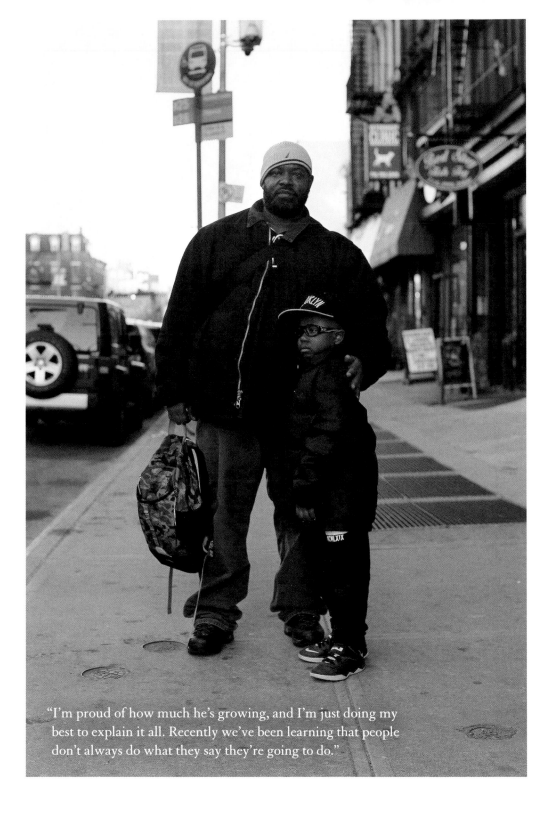

"I'm proud of how much he's growing, and I'm just doing my best to explain it all. Recently we've been learning that people don't always do what they say they're going to do."

"I'm dealing with the aftermath of a really horrible breakup."
"What was so horrible about it?"
"Well, I was engaged. And now I'm not."

"I guess she just decided that she was meant to be with a different person."
"Different in what way?"
"It's been four years, and I still haven't figured that out."

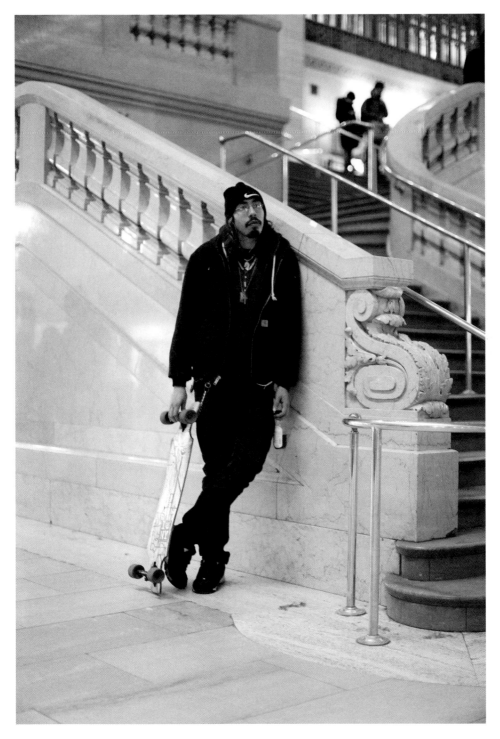

"I told her that if she wanted to start over, to meet where we first kissed.
She was supposed to be here fifteen minutes ago."

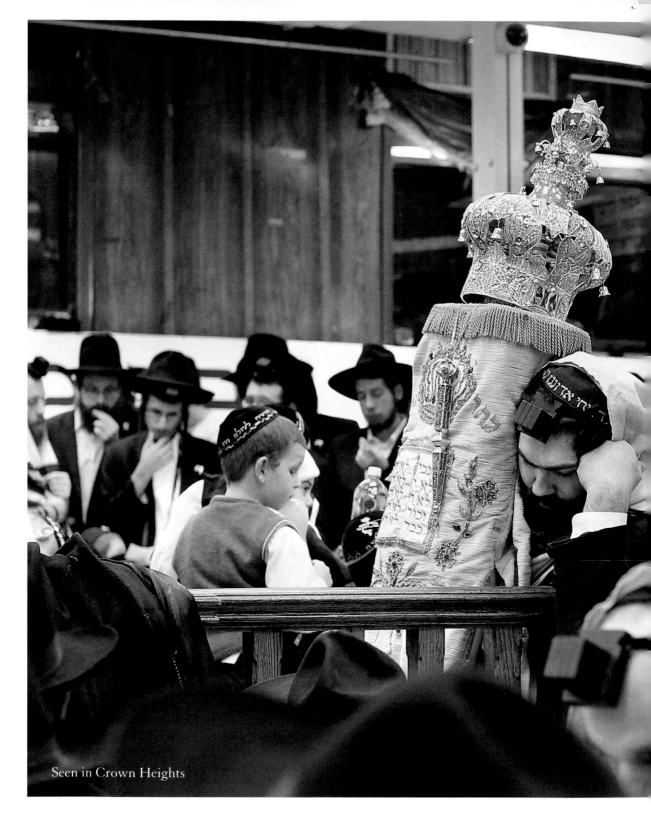

Seen in Crown Heights

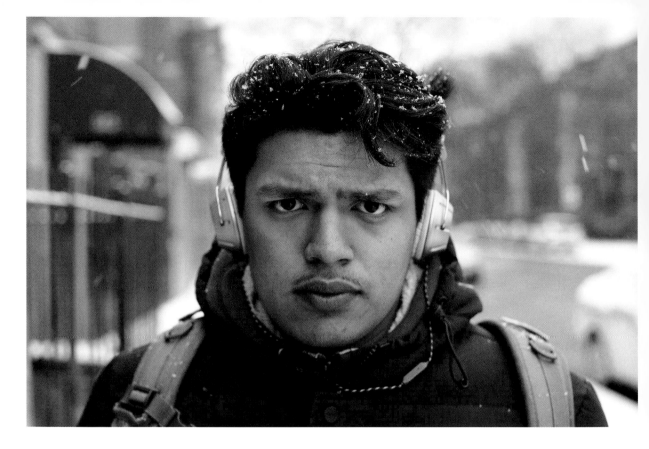

"I had a whole vision. I wasn't a pro, but I could film from different angles and stuff. I was going to have a whole YouTube channel with different kids doing rap battles. I worked really hard at it, but nobody except my friends ever looked at it. And all the adults in my life told me that I was wasting my time. So one day I got mad at life, and started deleting, deleting, deleting, until it was all gone."

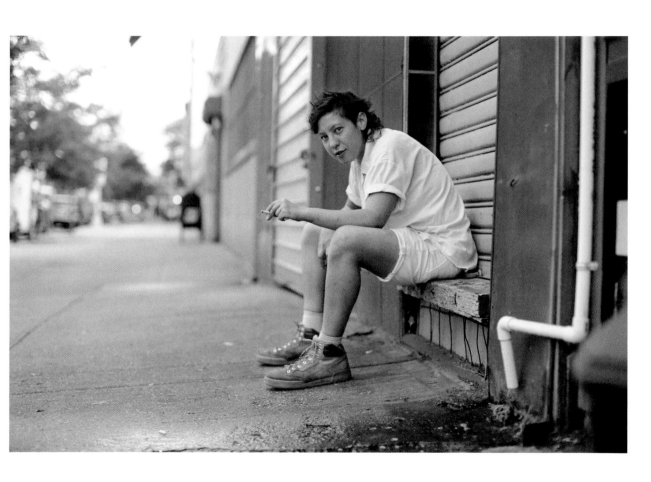

"I just ate some West African land snails. So I'm happy."

"I'm an opera singer."
"What's the highest note you can hit?"
"An F-sharp."
"What does that sound like?"

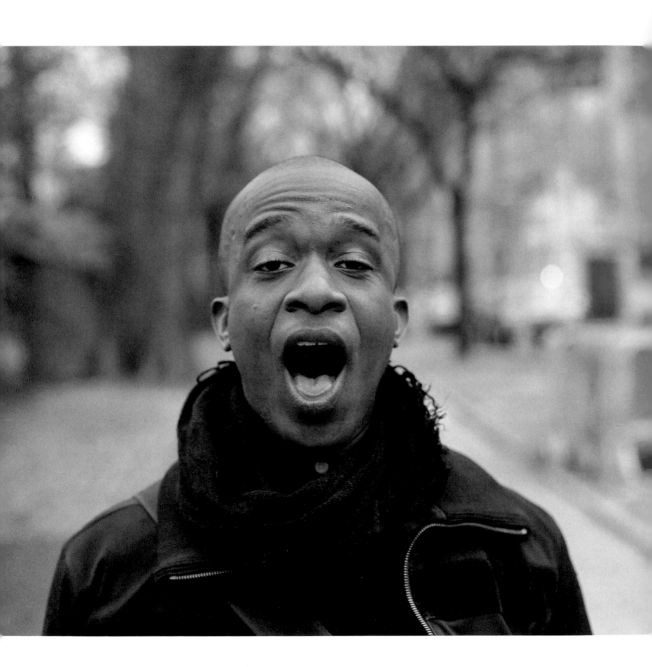

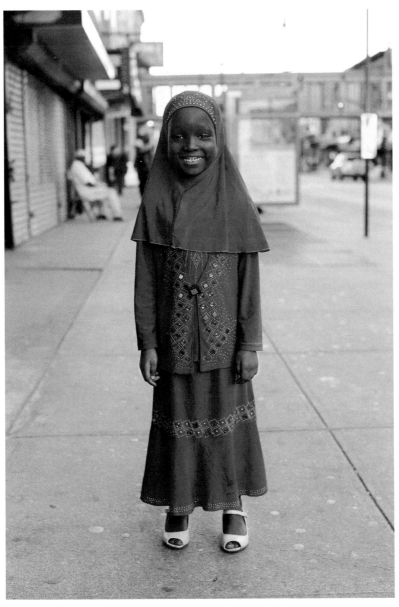

Today in microfashion . . .

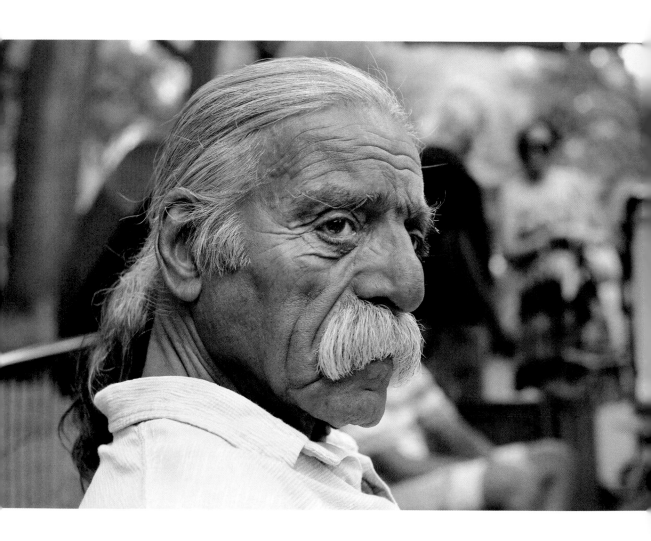

"A photo of me once hung in the
Metropolitan Museum of Art,
sixteen inches high."

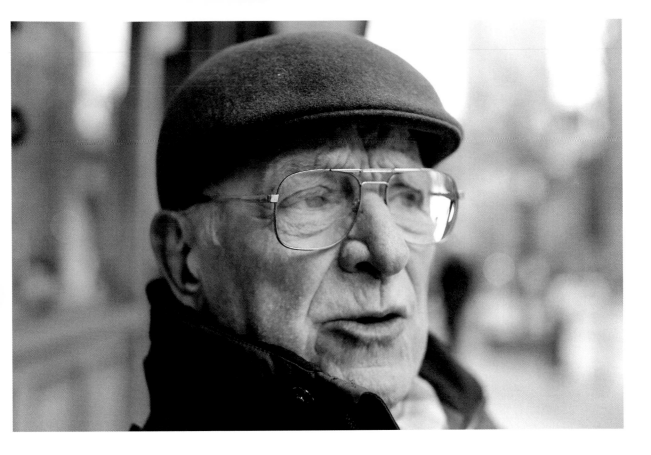

"They say it's gonna snow tomorrow.
Well, I just got a bottle of whiskey.
So let it fucking snow."

"Well, there's this girl
 that I'm friends with,
 and you know, I like
 her, but I don't know
 if she likes me . . ."
"Do you mind if I
 share that?"
"I don't know, if you
 share it, she might
 figure it out."
"She'll definitely figure
 it out."
". . . Do it."

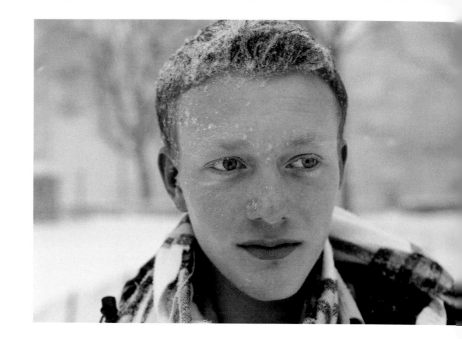

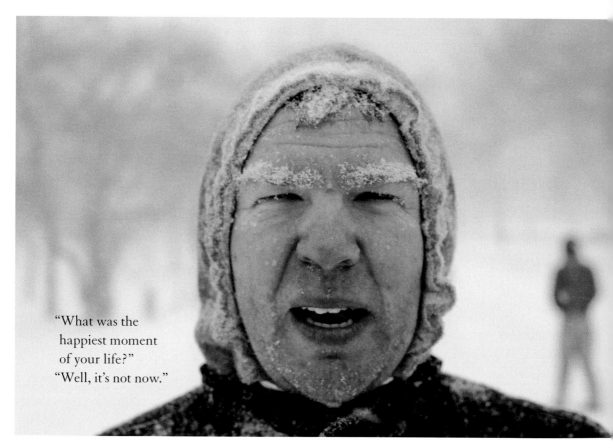

"What was the
 happiest moment
 of your life?"
"Well, it's not now."

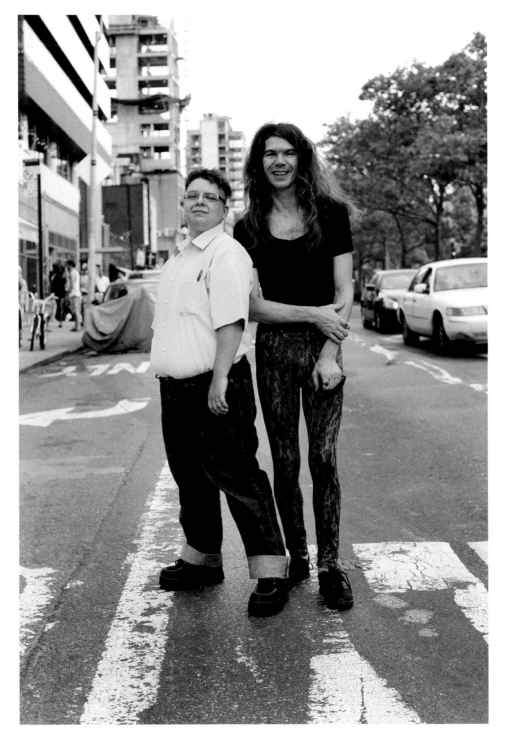

"We timed our wedding so we could honeymoon at Star Wars Week at Disney World, then walked down the aisle to the 'Imperial Death March.'"

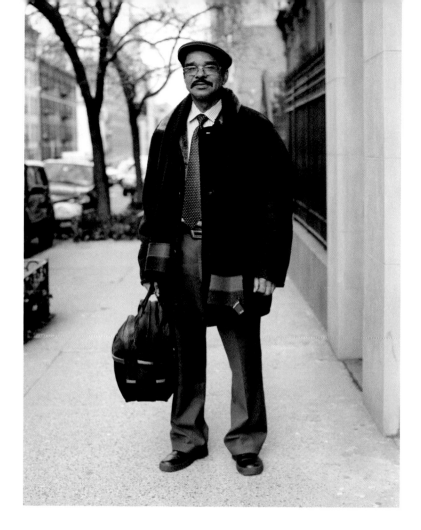

"I've been working for forty-five years, and so has my wife. But we have no money. You know why? Because my five kids have two bachelor's, a master's, and two doctorate degrees. They are my wealth."

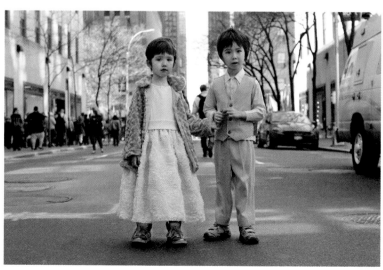

Today in microfashion . . .

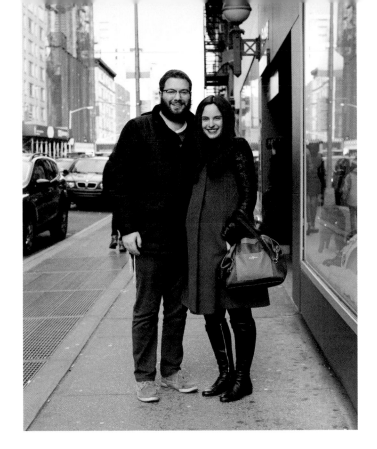

"Today's the due date. I gained more weight during the pregnancy than she did. Seriously, I gained forty pounds."

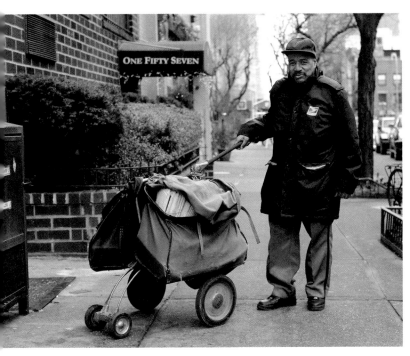

"Listen, I've got to go. If I tell them I'm late because I was getting interviewed, they're not gonna want to hear that. Not gonna believe that for a second."

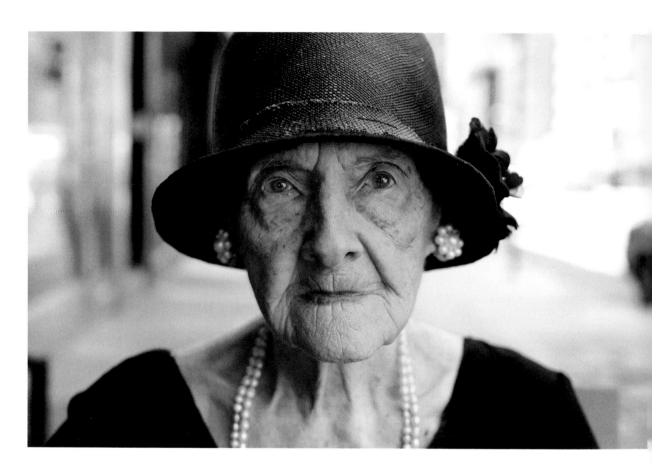

She asked if I wanted to hear a poem she'd written when she was younger. (At what age, she couldn't remember.) She then recited it from memory. I had her repeat it several times so I could get all the words right:

Were I to dream,
then dream I would
of days that have gone by.

Your eyes would gleam
and so would mine,
but joys remembered are no longer mine.

I walk in a garden of memory,
reliving the joys and the sorrows as well.
I walk with a cane down memory lane.
Perhaps there, joys remembered will remain.

Perhaps when my hair has turned to gray
and my face is etched with pain,
I'll walk with a cane down memory lane.
Perhaps there, joys remembered will remain.

"This morning I took a bunch of water and soap and put it in plastic bags and shook it up because I wanted to make a store that sold soap. Then I put some toilet paper and water and soap and cake inside a container because I wanted to make an experiment. But Mom said that was not the right way to make soap and if we wanted to make some soap we had to find a recipe online so I made an apology note with invisible ink and it had a flower with a smiley face and zigzag hair and heart hands and it was holding a balloon and I drew the sky and I wrote, 'I love you, Mom.'"

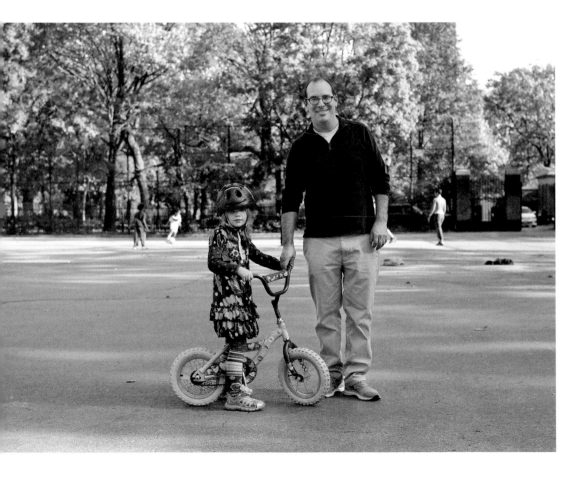

"I don't know how to skateboard."

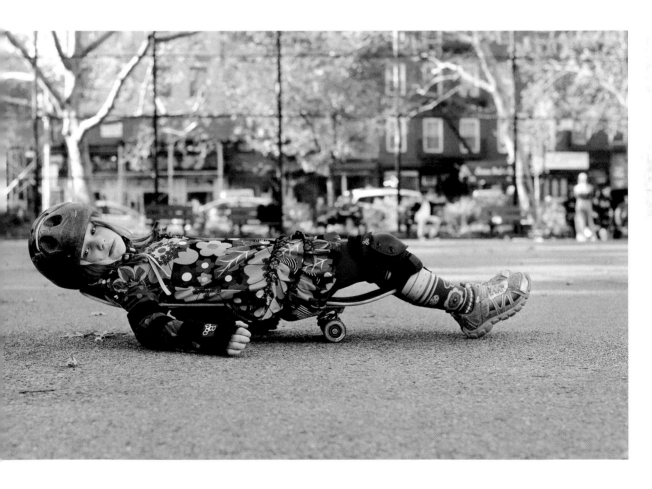

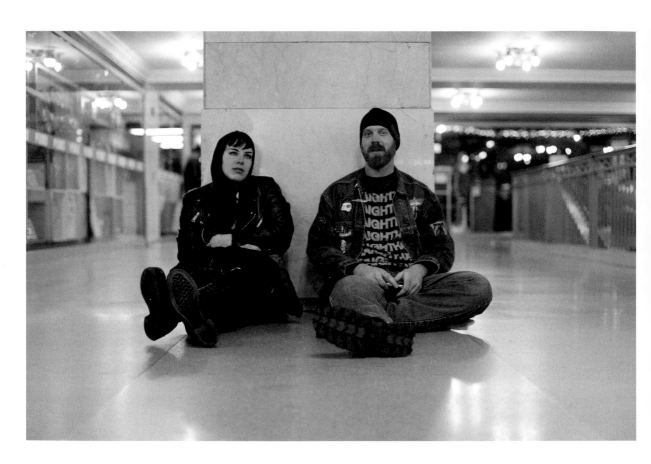

"From the outside Metal looks very aggressive and nonconformist. But that's just because we get all our aggression out in music, and not by doing some other shit. It's actually a very loving community. No matter where you're from, or how much money you make, a metalhead is a metalhead."

"It was right after Katrina hit. I was twenty years old,
in the midst of a righteous political phase, and I didn't
really have plans for the summer. So I said: 'Racist shit is
happening in New Orleans! I've got to get down there!'"

"My father died in an
accident back in Guyana.
He was riding a motorcycle
and got thrown into a
stream."

"Do you remember a
moment when you most
admired your father?"

"He was a carpenter. And
when I was growing up,
he would take a ferry every
morning across the river
to find work. It was the
Essequibo River. A very
dangerous river. When
he returned home in the
evening, sometimes I
would wait by the docks
for him. Every once in a
while, the tides were so bad
that the boat could not land.
And it would wait offshore.
If he saw me waiting for
him, he would jump off the
boat and swim to me. No
other man would do that. It
was a very dangerous river."

"I shouldn't have
moved in with
him just because
I was lonely."

"My goal is to run
the 400m for the
Dominican national
track team. I'm about
two seconds away.
But the last two
seconds took me
four years."

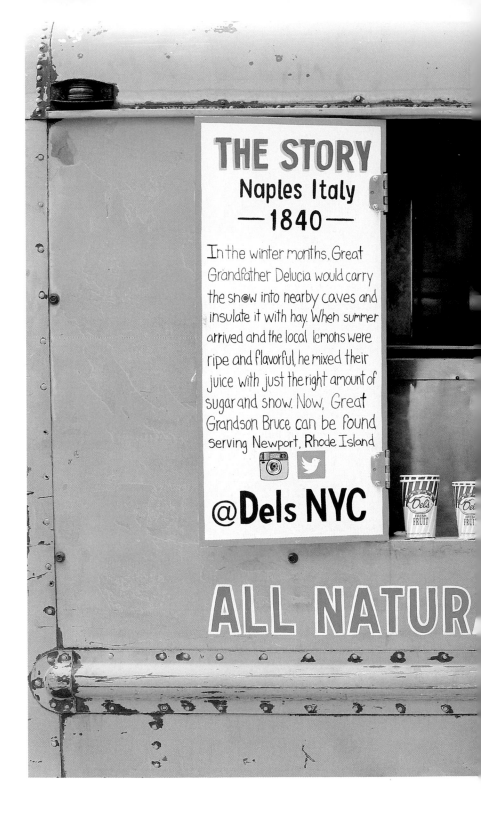

THE STORY
Naples Italy
—1840—

In the winter months, Great Grandfather Delucia would carry the snow into nearby caves and insulate it with hay. When summer arrived and the local lemons were ripe and flavorful, he mixed their juice with just the right amount of sugar and snow. Now, Great Grandson Bruce can be found serving Newport, Rhode Island

@Dels NYC

ALL NATUR

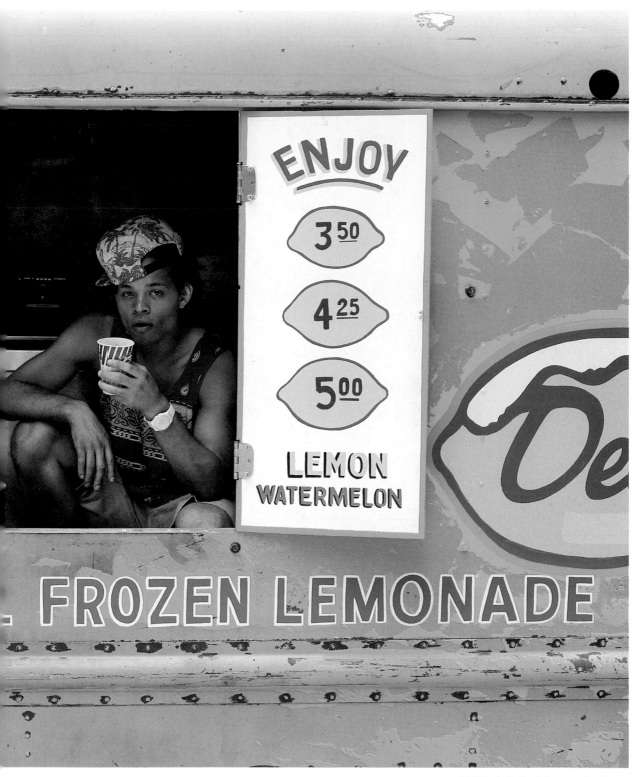

"This job fucking sucks."

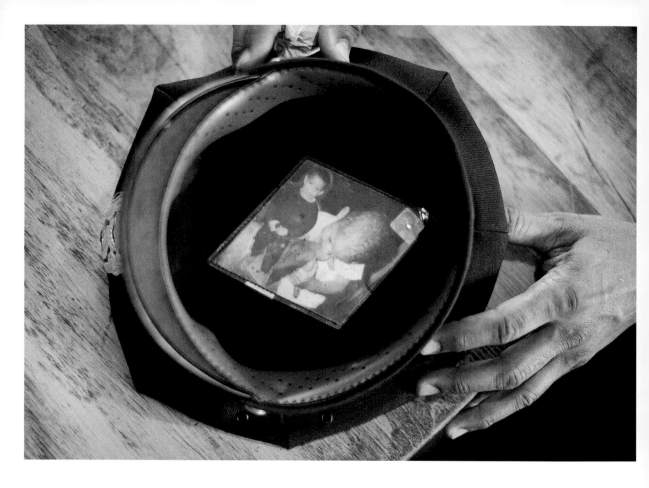

Yesterday at lunch, I noticed something
inside the hat of a policeman sitting next to
me. So I asked if I could photograph it.

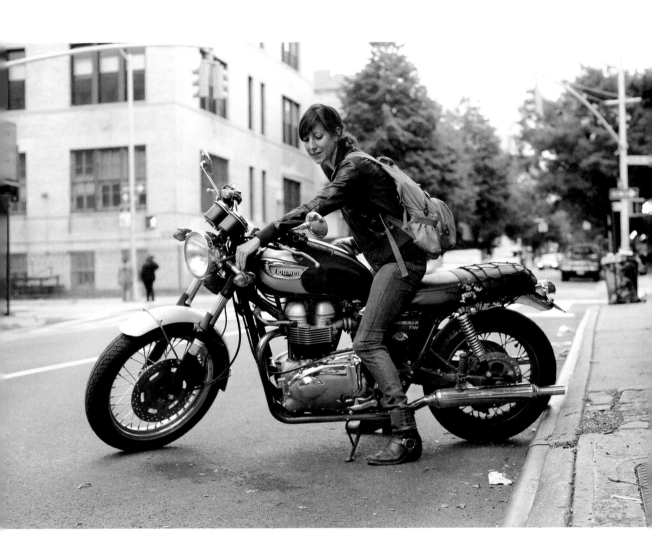

"I'm a science writer. I like anything complicated."

"We were twenty-five and twenty-eight, but we acted like fifteen-year-olds. Fighting over little things, storming off, breaking up for a week, and then getting back together. But developmentally, we were fifteen-year-olds. We'd been in the closet our whole lives, so we didn't have any practice with relationships. He still hadn't come out to his family and a lot of his friends. We were on one of our 'little breaks' when he died suddenly from a seizure. And nobody in his family or circle knew I existed. It took me four months to find out that he died. I thought he'd just decided never to talk to me again. His family never found out about me. Or him, for that matter."

"My son worked on the ninety-first floor of the North Tower. The whole family came over to my apartment and gathered around the TV. When we saw the building come down, we all looked at each other, and said: 'That's it.' "

"We've run marathons together on all seven continents."
"You ran a marathon in Antarctica?"
"Ran it? She won it!"

"We met in 1944, and we didn't like each other. He was in uniform, I was an art student. I called him a fascist. But we met again a few months later when he was on furlough from the army. We were both vacationing at the same dude ranch. I was wearing my father's suede jacket, because he'd just passed away, and the sleeves were too long for my arms. And without saying a word, he walked up to me and rolled the sleeves back a bit. And I thought it was such a sweet gesture."

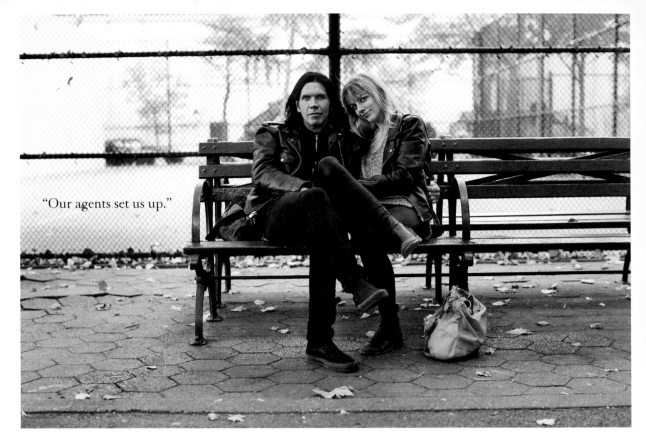

"Our agents set us up."

"When my mother found out that my dad had married another woman, she just let herself die. She stopped eating. All she was doing was smoking. We took her to the doctor and they couldn't find anything wrong. She died while the doctors were doing tests on her."

"I wasn't planning on it happening. It just happened. I don't know what to say. I lost about ten or fifteen pounds during the affair, just from the stress. The longer it went on, the more the other woman wanted to control me—that's how they always get. She wanted more and more of me as time went on: 'Come over,' 'Let's do this,' 'Let's do that.' It got more and more difficult to hide. I'd been with my wife since we were sixteen, so she knew something was up. One day she just straight-up asked me, and I said: 'Yes.' It was almost a relief. There was crying, screaming, yelling. All my shit went out on the lawn. Then it was back in the house. Then it was out on the lawn again. But we went to therapy and we got over it, and she forgave me. I think."

"I'm a neuroscience researcher."

"If you could give one piece of advice to a large group of people, what would it be?"

"Listen to your inner voice."

"You're a scientist. Isn't 'inner voice' a spiritual term?"

"Bullshit! You'll hear scientists talking about following their inner voice as much as you'd hear a musician or a priest."

"So how do you know which of your thoughts are your true inner voice?"

"All of them are! The question is—how much weight do you give them? How much authority do you give your own thoughts? Are you taking them seriously? Or are you sitting in front of the damn tube letting other people tell you what to think?"

"Studying the brain is like working in a toy store. Nothing could be more fucking fun."

"What do you think is the greatest weakness of the brain?"

"That's a lousy question! I'm not answering it."

"Why is it a lousy question?"

"What do you want me to say? Road rage? That we get pissed and shoot people? That the newest parts of our brain should have been in the oven a little longer? How's that going to help you? If you ask a crappy question, you'll never get a decent answer. You need to ask smaller questions— questions that give you a pathway to finding some pertinent information. The major advances in brain science don't come from asking crappy questions like, 'What is consciousness?' They come from microanalysis. They come from discovering pertinent information at the cellular level."

"I started taking heroin to get away from the draft,
then joined the army to get away from the heroin."

"The Russians run an underground fighting league in Coney Island where they pay junkies to fight. I fought about fifty fights for them. They pay you two hundred dollars, win or lose. They'd always make sure I was real doped up before the fight. I mean, they weren't good people but it did make me feel kinda important to have all those gangsters cheering for me. And they'd always be really happy if I won, because that meant I'd made them money."

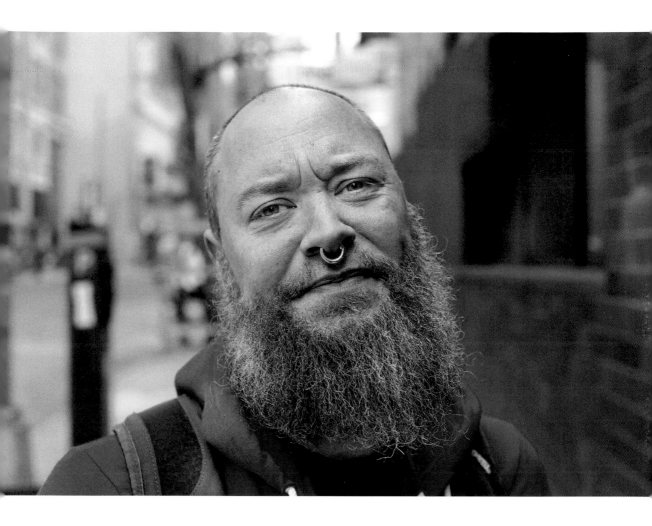

"I dated a meth addict once. I didn't find out until eight months into the relationship, so I tried to stick it out. After he got clean, we took a trip to San Francisco so we could 'start over.' The first morning there, he woke up early and said he was going to get some breakfast. Then he took all my money, and all my credit cards, and disappeared for two days. When I finally found him, he was getting blown by some dude in an adult theater, so I backhanded him in the face and knocked out a couple of teeth. The entire flight back, he wrote me apology notes on airplane napkins. Which I still have, by the way, to remind me never to date a meth addict."

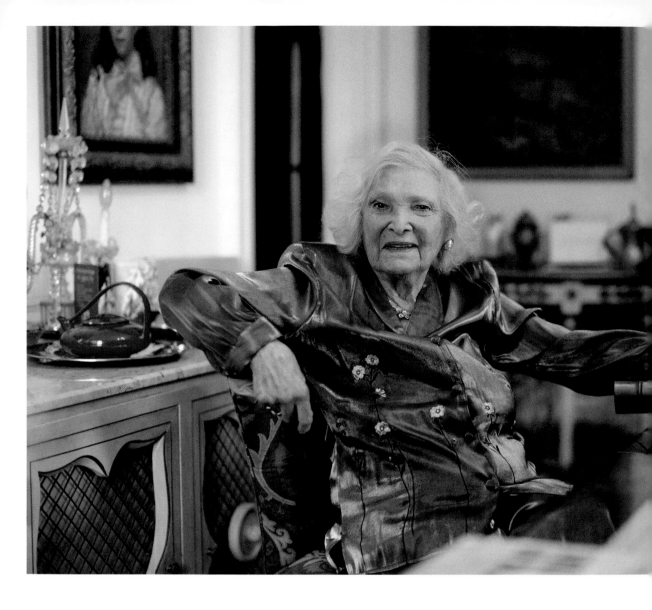

"When I was nineteen, my girlfriend and I were going to study in Paris. Our boyfriends came to the docks to see us off. Right as we were getting on the ship, my friend's boyfriend said to her: 'If you go, I won't wait for you.' So she turned around and decided to stay. My fiancé saw this and told me: 'I won't wait for you, either.' I said: 'Don't!'"

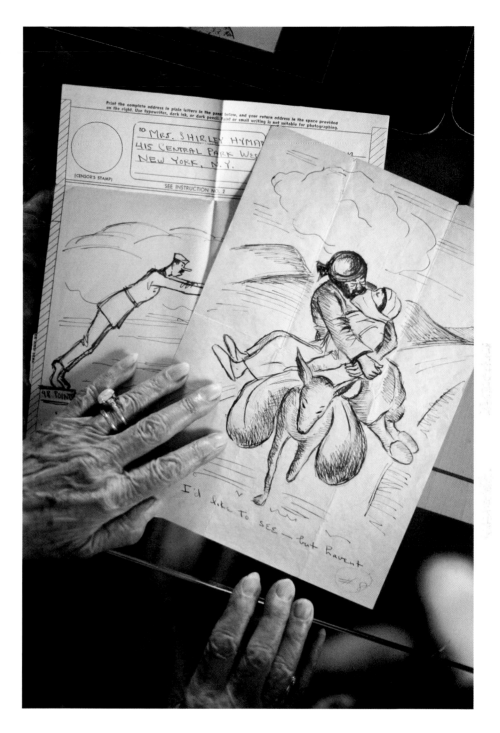

"He was away for almost four years during the war. When he wrote me letters, he was never allowed to tell me where he was. So he'd draw cartoons to help me guess."

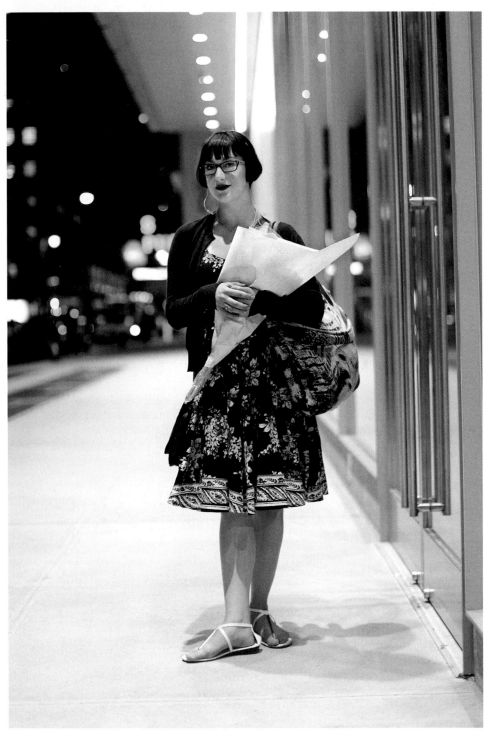

"Therapy seems to be going well. Dad said, 'I love you.'"

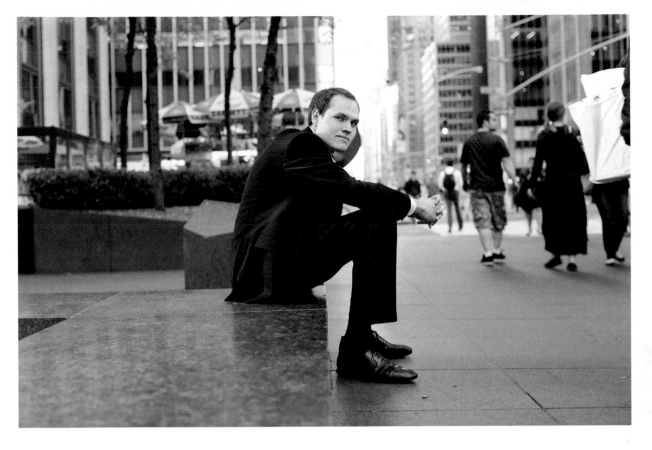

"My dad died in 9/11. They opened up the museum to families today, so I went this morning. My plan was to go to work after, but I just couldn't do it."

"What happened to him?"

"He was a cop. He actually had the day off. But as soon as he heard, he drove into the city and got there just in time for the second tower to fall. A witness said that my dad had started to run when the tower fell, but turned back because a trapped woman was calling to him."

"What do you remember?"

"I was in science class. And my teacher told us that there had been a plane crash. That's all she said. Then kids started getting pulled out of class. So I knew something big was happening. Soon we got let out of school. On the ride home, I remember thinking that my dad was going to be working overtime on this. I imagined he'd be down there every day, saving people. 'I bet I won't see him for weeks,' I said."

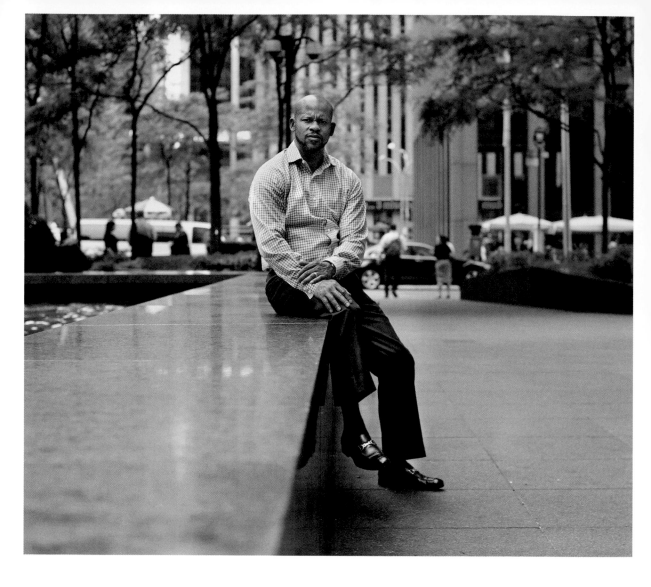

"I'm thinking about something at work, and how I'm going to conquer it. There's a project I'm working on with a group. And I think I've figured out a way to do it better, faster, and cheaper. So I'm gonna be like a hawk. I'm about to swoop in. I'm not gonna be a vulture. A vulture waits until things fall apart, then comes in with the solution. But I'm not waiting. I'm gonna swoop. Like a hawk. A hawk grabs the rat while it's still alive."

"So are your coworkers the rats?"

"No, no, no. They're helping with the rats. They're mongooses. Mongeese."

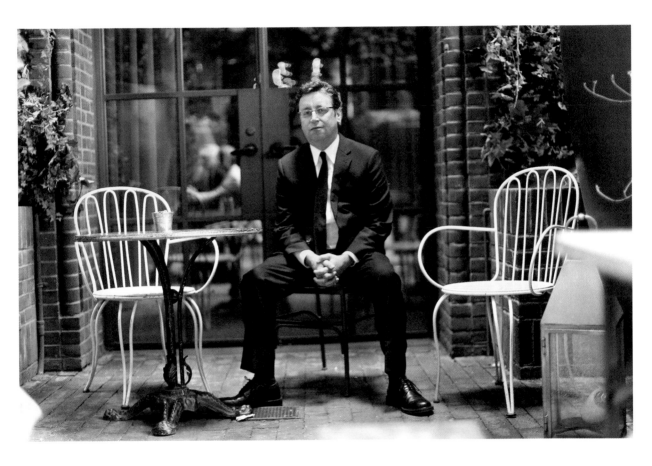

"After the kid came, we both became less attached to each other and more attached to the kid. We stopped talking to each other at night. We stopped being intimate."

"Did you realize this was happening?"

"We did."

"Then why didn't you stop it?"

"Because I think we both wanted it to happen."

"You stopped a live one today, honey. I'm an international cougar!"

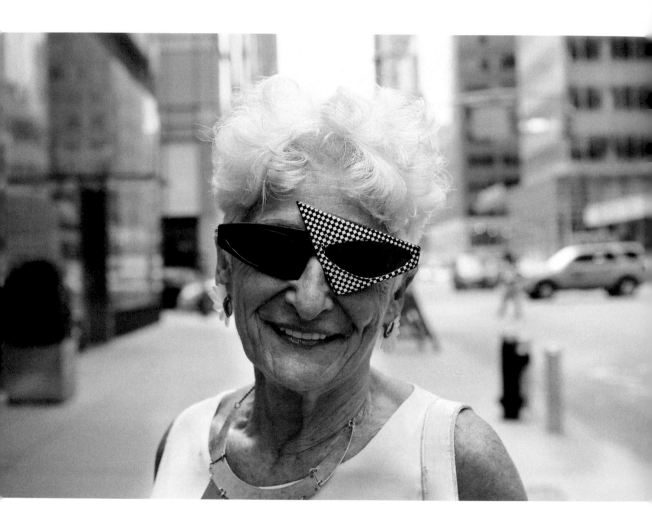

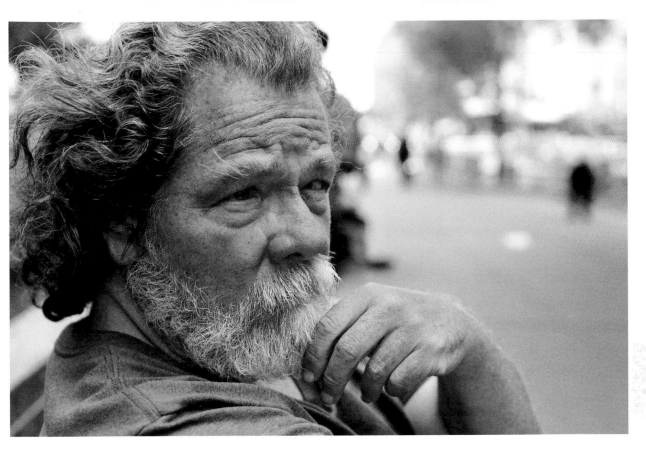

"It was the late nineties. The police commissioner had figured out that all the people committing small crimes were the same people committing big crimes, so the cops started cracking down on all the little stuff—and crime kept going down, down, down. Everything except bank robberies. Because all the big national banks were moving into the city and buying out all the local banks. And these new corporate banks were all about 'customer service.' So they replaced the retired cops at the doors with 'greeters' who would give you coffee and doughnuts. So word got around fast that robbing banks was fucking easy now. All you had to do was walk in, hand them a note, and they'd hand over the cash. I never even carried a gun. The security footage was so grainy back then, you could barely see anything. It was easy. It's much tougher these days. I've had dye packs explode on me three times. The worst was about a block from here. I had just left a bank and was walking by the entrance to Penn Station during morning rush hour. Suddenly a noise starts coming from my pants, and a bright neon cloud starts shooting out. Hundreds of people were staring at me. I threw the thing away from me, hopped in a cab, and went to a bar."

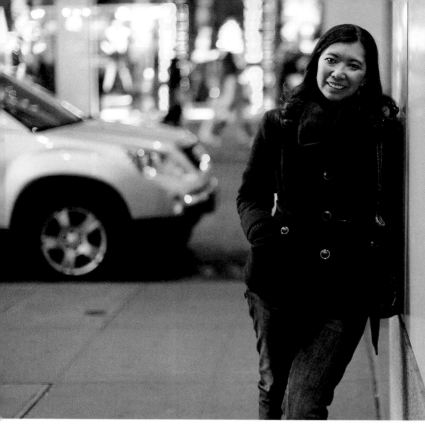

"A few days before I met him, I'd actually told a friend: 'I'm really content with myself right now. I'm about to meet someone.' Then later that week I was sitting at a bar and I saw him walk in. It was love at first sight. The moment I saw him, I turned to a friend, and said: 'He's the one.' He was gorgeous. Sometimes I still look at him, and think: 'He's the most gorgeous man I've ever seen.' And he was so funny. Not Jim Carrey funny, but a quiet kind of funny. Which is exactly the kind of funny that I wanted. He'd always find the quirkiness in things. In the beginning, he used to write me these love letters that blew me away."

"We've been together for twenty years now. The vows from our wedding day are framed above our bed. And he did tell me that we were going to go through hard times. Our kids are getting older, and we're at the point where we have to reconnect. Sometimes we come home from work and don't say a word to each other, or we don't eat dinner together. Sometimes we'll take a road trip and I'll realize that it's just been me and the kids talking the entire time. Or if we're in bed together, we'll face the other way. He thinks that just being together is enough, and it's so hard for me to tell him that I'm lonely."

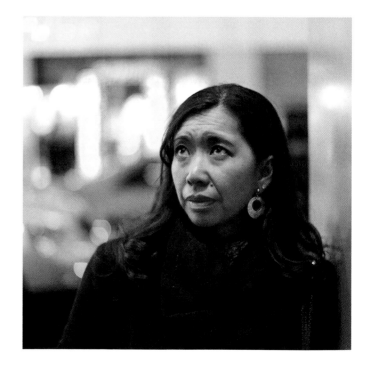

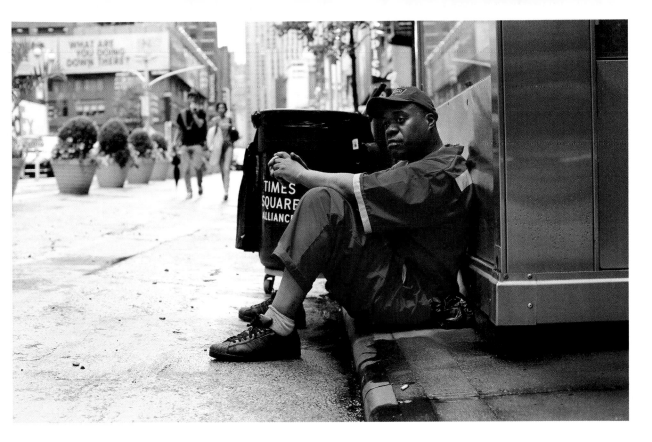

"In my heart of hearts, I wanted to do the right thing, but selling drugs was easy. Everyone was doing it. I mean, I'm not using that as an excuse, I made my own decisions. But I grew up around these Robin Hood figures who would sell drugs, then buy supplies for kids who were going back to school, or pay rent for an old woman who was about to get evicted. All my friends were doing it. It almost seemed fashionable. I never felt proud of it. I always thought I'd transition to a job with the Transit Authority, or a job like this—something I'd feel good about—but instead I transitioned to jail. I did six years. When I got out, it was tempting to go back to the easy money, because everyone around me was still doing it, and I couldn't get a job. But luckily I found an agency that helps ex-cons, because there aren't many companies looking to give people a second chance. I've had this job for a few years now. You know what product I'm selling now? Myself. Everyone around here is my client. Times Square is a drug to these people. And I'm picking up all the trash so that they can have the full Times Square experience."

"I always say that I've done a life sentence—in installments. My behavior funneled me into the criminal justice system at the age of seventeen. I've done three state bids and numerous stints at Rikers. The cycle of recidivism is difficult to break. When you come out of prison, you have nothing: no home, no family, no money, and no job. The only thing you have is your social standing. And if your social standing in jail is perceived as higher than that on the outside, sometimes it's preferable to go back. In prison, they called me 'Pops.' I got privileges. People respected me. I felt valued. When I got out, I had to start over."

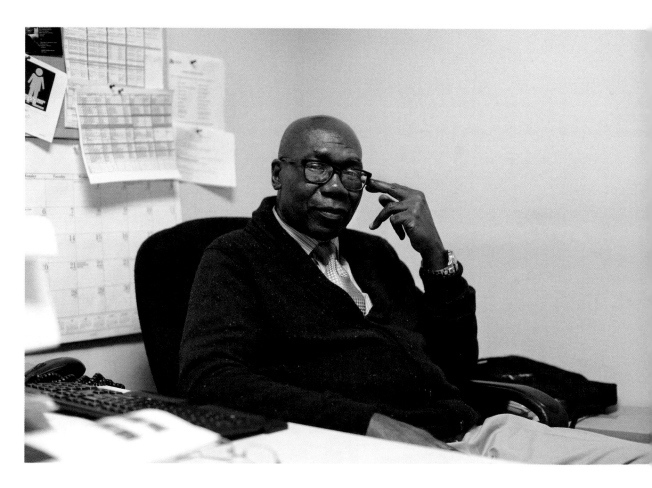

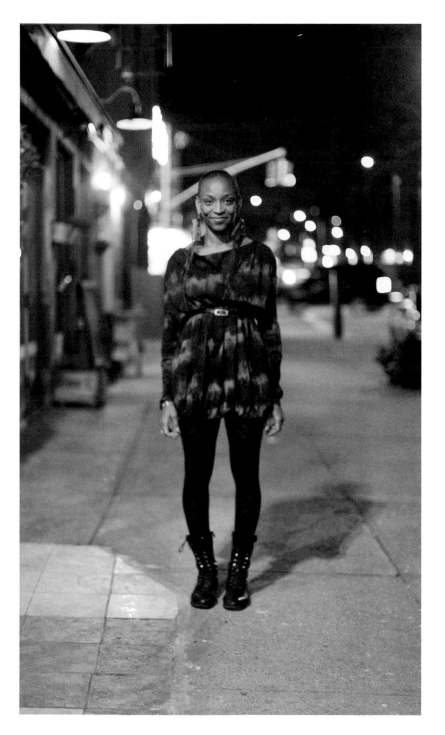

"My children's father was physically and emotionally abusive, so by the time I left him I had very low self-confidence. I needed something to boost my ego. One day I saw some firefighters handing out recruitment material on the street so I decided to give it a try. All the female recruits trained together, because we had to work harder than the men to pass the test. We trained for six months, three hours a day. I'd go straight from my job to the training sessions. I'd bring my kids with me, and when it was my turn to do the drills, the other women would take turns passing them around. At the end of the six months, I was 120 pounds of solid mass, and I passed the test easily. I never became a firefighter, but those women are still my friends."

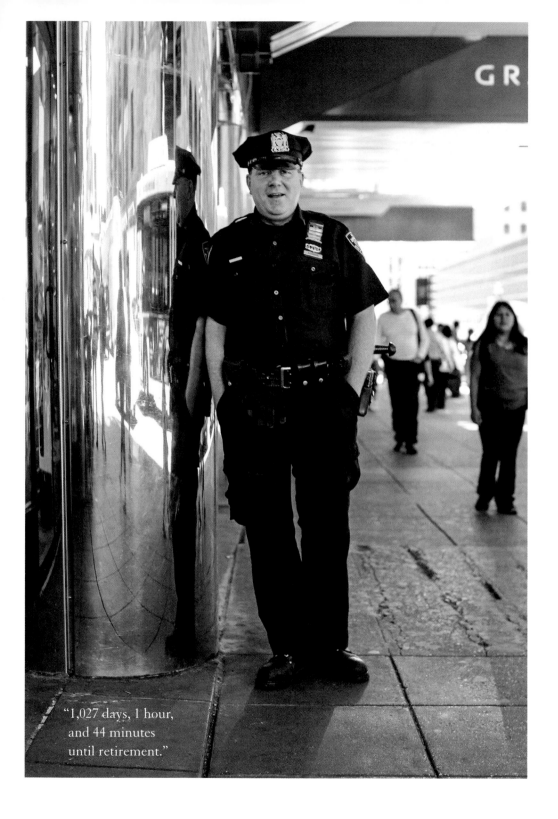

"1,027 days, 1 hour, and 44 minutes until retirement."

"I was down to the final two in an audition for the lead in a major TV show pilot. The network flew me out to Los Angeles. They put me up in a nice hotel and they introduced me to all of the executives. Everything felt perfect during the screen test. I thought I nailed it. Then right before I got on the plane back to New York, I got a call from my manager. He said the network thought I was 'too nice' for the role."

"I had a child when I was sixteen. I got kicked out of high school because of all the absences. My family and community pretty much wrote me off. But right away I got a job at a sporting goods store. Soon I was able to get a job as a receptionist at a tax company, and they gave me enough responsibilities that I learned how to do taxes. Eventually I learned enough to become an associate. Then I got offered a job at a smaller company, and even though it was a pay cut, they offered me responsibility over all the books—accounts payable, accounts receivable, everything. It was less money but I wanted that experience so I took the risk. And I'm so glad I did, because six months later, the controller of that company left and I was given that position. They told me they couldn't officially call me the controller because I didn't have a college degree. So I finished my degree five months ago—just to make it official! So after having a child at sixteen, I made it all the way to controller of a company, without even having a college degree. Can you believe that? Honestly, I've been waiting to tell that story so long that I told it to a customer service representative on the phone last week. She was nice about it and pretended to care."

"I'm a feminist. So if a woman and I are going for the last empty seat on the subway, I'm not holding back."

"We're going to get inside this tire and roll down the hill!"

"No, you're not."

"Yes, we are!"

"No, you're not."

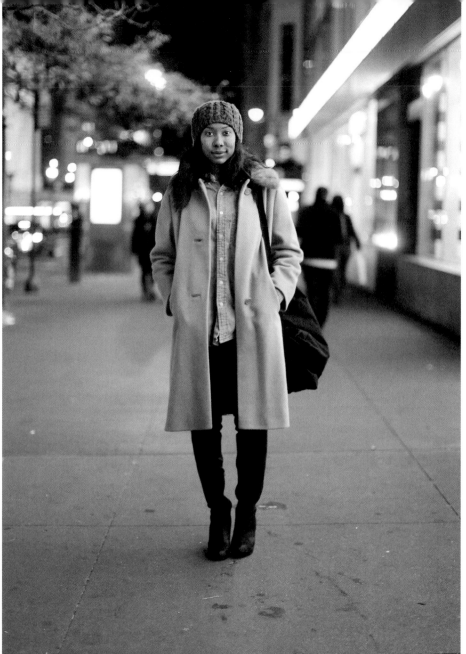

"He did tell me once that he had cheated on his last girlfriend. So I thought: 'Since he's being open about it, I can trust him.' "

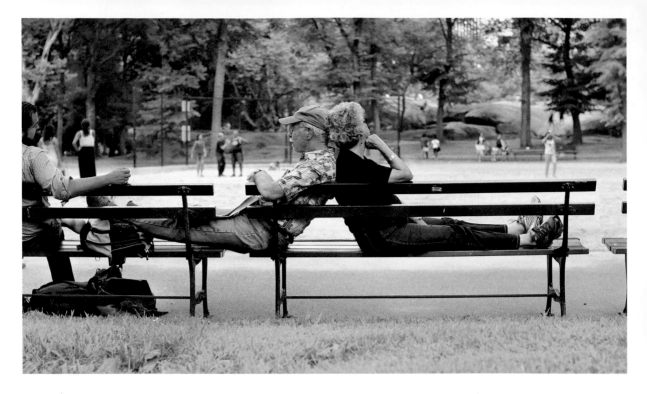

"Those are my parents. They've been married fifty-five years. Two years ago, we were all visiting Italy. And I busted the two of them making out in a corner. I snapped a photo. Dad's got Mom pinned up against a wall and he's macking her hard."

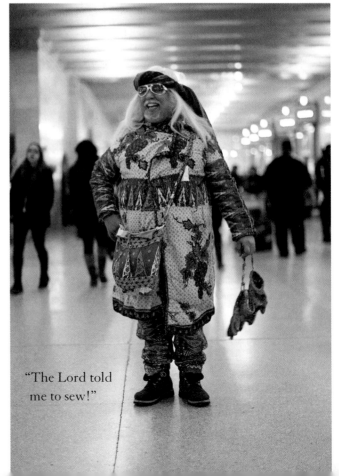

"The Lord told me to sew!"

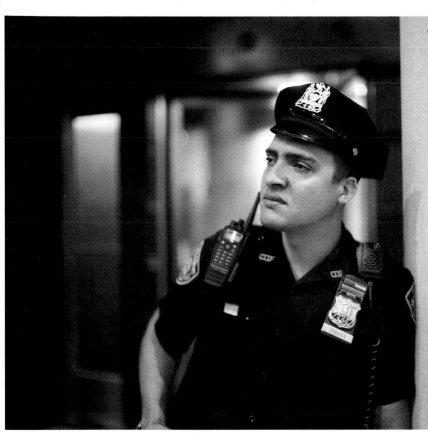

"I'm a traffic cop. It's a job. Somebody's got to do it. I don't even represent myself when I'm working. If I was representing myself, I'd let everyone off with a warning. I represent a system. Did I design the system? No. I just enforce it. It's not for me to decide the system. We elect the people who decide the system. When I write a ticket, everyone tells me a reason that they don't deserve it. If I gave a warning to everyone with a reason, I wouldn't give any tickets, and the system wouldn't work. I don't get any joy by giving a ticket. And I'm not upset if you beat it in court. It's not personal. It's my job."

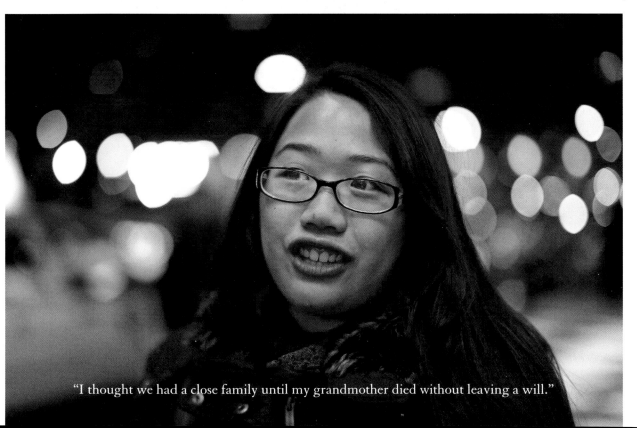

"I thought we had a close family until my grandmother died without leaving a will."

"It's not even about making money for me, it's about gaining respect. Seems that for kids around here, all the respect goes to the drug dealers, because they're the ones with money. But you know what saved me? Family. Instead of hanging out with friends after school, I'd take the bus from the Bronx to work with my dad in the recycling yard. He'd drive me around in his truck while he was doing pickups, and he'd tell me stories. And every one of his stories started the same way. He'd say: 'I wish that when I was your age, I knew the things that I know now.' And he'd also ask me questions. He'd say: 'When you get a car, are you going to lease it or buy it?' He'd say: 'What stocks do you think we should buy with the money we make today?' He'd say: 'Where do you think is the best place to buy a piece of property?'"

"I wanted to be a defense lawyer because I wanted to come back and protect my community. I wanted to protect my people from the police. People around here grow up hating the police. But you know what they've done? The police have recruited our people. They've made it more complicated. They've got Dominicans and Puerto Ricans doing their work for them. Because they know it's hard to hate your people. But as soon as that badge goes on, it changes you. Once that badge goes on, your people are the 'boys in blue.'"

"It's been tough in law school. 'Cause you know, I grew up around here, and I've still got some of that ghettoness in me. I talk a little different. I came up with this sort of nonchalant attitude, and now I'm competing with a bunch of private school kids that are ruthless. I'm supposed to read sixty pages a night, and I'm realizing that I don't read as well as I thought I did. I realized that public school kids are at a disadvantage. I did horrible the first year. I almost folded. But I pulled it back together. I took a tough internship that summer and came back strong. 'Cause it's destined to happen."

"You can make about 75 percent more money with a cat on your head than you can with a cat on your shoulder."

"I have a neck injury so I had to tone it down this year."

"I perform in angle grinder shows. I put on a metal outfit,
then I grind the metal off it so that sparks shoot everywhere.
Most of the time there are naked chicks involved."

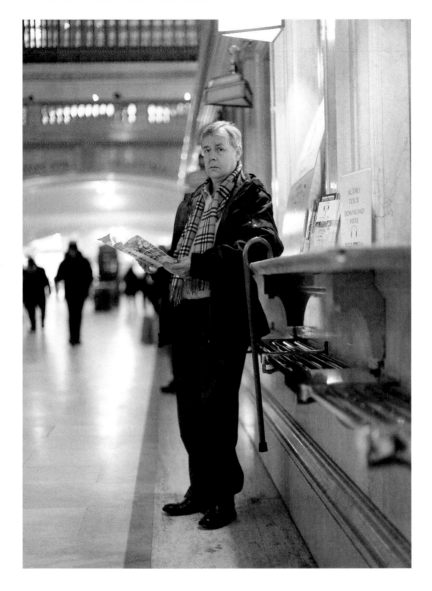

"I know this isn't going to be a popular opinion, but I'm gay, and I don't think there's nearly as much discrimination as people claim. Don't get me wrong, I've experienced discrimination. But it hasn't been a huge factor in my life. I feel like a lot of people bring discrimination on themselves by getting in people's faces too much. They like to say: 'Accept me or else!' They go around demanding respect as a member of a group, instead of earning respect as an individual. And that sort of behavior invites discrimination. I've never demanded respect because I was gay, and I haven't experienced much discrimination when people find out that I am."

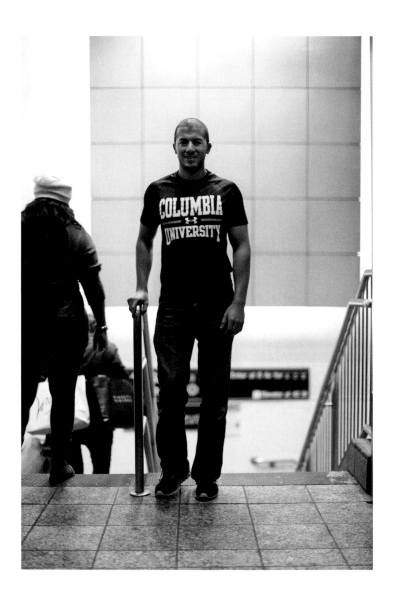

"I was born in Egypt. I worked on a farm until third grade with no education. I came to the U.S. for one year, started fourth grade, but was pulled out because my father couldn't find work and returned to Egypt for a year. The first time I went to an actual school was middle school, but the whole school was in one classroom, and I was working as a delivery boy to help the family. It was illegal for me to be working that young, but I did. When I finally got into high school, my house burned down. We moved into a Red Cross shelter, and the only way we could live there is if we all worked as volunteers. I got through high school by watching every single video on Khan Academy and teaching myself everything that I had missed during the last nine years. Eventually I got into Queens College. I went there for two years and I just now transferred to Columbia on a scholarship provided by the New York Housing Association for people who live in the projects. It's intimidating because everyone else who goes to Columbia went to the best schools and have had the best education their entire lives."

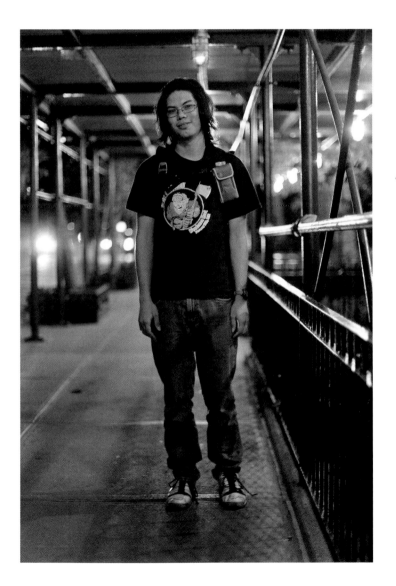

"There's a lot of pressure being the child of immigrants. My mother is Thai, my father is from Chile. They met while working at a restaurant. There's a knowledge among first-generation immigrants—that they aren't going to be the ones to achieve the American Dream. They have to work hard and struggle so that their children will have a shot at it. So they educate their children and pass the Dream along to them. And now I have an obligation to make more fucking money than them, to live the American Dream, to validate all the risks they took and everything they went through. And that's a heavy burden."

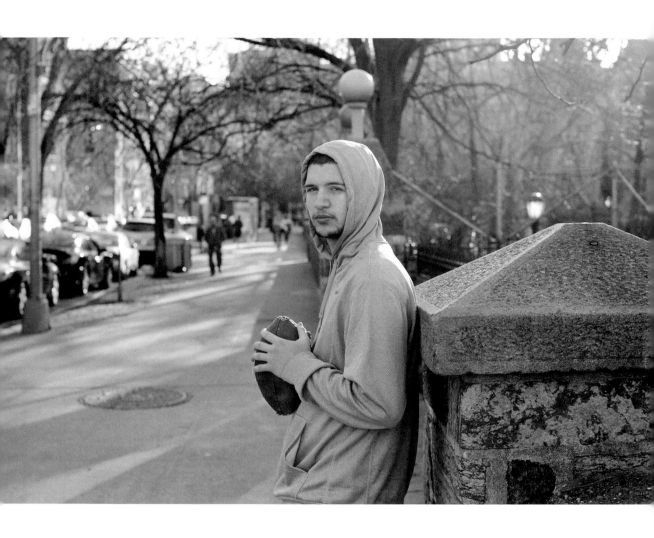

"I haven't taken it seriously so far, but I have plenty of time."

"I need to make it to the NBA so I can get out of the hood and help my mom."

"I got heartcrushed. She told me that she liked another boy while we were sitting in class, so I told the teacher that I needed to go to the bathroom, but I really just went and splashed water on my face."

"Do you have any advice for other fishermen?"
"You have to sneak up on them and catch
them real fast. And you have to wear boots. I
once caught a monster fish that went all the
way up to the sky like a giant. I like giants.
But not mean giants. I like nice giants."

"We were best friends in high school. I knew
 she was gay. She didn't know I was."
"So how did she find out?"
"I wrote her a love letter."

"I tell my daughters they need a college education so that they can have a career, and not a job. Because I've got two jobs, and they still don't add up to a career."

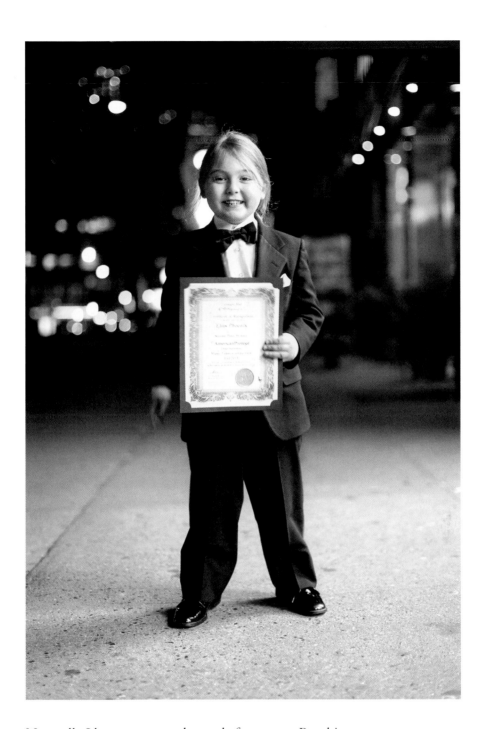

Normally I have to approach people for quotes. But this
kid walked right up to me, held his certificate in the air,
and screamed: "I played at Carnegie Hall!"

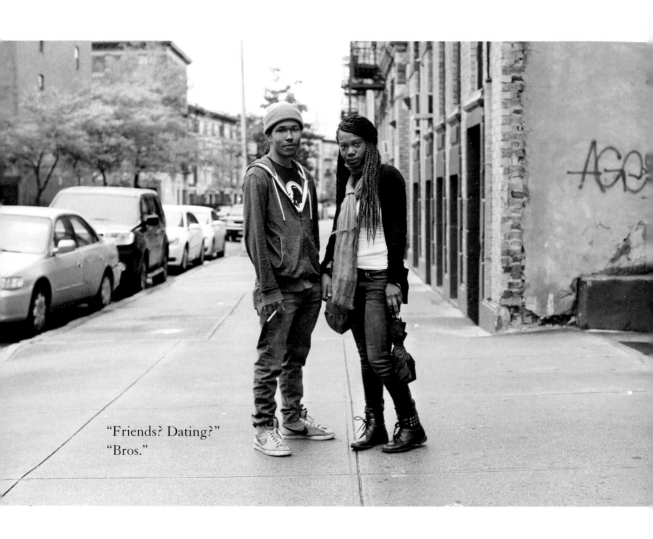

"Friends? Dating?"

"Bros."

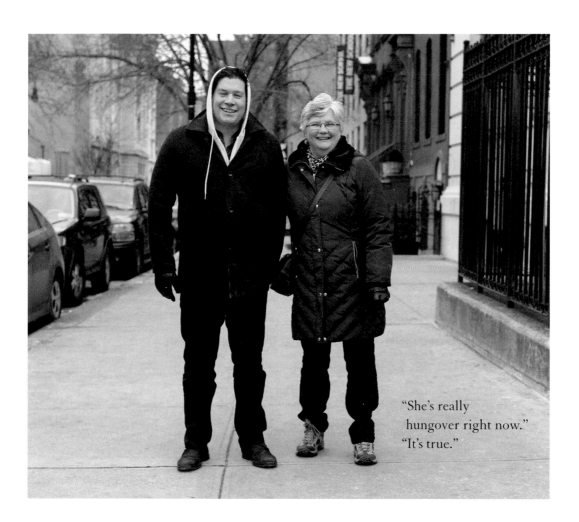

"She's really
hungover right now."
"It's true."

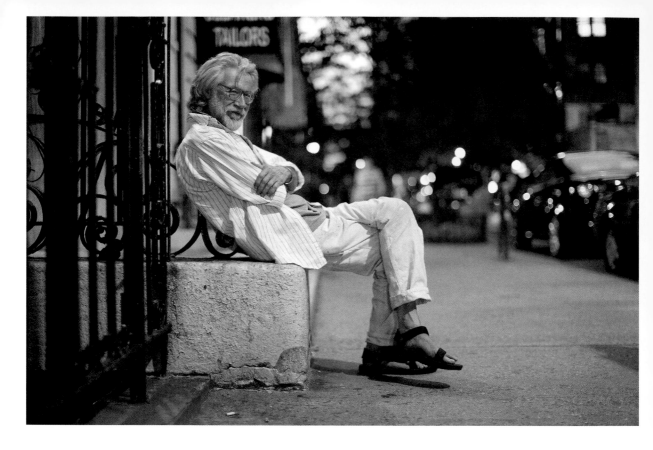

"I'm a philosophy professor. I tell my students 'never make an exception of yourself.' People like to make exceptions of themselves. They hold other people to moral codes that they aren't willing to follow themselves. For example, people tend to think that if they tell a lie, it's because it was absolutely necessary. But if someone else tells a lie, it means they're dishonest. So never make an exception of yourself. If you're a thief, don't complain about being robbed."

"I'm a psychotherapist. And a drunk."

Seen in Jamaica, Queens

"My best friend committed suicide. I think like most people who take their own lives, he was just feeling very isolated. He'd just come back from college, was living with his parents, and was in a very bad place. I've always felt guilty about my last words to him. I visited him at his parents' house, and as I was leaving, I told him: 'This is a bad situation. You've got to get out of here.'"

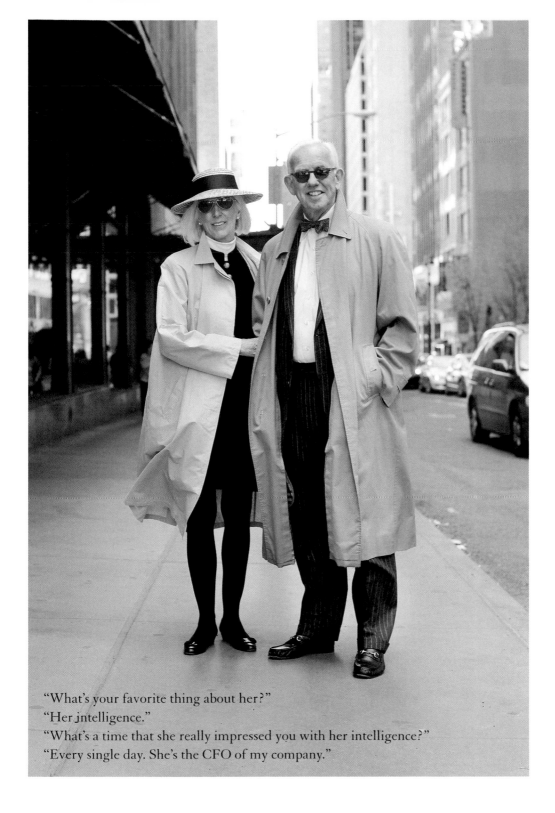

"What's your favorite thing about her?"

"Her intelligence."

"What's a time that she really impressed you with her intelligence?"

"Every single day. She's the CFO of my company."

"I haven't slept in a very long time. I work two jobs at two different hotels. I just finished three shifts in a row. Last night I went to my room service job at 11 P.M. and worked through the night until 6 A.M. I went home to take a shower, then had to be at the other hotel for my front desk job at 8 A.M. I worked there until 3:30 P.M., then ran back to the first hotel for another shift that started at 4 P.M. I just got off a few minutes ago, and I'm sitting here to rest for a moment before getting on the train home."

"I work this hard because I'm a single parent. I came here when I was very young from the Dominican Republic. I'm very happy with what I have done. I started with nothing and I raised two kids. But I have to work two jobs so that they can get an education and go to college. I tell them every day: 'Look at how hard I work. Look at how I don't have time to sleep. I can't control my own time. I can't manage my own schedule. This is why you need an education. I work this hard so that you can do the things that I am unable to do and have the things that I can't have.'"

"Do me a favor. Send this pic to every modeling agency in town, and tell them you've found a face that will really make people stop and stare at their products."

"My daughter lives in Pennsylvania. She's working at a nursing home and studying to be an accountant. I don't tell her I'm homeless. She's got enough to worry about. I just tell her that I'm retired."

"Today I'm supposed to meet the manager at my new job, get a physical, and study for the SATs. But I think I'm just going to head to the skate park."

"He proposed to me in a cemetery."
"Well, it sounds bad when you say it that way. It was a scenic cemetery.
More of a lookout point, really. And there were all these neat headstones.
It was her idea to go there, anyway."

"I'm Hustle Man! That's all you need to know."

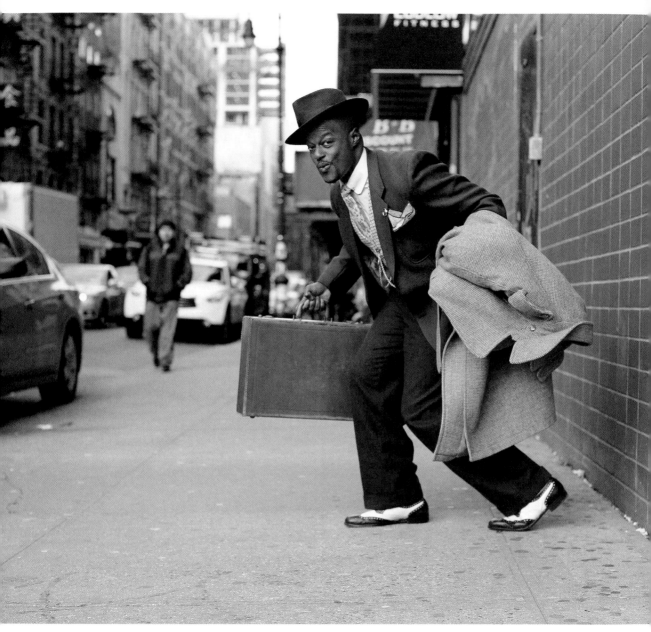

"I'm wearing really plain-looking underwear."

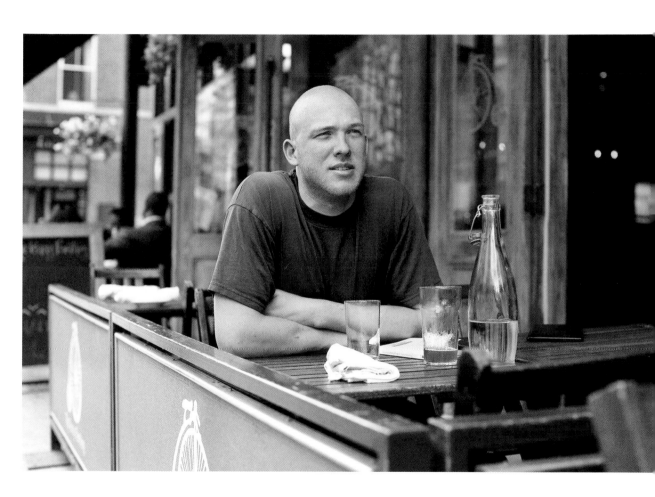

"It's hard to be taken seriously when you don't have connections. And unfortunately, when you don't have connections, it seems like the only people you can connect with are other people who don't have connections."

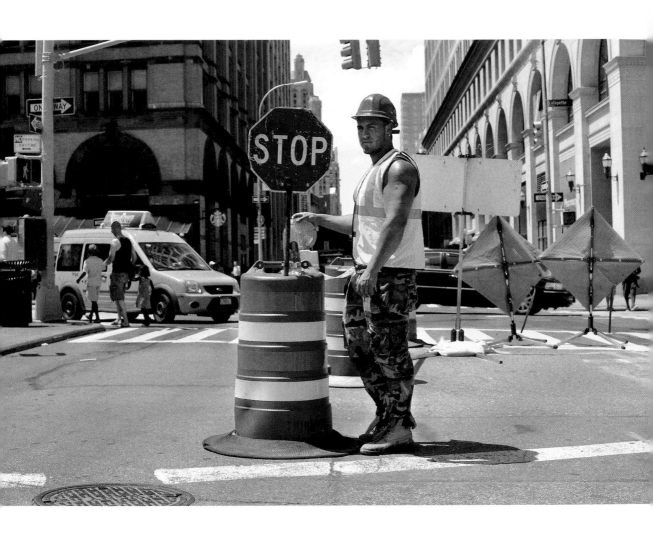

"What's your best quality?"
"My body."

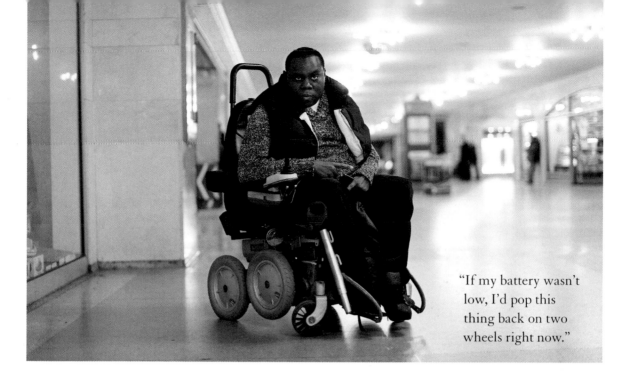

"If my battery wasn't low, I'd pop this thing back on two wheels right now."

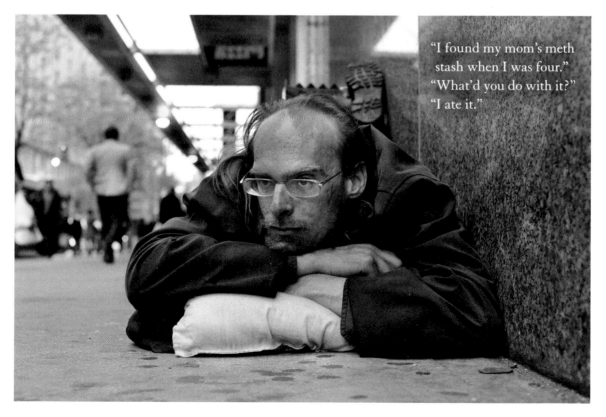

"I found my mom's meth stash when I was four."
"What'd you do with it?"
"I ate it."

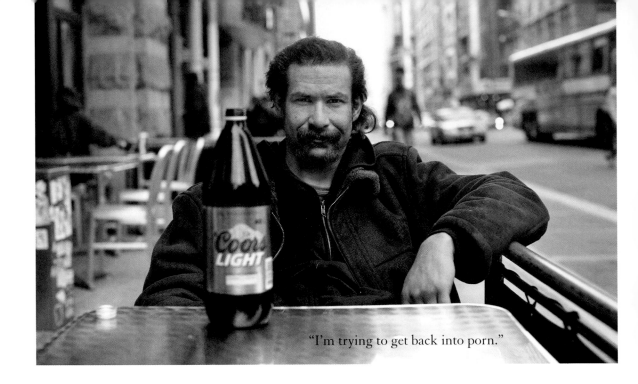

"I'm trying to get back into porn."

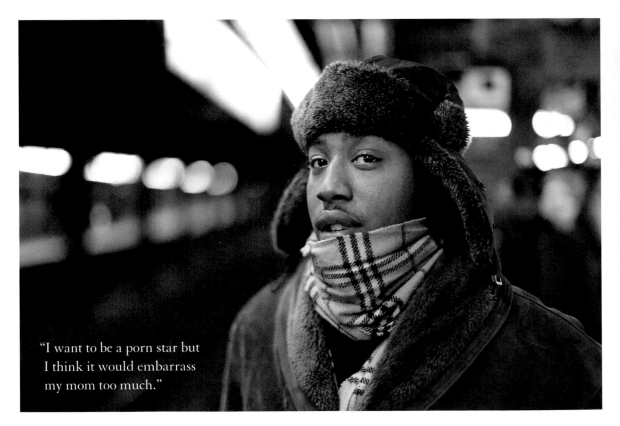

"I want to be a porn star but I think it would embarrass my mom too much."

I saw a drummer in Central Park give his
sticks to a little kid so that he could have a try.
Ten minutes later, this was happening . . .

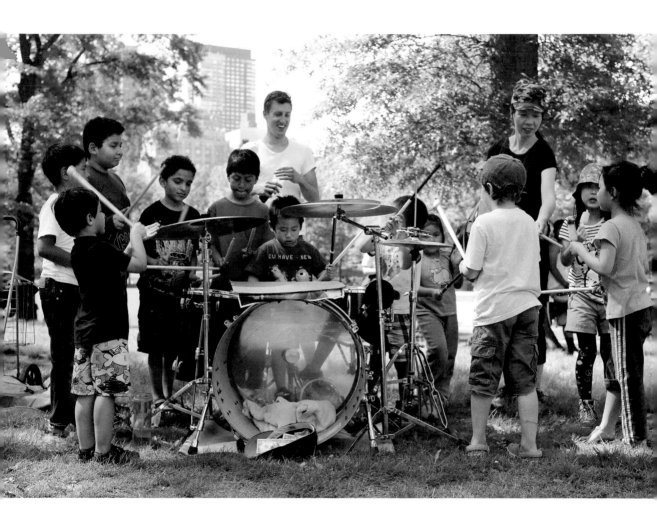

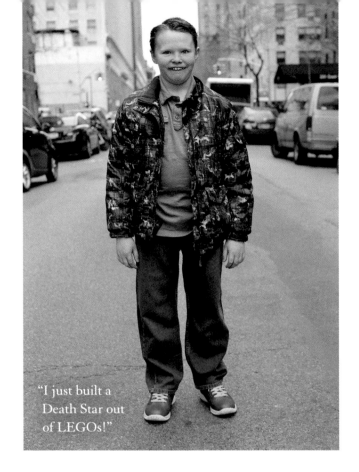

"I just built a
Death Star out
of LEGOs!"

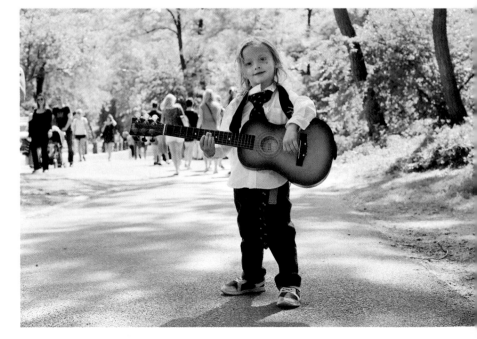

I asked him to tell
me his favorite
song. He strummed
randomly on the
guitar a few times,
and said: "That one."

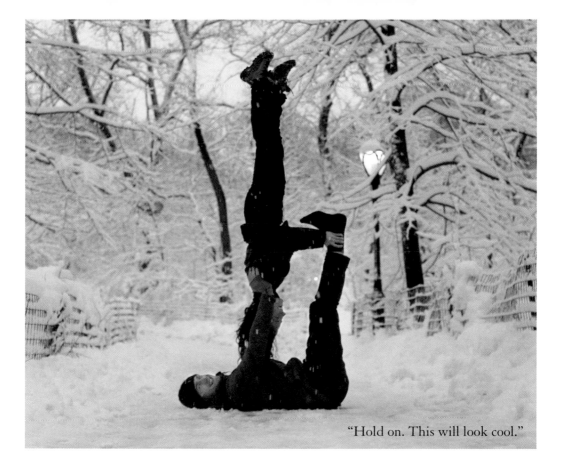

"Hold on. This will look cool."

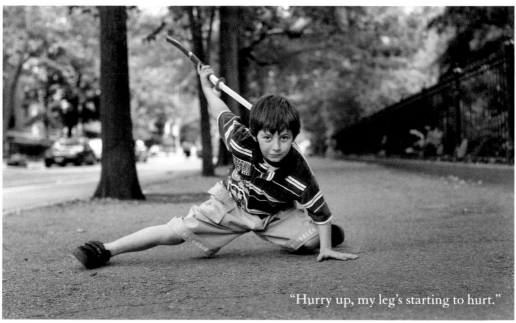

"Hurry up, my leg's starting to hurt."

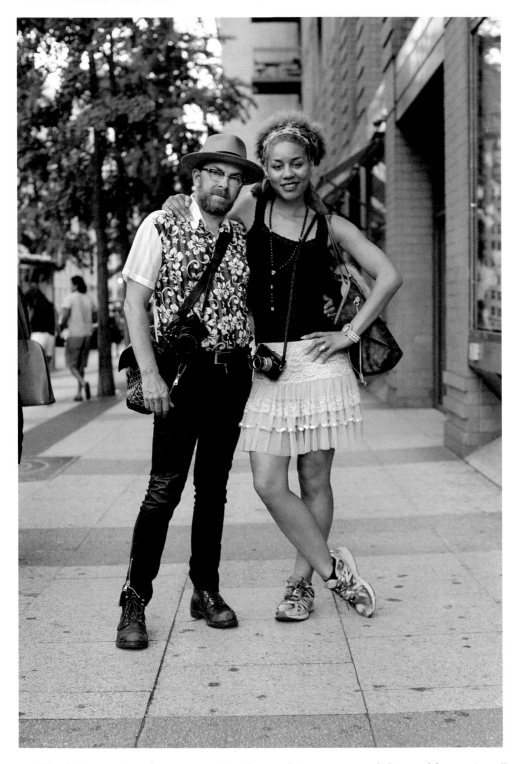

"He kidnapped me last year and has been taking me around the world ever since."

"I've been off cocaine for about four months now. My
 parents stepped in and started randomly drug-testing me."
"Did you resent them at the time?"
"No. I only resented that they had to do it for me, because I
 couldn't do it myself."

"I make freaky,
sexual films because
my childhood life
was boring as fuck."

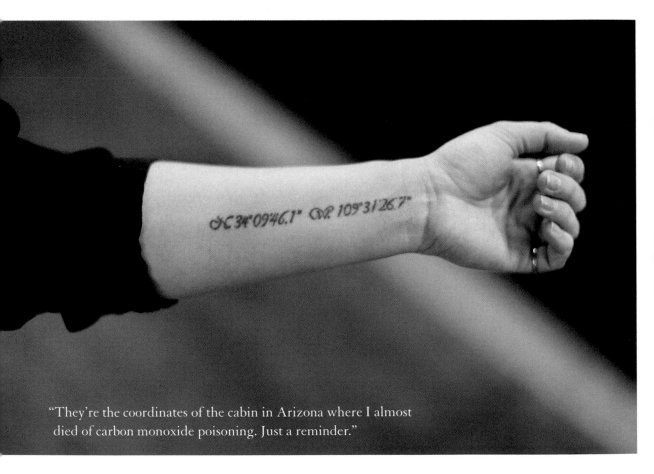

"They're the coordinates of the cabin in Arizona where I almost
died of carbon monoxide poisoning. Just a reminder."

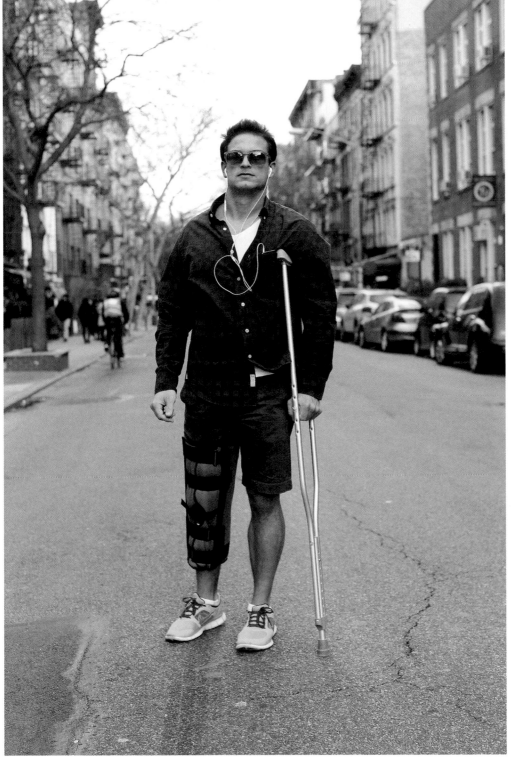

"A drunk girl fell on my leg."

"I'm a little worried because he's two and he's not talking yet. Everyone is telling me that he should be talking, and I see other babies imitating and having little conversations. But he's only two, so we'll give it another year."

"I'm afraid my band is getting too 'poppy.'"

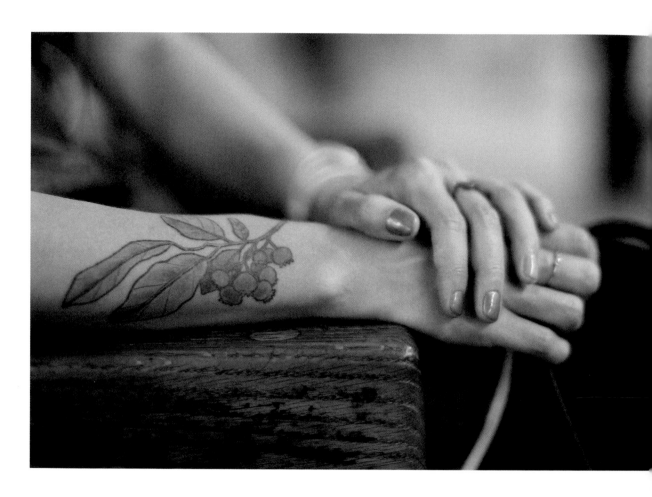

"I'm always sad."

"Are there certain thoughts associated with the sadness?"

"No, the sadness is under the thoughts. It's like when you're on a camping trip,
 and it's really cold, and you put on extra socks and an extra sweater, but you still
 can't get warm, because the coldness is in your bones."

"Do you hope to get away from it?"

"Not anymore. I just hope to come to peace with it."

"I don't understand my feelings. Sometimes I feel sad and I don't know why. Then sometimes I feel silly, and I don't know why, either. Now I feel 'Wow,' because this is my very first interview."

"I try to stay away from other people. I don't like to have to be keeping up pretenses all the time—it's exhausting. I'm always having to make up little stories to get out of social situations. But I'd much rather be alone, watching films. I enjoy watching actors. They're always pretending, just like me."

"These experiences were so meaningful to me that I don't want you to soundbite them."

"Looking back, I probably should have gotten more angry after the first
marijuana arrest. I probably should have put my foot down. Instead, I said:
'Don't worry. I'll call a lawyer. We'll get this straightened out.' I never got
angry, because I never wanted him to be angry with me."

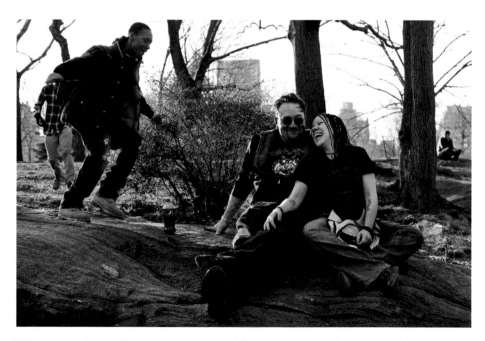

"We met on Craigslist. He put up an ad for a tattooed girl with a soft heart.
When he came to pick me up the first time, he got out and leaned against his
truck with his arms crossed, trying to look like a badass."

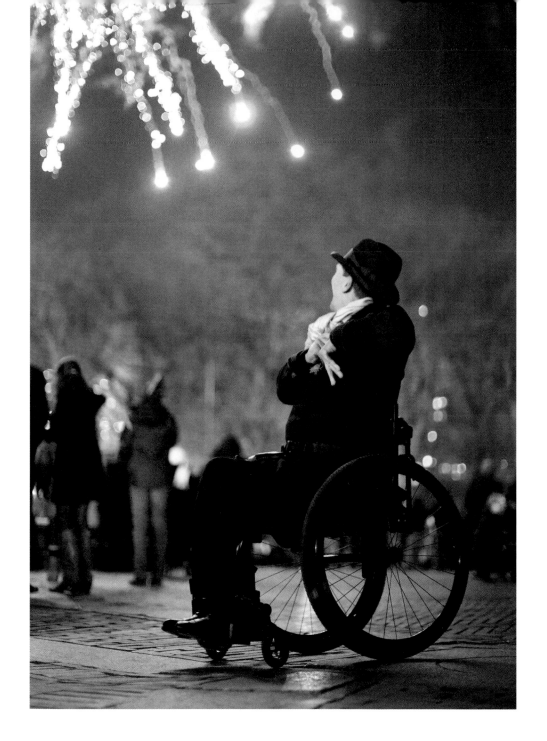

"Do you remember the saddest moment of your life?"
"When I realized that I hadn't killed myself, and I was still alive."

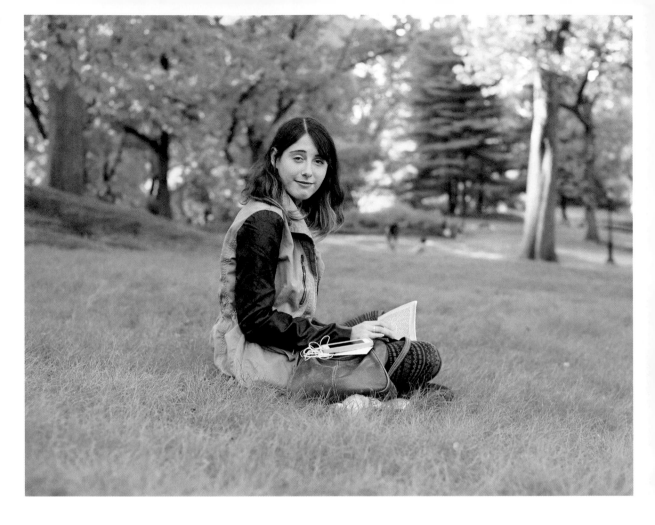

"I had really hippie, alternative parents. They pulled me out
of middle school because they didn't think it was fulfilling
me creatively, and we drove across the country in an RV."
"You can't just not go to school, can you?"
"Actually, you kinda can."

"My father is from Paraguay, and he brought his culture with him. When we were growing up, he'd always say that everything we did wasn't *decente*. Sleepovers weren't *decente*. Painting my nails wasn't *decente*. Shaving my legs wasn't *decente*. Having a boyfriend wasn't *decente*. He was always reminding us how much he sacrificed for us. Now, even as an adult, I hate who I am when I'm around him. Whenever I visit him, I get weak. I don't wear makeup. I take off my nail polish. I don't tell him anything about my life. My voice changes. It becomes softer and more obedient."

"Do you resent him?"

"I wouldn't say that. Honestly, I just think he loves me too much."

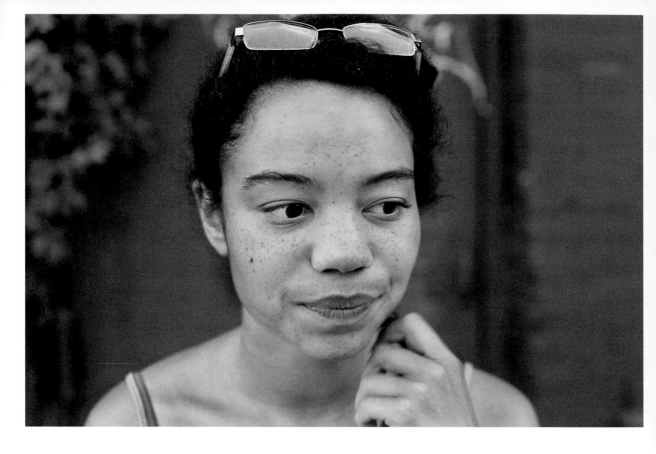

"My dad died of a brain tumor on my fourteenth birthday. He had a lot of mental problems. For a while he thought I was the Messiah, and that I could do anything. It was weird, because on one hand, it was the most anyone has ever believed in me. On the other hand, it felt hollow."

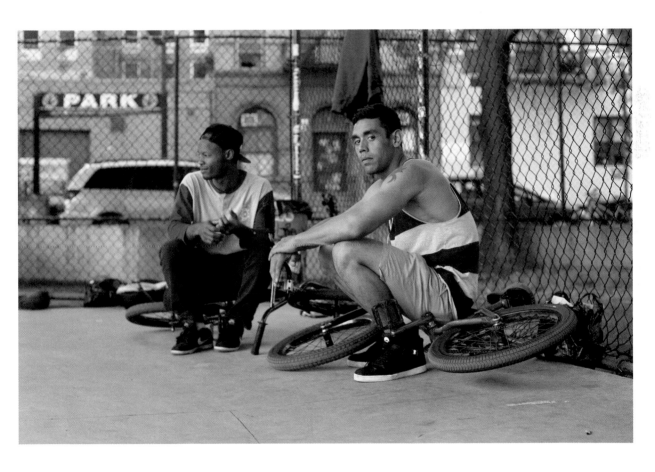

"My ex-girlfriend seemed to love me a lot more than I loved her,
so I made the mistake of thinking I didn't love her."

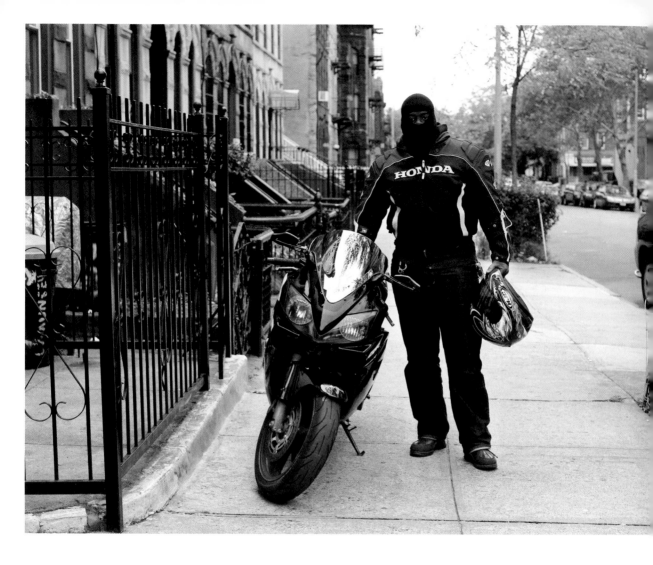

"My mother abandoned us when we were sixteen. She was a single mother raising four kids, and one day she just said, 'Fuck you,' and left. That's actually what she said when she was walking out the door: 'Fuck you.' I'd always been a loner so I didn't have many friends to stay with, so I started sleeping in abandoned houses. I still had a job in the afternoons, so I used that money to eat. I didn't tell anyone at school. I wore the same sweat suit every day. I just barely got through classes. When I went to college, I had to take all these remedial classes. I basically had to do everything over. But I became the first person in my family to get a degree."

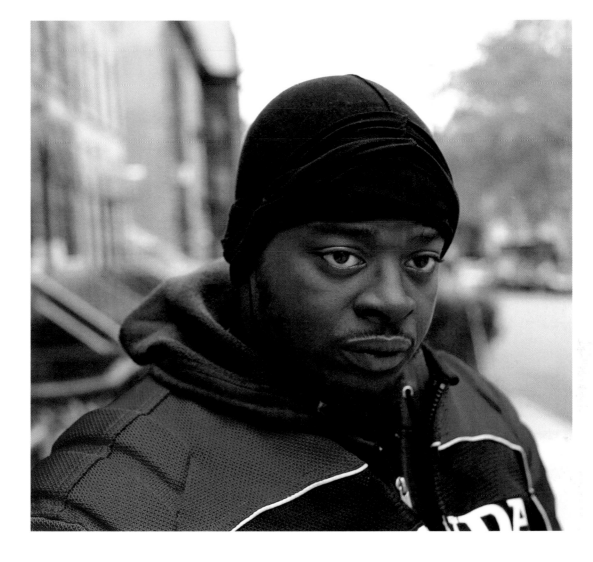

"It's hard when you don't have anybody behind you. It's easy to start something, but when you don't have anybody supporting you, it's easy to quit. Because I think no matter what we say, the main reason we do things is because we're trying to please somebody. And when things get tough, that helps keep you going. I tried to take boxing lessons once. And every time I had a fight, there was nobody in the stands cheering for me. Whenever things were going well for my opponent, I could hear all his friends and family encouraging him. Whenever things were going well for me, there was silence."

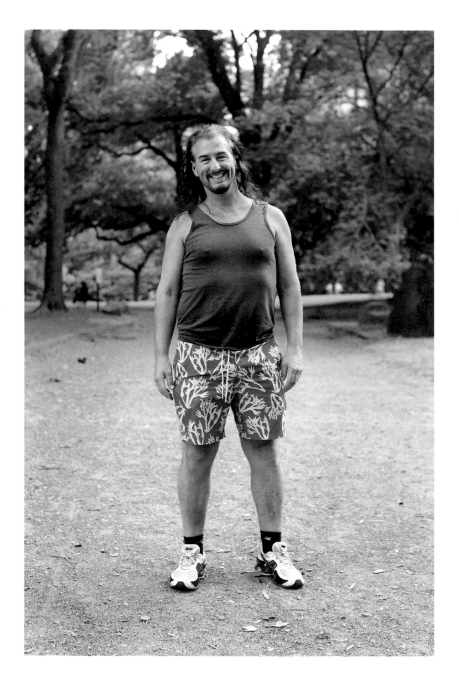

"I was driving out into the Mexican desert with a shaman, and we were on our way to a peyote ceremony. We'd just eaten the peyote, and the shaman turned on the radio and started playing the Talking Heads. He was this little indigenous dude, just banging on the steering wheel and singing along to the Talking Heads at the top of his lungs. I thought we were supposed to be contemplating life, so I said: 'Are you sure the radio should be on right now? Is that how the ceremony is supposed to work?' And he said: 'This is exactly how it's supposed to work.'"

"My family made me come. But I hate it. I can't get a job because I have a lot of accent. I was an assistant manager at a big jewelry store in the Dominican Republic, now I clean tables. We had a big house there. Now we live in a small apartment. If I was home right now, I'd be in a very nice restaurant, on the beach, laughing with my friends. Not sitting alone on a bench, trying to learn English. There I was a princess. Here I am an immigrant. A servant."

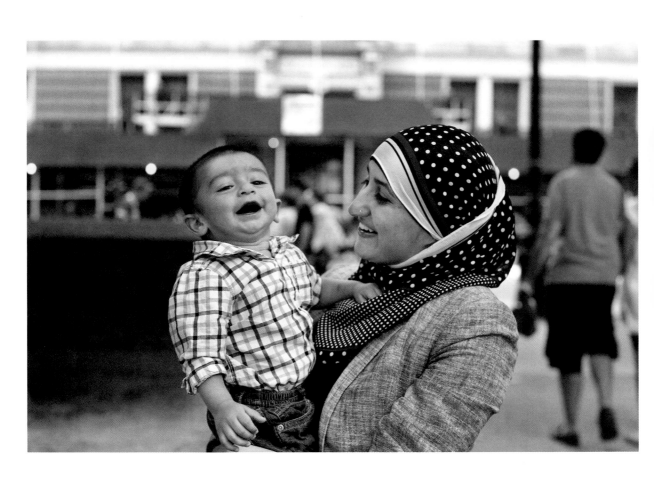

"He had his first birthday yesterday, so he goes crazy
 every time he hears the 'Happy Birthday' song."
"Let's see it."

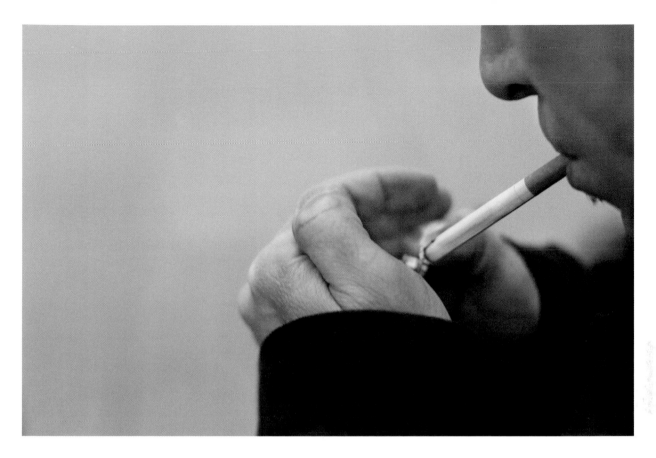

"It took me getting into a lot of fights before I was diagnosed with PTSD. I have
something called 'hypervigilance.' I get really nervous around people. Especially
people from the Middle East."

"What happened to you?"

"I was in a vehicle when a mortar round exploded in front of us, and we fell into the
crater and got trapped. There was a burning oil rig near us, so it was like being in a
microwave. And we couldn't get out. And I also saw a lot of hanky shit. Mostly from
our side. Everyone was really revved up from 9/11. We did a lot of bad things. I saw
decapitations, and that was our guys doing it."

"What happened?"

"We were supposed to bring POWs back to the base. But instead we gave them a
cigarette to calm them down, and told them to get on their knees. One of our guys was
240 pounds, and he'd taken this shovel we'd been issued and he'd sharpened one of the
sides until it was like an ax, and he could take off somebody's head with two hits."

"How many times did you see that happen?"

"Three."

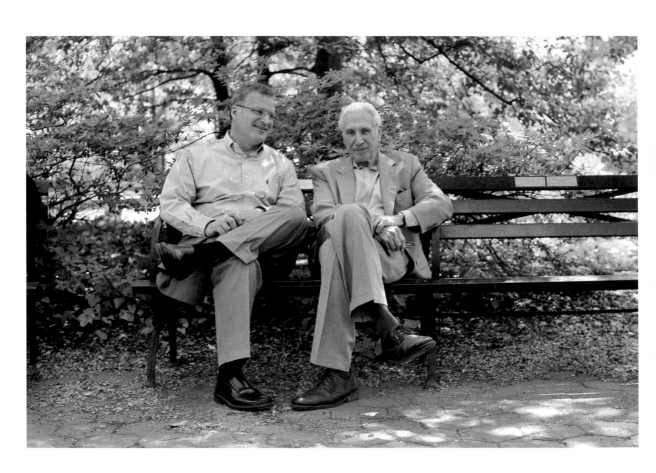

"We're eye doctors."

"What's something about the eye that most people don't realize?"

"The eye doesn't see. The brain sees. The eye just transmits. So
what we see isn't only determined by what comes through the
eyes. What we see is affected by our memories, our feelings, and
by what we've seen before."

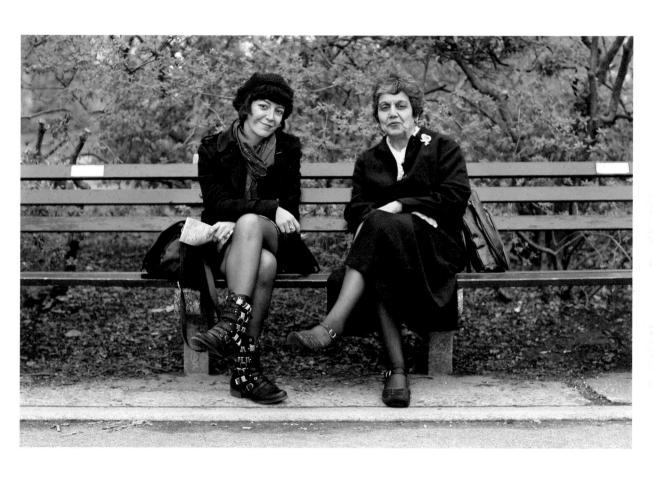

"She's dating my son. It's Meet the Mom Day."

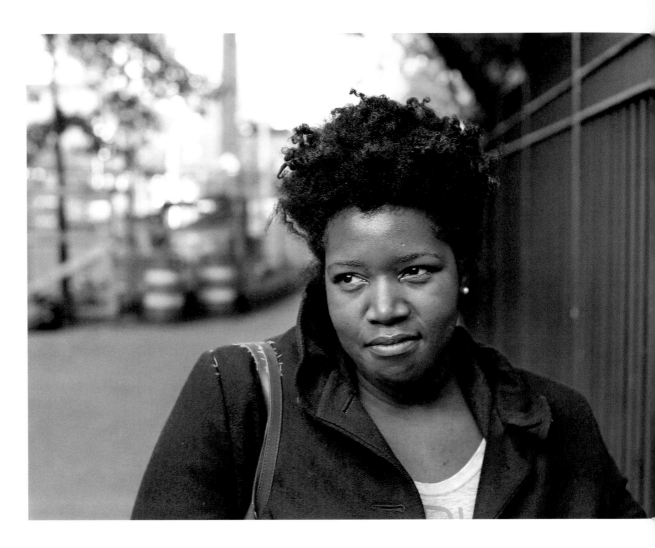

"Sometimes it feels like I'm not a part of anything. There are so many people here, you'd think that I'd be able to make friends with one of them. But it always seems like everyone has got their own thing going on, or their own group of friends that they hang out with. Most weekends I just take a long walk, or go to a restaurant by myself. I've done some neat things alone, and I'm glad that I did those things, but I'm really getting to the point where I'd also like to experience things with other people. Everybody tells me: 'You should do this,' or 'You should do that.' But nobody says: 'Let's do this,' or 'Let's do that.'"

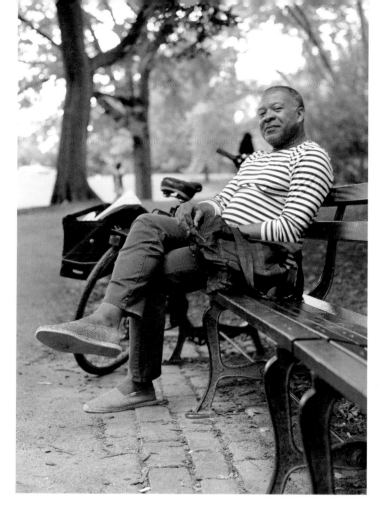

"Julia Child would have been 101 last week. I celebrate her birthday every year. This year I cooked some smoky eggplant soup and ate it in Central Park."
"Were you alone?"
"Of course. I love to be alone. I'm fabulous."

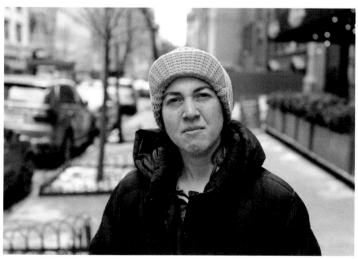

"I can't even find peace in my yoga class. Somebody barged in and started arguing with the instructor."

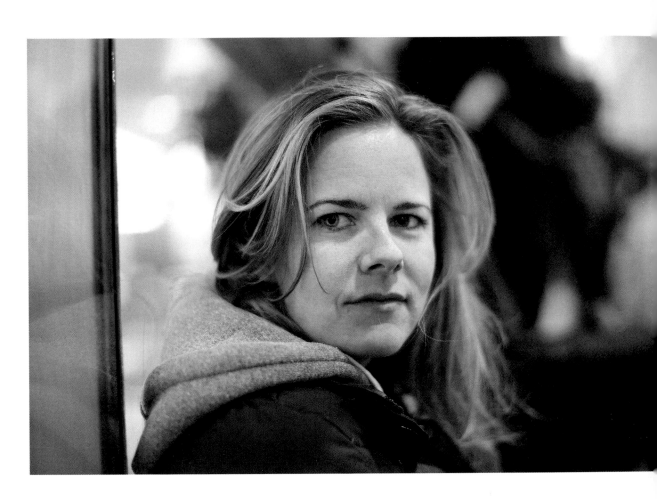

"I just broke up . . . well . . . I just got broken up with. I thought I was going to marry him. It's frustrating. After being independent for so long, and going from place to place and man to man, I've finally come to a point where I'm ready to settle. And I can't."

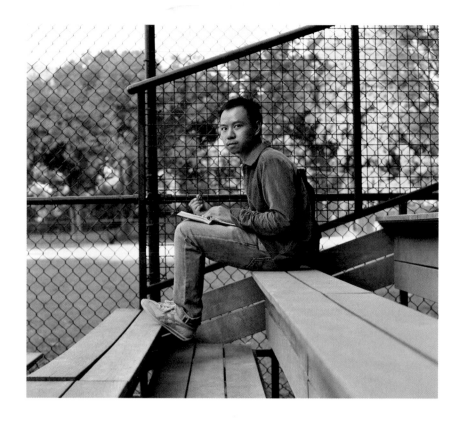

"I came from Thailand one month ago. It is very difficult for me to, how do you say, make communication with someone. I cannot say anything complicated. It make me look like fool."

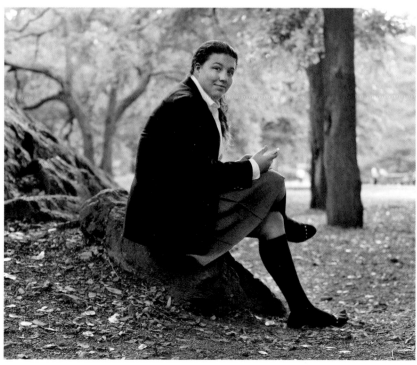

"I'm trying to be myself. But it's hard to be yourself, because people might not like who you really are."
"And who are you, really?"
"I don't know yet."

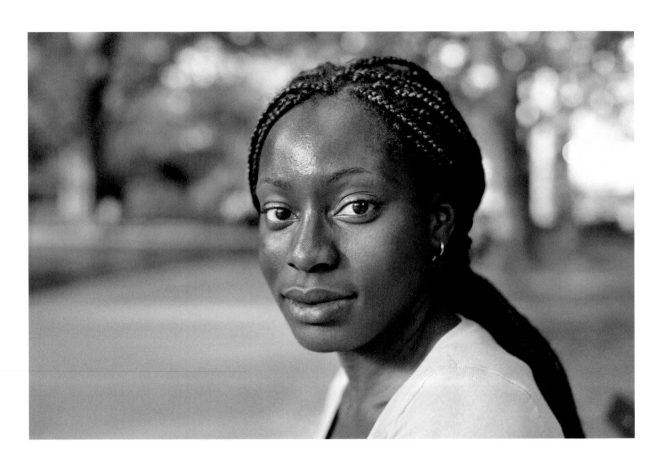

"My mom moved to New York and left me in Jamaica from the
age of five to thirteen. I was angry with her when I finally got
here, but things are fine now."
"Did you have any siblings?"
"A younger brother. She brought him with her."
"Why didn't she bring you, too?"
"Honestly, I've never wanted to ask."

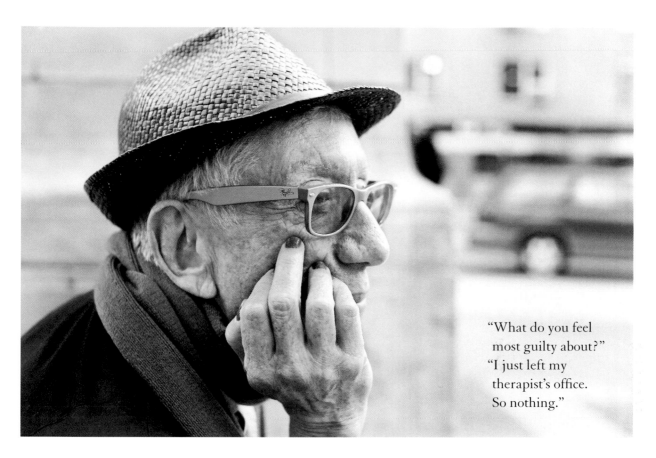

"What do you feel
most guilty about?"
"I just left my
therapist's office.
So nothing."

"Everything is
beauty to me. The
world is like a
love feast for my
eyes. I mean, look
at this rug at my
therapist's office.
It's fabulous!"

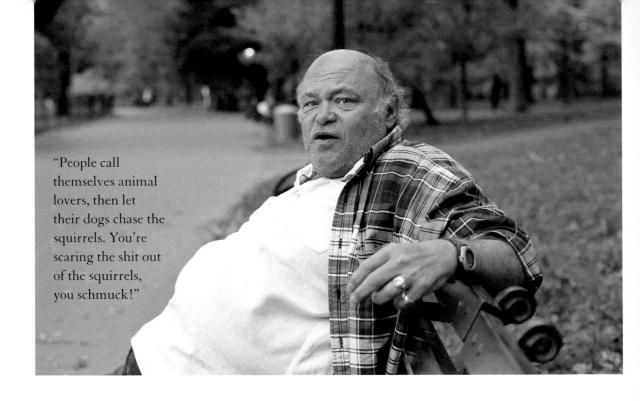

"People call
themselves animal
lovers, then let
their dogs chase the
squirrels. You're
scaring the shit out
of the squirrels,
you schmuck!"

"This is my teacher
now. They call
her the 'hugging
saint.' She's hugged
30 million people.
Sometimes she'll sit in
one place for twenty
hours and hug 15,000
people. I've probably
hugged her over two
hundred times."

"I survived a long-term murder plot against my life."

"I'm finding out that being an adult is a lot more than learning how to cook."

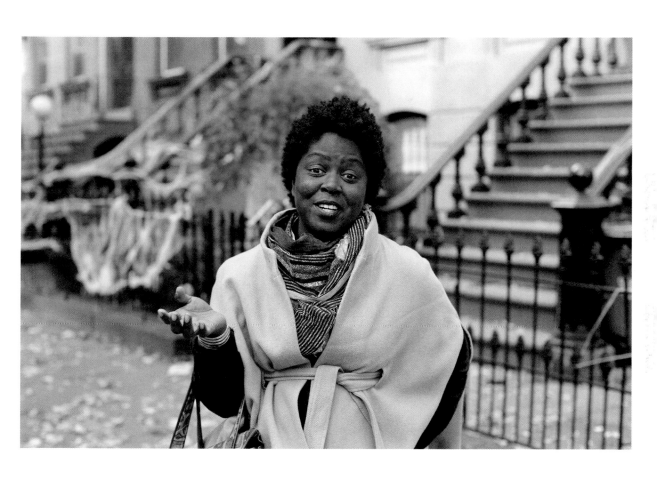

"He likes to take the lead, so I've learned to lead more quietly."

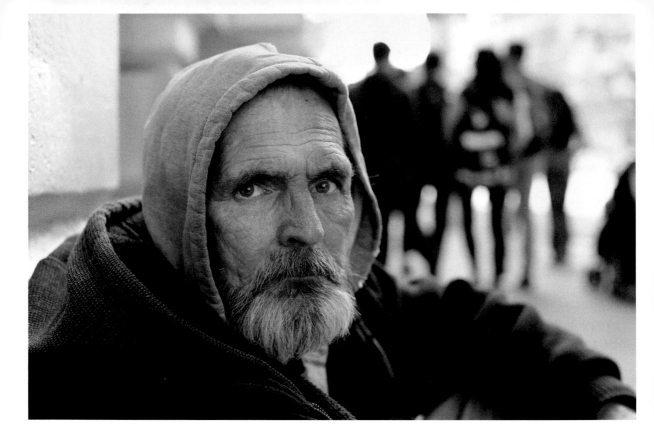

"It was hell growing up. My parents were two pieces of shit. You don't know what it was like coming home from school and being afraid because your mom is flying on fucking drugs so you go and hide under your bed and listen to them scream and wonder whether your dad or your mom was going to kill the other one first. One time my dad told my mom that he'd kill her if she hit me again. He came home that night and saw my face bruised up, so he dragged my mom out of her room by the legs, lifted her up by her throat, and pinned her against the wall. Her face was turning more and more purple and I was pulling on her legs trying to get her feet back on the ground. 'Cause I didn't want to see my dad kill my mom. She always beat me and called me a piece of shit and told me that I was going to hell, but that was my mom."

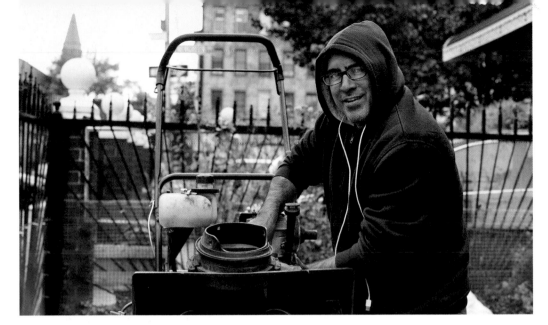

"The whole block chipped in and got this snowblower because we don't want any of the old-timers having heart attacks from shoveling snow."

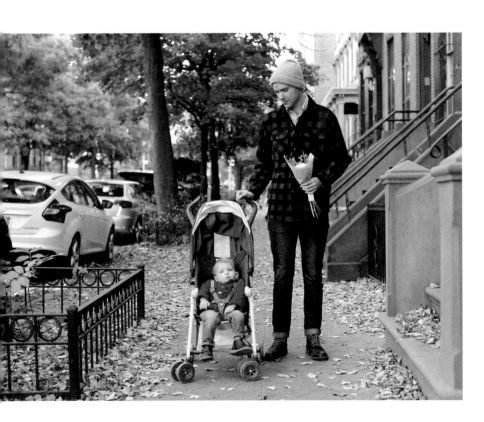

"What are the flowers for?"
"We woke up at 5 A.M. today. So we're saying 'sorry.'"

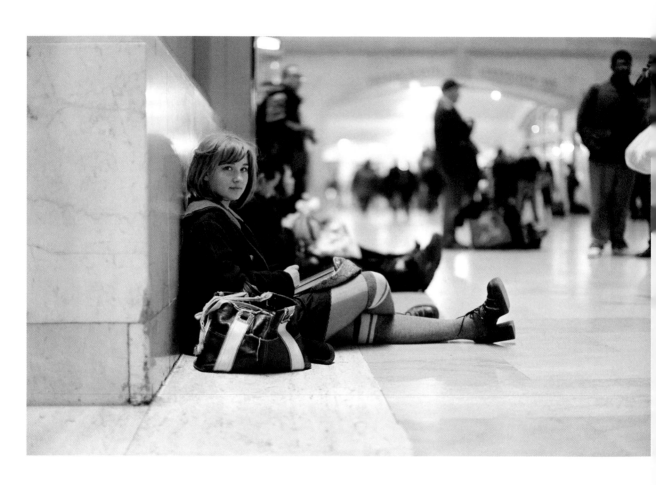

"I'm trying really, really hard to be authentic. Sometimes I'm successful, but other times I overthink it and a lot of bullshit comes out."

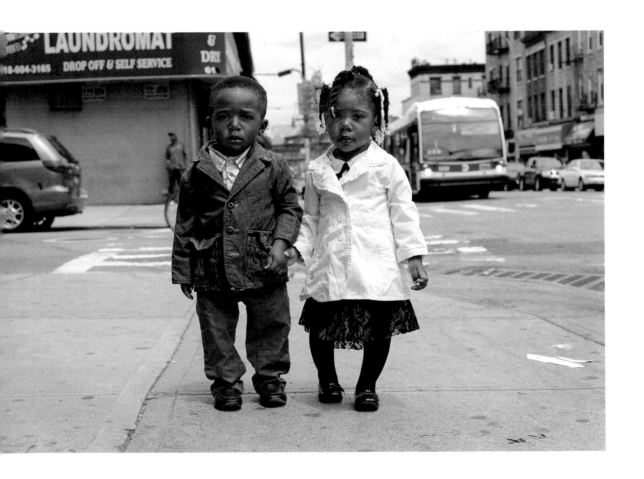

Today in microfashion . . .

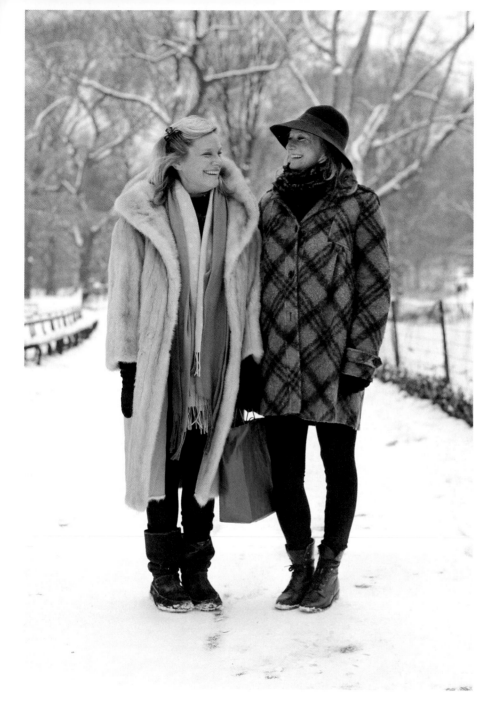

"She can turn any ordinary moment into an adventure.
When Hurricane Sandy destroyed the bottom floor of our
house, she decorated the rubble in Christmas lights."

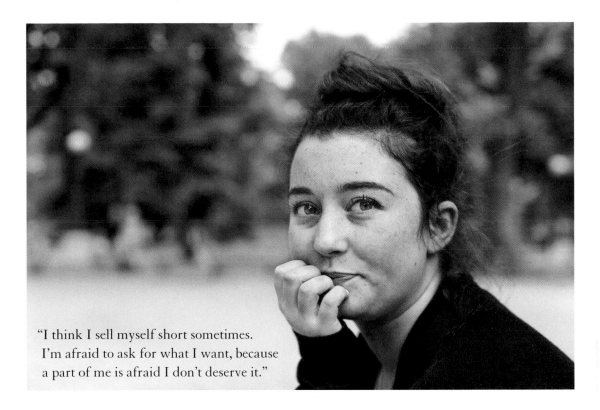

"I think I sell myself short sometimes. I'm afraid to ask for what I want, because a part of me is afraid I don't deserve it."

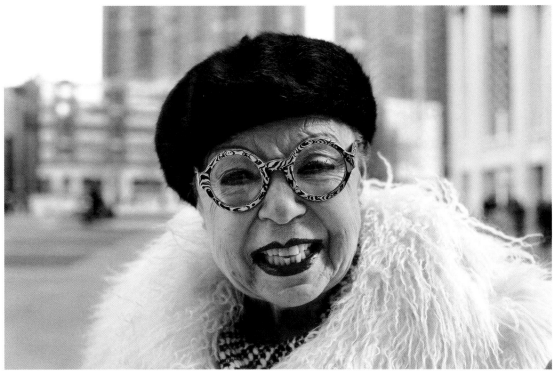

"I'm trying to fight my way into these fashion shows!"

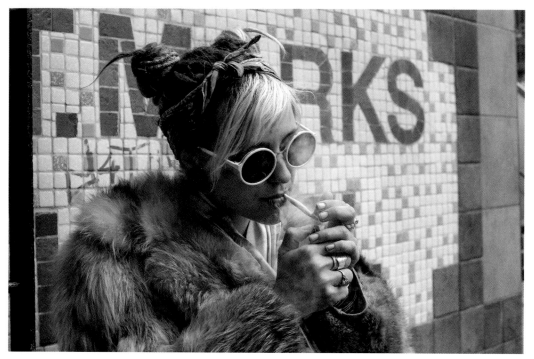

"I've been on a mission all day. It ended with this coat."

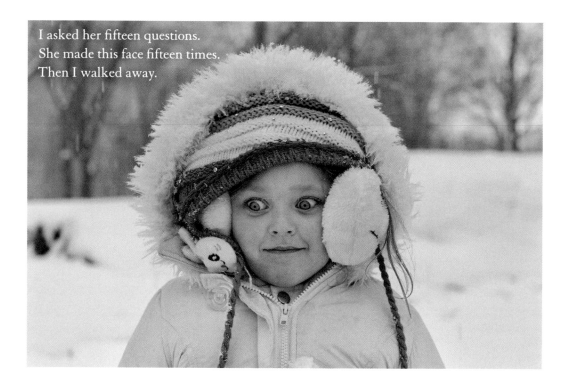

I asked her fifteen questions.
She made this face fifteen times.
Then I walked away.

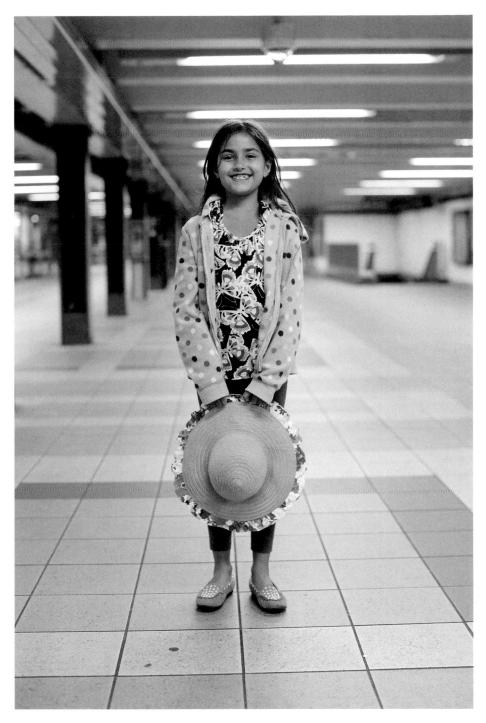

"I'm going to be an artist."
"Do you have any advice for other artists?"
"Don't press down too hard with your crayons."

"I'm finished."

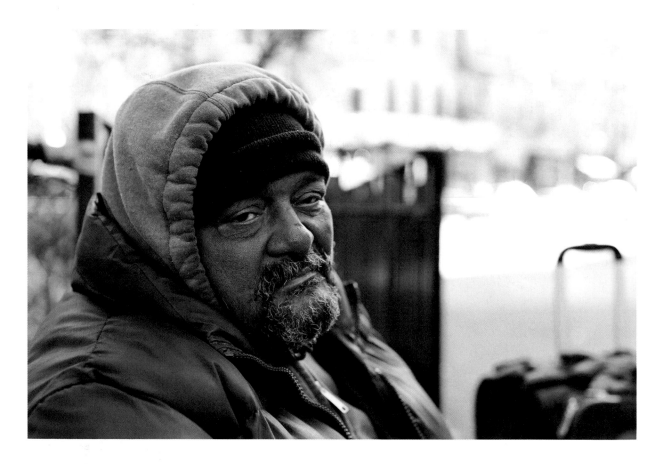